SOUTINE

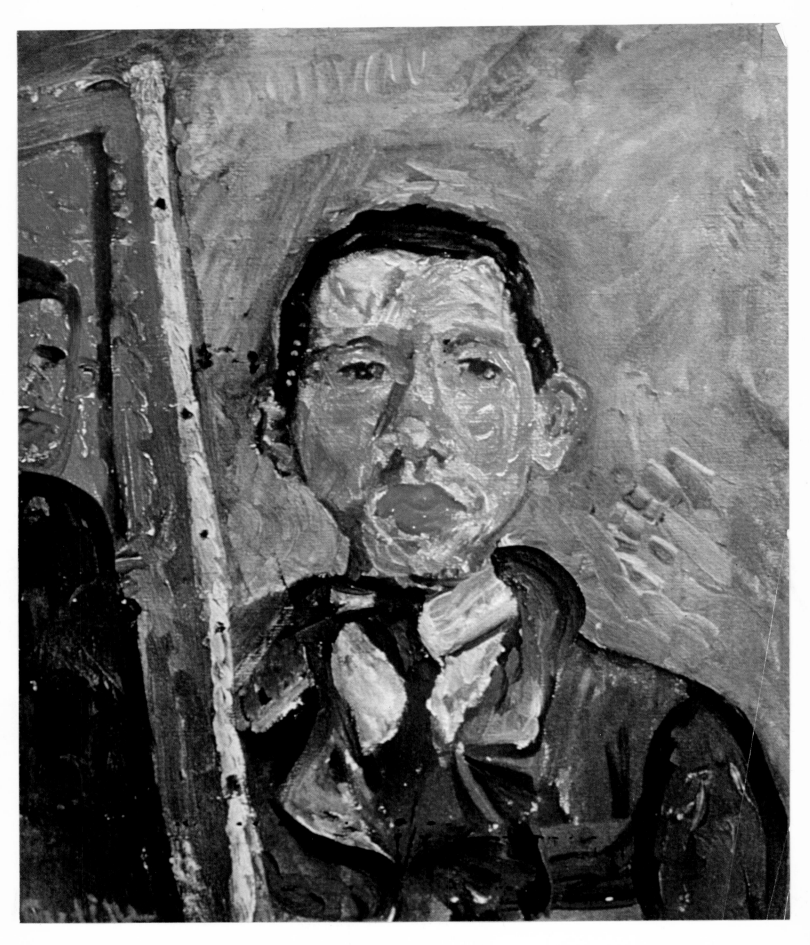

LIFT PICTURE FOR TITLE AND COMMENTARY

CHAIM
SOUTINE

TEXT BY

ALFRED WERNER

THE LIBRARY OF GREAT PAINTERS

THAMES AND HUDSON

On the jacket: *Still Life with Ray* (see colour plate 22)

Editor: Edith M. Pavese
Designer: Julie Bergen

First published in Great Britain in 1978
by Thames and Hudson Ltd, London

Printed and bound in Japan

To My Wife Lisa

CONTENTS

Text by Alfred Werner

COLORPLATES

PAINTING WITH FURY

"He [Soutine] had no intellectual culture whatever, and he used this idiom, which he acquired (from earlier masters) without thinking and applied with a hallucinated energy, for the sole purpose of expressing his tragic cast of mind. He attacked the world of things like a man driven by hunger, and beneath his avid frenzy they took on a tragic poetry, which always revolved about the themes of decay and sadness."

Werner Haftmann (in Painting in the Twentieth Century, 1965)

Chaim Soutine was not one of those gentleman-artists—cultured, refined, often inspired by literature and legend—as was Delacroix in the early part of the last century, or Soutine's contemporary, Jacques Lipchitz. He was much closer in his make-up to the anti-bourgeois painter he so much admired, Gustave Courbet, or, among twentieth-century artists, to Jackson Pollock (without sharing the political orientation of the former or the self-destructive tendency of the latter). By and large a simple man, Soutine painted with his guts, without much regard for the intellectual or aesthetic world around him.

The American painter George Biddle, scion of a well-known Philadelphia family, reports having invited Soutine in 1924 to a party at his Paris studio: "Soutine, pale, crumpled and a little forbidding, asked me in a tense voice where were the pornographic drawings, was this or was it not a *maison de passe* and when would the girls undress and the floor show begin.... Léger looked ruffled and left early. I was told the next day by some of my friends that Soutine was furious because Léger had been invited. They disapproved of each other's painting" (in *The Yes and No of Contemporary Art*, 1957).

The uncouth Soutine was clearly out of his element at this large and probably elegant studio. Besides, for a painter who is said to have approached his canvas like a madman, the cool, detached, intellectual manner of the orthodox "Salon Communist" Cubist Fernand Léger was unbearable. Léger, on his part, could not possibly have accepted the extreme untidiness of execution in Soutine's work, even though he must have admitted in a minute of honesty that this "smearer," in the last analysis, did possess an unerring feeling for pictorial organization.

Indeed, even in Paris, which in the 1920s had more varieties of painting than any other big city and housed a vast number of critics, dealers, and collectors, Soutine was a bit of an "untouchable." Curiously, it was a visiting American, Dr. Albert C. Barnes, of Merion, Pennsylvania, a manufacturer of pharmaceutical products, whose astute appreciation of Soutine's true importance saved the French-

All works are oil on canvas except where noted.

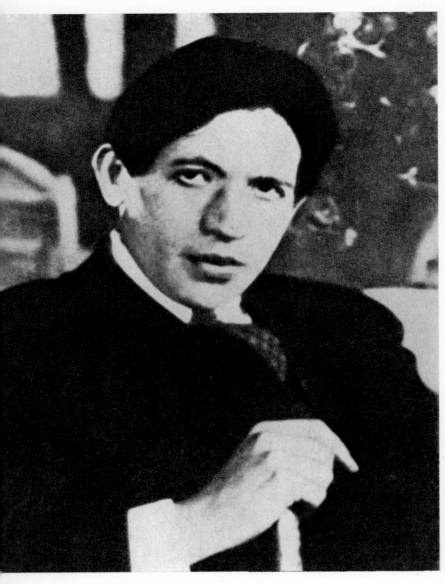

1. Soutine

and to have exhibited, along with other contemporary European art, in the Pennsylvania Academy of the Fine Arts, caused Philadelphia critics to become more alarmed than ever before.

One of them complained about Soutine's "seemingly incomprehensible masses of paint, known as landscapes." This critic ironically added: "Some of the pictures of alleged human beings might serve as illustrations to Gorky's gay and optimistic masterpiece of dramaturgy, *The Lower Depths.*" Another critic wrote, in a mixture of admiration and disparagement: "To us, Soutine represents the falling to pieces of old concepts. He may be mad, he may be an outcast, and being a Russian he may be morbid, emotional and unliteral, but he presents his life as he sees it.... The question is: Are we willing to look at the world with his eyes...even if it seems to us diseased and degenerate? Is it a good thing to visit morgues, insane asylums and jails even if we know what is inside?" (from *Art and Argyrol,* a biography of Barnes by William Schack, 1960).

The local journalists had, of course, been forewarned—by the art of Francisco Goya, by that of Vincent van Gogh, and by whatever samples of Expressionism had crossed the ocean—that irresponsible escapism was of no use, and that it was the function of art to reveal rather than to conceal. It is safe to assume that Soutine, always suspicious, always standoffish, was not filled with that evangelical force which had caused Van Gogh to live among the miners of the Borinage in Belgium, to instruct them, and even to give away his shoes and bed, and to sleep on straw laid on bare boards. Soutine was not one who would express himself in sermons, let alone social action. But who is to say, that, simple-minded and egotistical as he may have been, he was not more fully aware of the horror of the human condition and even the world situation than many a colleague of his who was well informed, approved of social action, and even belonged to a political party!

Modern artists, at least those who are neither mere decorators nor playboys, owe a great deal to the liberating forces of Goya who, deaf, lonely, politically isolated, painted his "Black Pictures"; to the Van Gogh who would rather starve than be without pigments; to the Soutine who could not be a "gentleman" even when,

based artist from continuing to live the kind of life of poverty and frustration to which he seemed predestined even within the modern equivalent of Athens or Florence. Whether Barnes, in 1923, bought sixty of Soutine's oils as some say, or, as another source gives it, as many as a hundred (the latter number seems exaggerated), he put him on the road to success—although not that of immediate success in the United States. At any rate, it was he who had the courage to write: "Soutine is a far more important artist than Van Gogh." Today, enough of the finest Soutines are in American public and private collections so that this volume actually could have been confined to the treasures in this country. But in 1923 the Soutines that Dr. Barnes brought home to keep

for a change, he put on a good suit and cleaned his fingernails—who was, and remained, the nervous, feverish artist *par excellence*. There is no need for a romanticized modern version of Henri Murger's *Scènes de la Vie de Bohème*. Murger's Paris had been dead for decades when Soutine arrived in the French capital in 1912. Nevertheless, there were still painters subjected to hunger, to misery—apart from Amedeo Modigliani and Soutine, Wols and Nicolas de Staël come to mind. But by 1950 or so these were the exceptions. As for the artists who have come to the fore since Soutine's death in 1943, they somehow do not fit the role traditionally assigned to that métier, or, for that matter, to poets and composers. Some of them have studios twenty times as large as those Soutine and other artists inhabited. Many of them have clever dealers, compared to whom Soutine's Léopold Zborowski was a hopeless bungler. They are good at manufacturing consumer goods. Unlike Paul Klee, who could

survive only because his wife, a piano teacher, supported him and their child with her earnings, they have no reason to complain that "the people are not on our side."

Nobody today conceives of the artist as a man suffering in a hovel waiting for a miracle to happen—a miracle like Dr. Barnes' chance discovery of *The Pastry Cook* in the show window of Paul Guillaume, another of Soutine's dealers.

But the virtual disappearance of the kind of artist who takes little notice of the public, who sacrifices all to his work and concedes nothing to his comfort, who cares for his art but does not care whether he cuts a fascinating figure in drawing-rooms—all of this makes us regret the more the replacement of the protester, the *artiste maudit*, by the smart performer who is more interested in titillating the public with tricks and surprises than in creating only what he must create.

INTENSITY...PASSION

"In a sense, Soutine had no biography outside his art; one might even say that his art was a substitute for a biography."

Hilton Kramer (in The Age of the Avant-Garde, *1973)*

It was some time in the year of 1912 that nineteen-year-old Chaim Soutine left Czarist Russia for Paris. And it was on August 9, 1943, that Soutine died there in a clinic. Yet his paintings contain nothing overtly related to the political or cultural events of these three decades. The artist bequeathed us few letters and no diaries, memoirs, or other written evidence to tell us exactly how he fared during childhood and adolescense in his native land, or, later, in France (eventually he was able to write French easily, though remaining a poor speller to the end). Maurice Vlaminck, Marc Chagall, Jacques Lipchitz and others have given us autobiographies that, apart from their personal story, help reconstruct the age in which they, as well as Soutine, created masterworks that now grace museums all over the

world. But no such literary assistance has come to us from Soutine, a morbidly introverted person, possibly the least articulate and certainly the most secretive and uncommunicative of twentieth-century artists.

His oils tell us much about his inner agitation, but do not hint at the world-shaking disturbances around him, especially during his final decade. They do not even aid any study of art history. The year 1914, to which *The Artist's Studio, Cité Falguière*, one of his earliest extant pictures, can be assigned, saw Pablo Picasso give full play to bright color as he was developing "Rococo Cubism." Giorgio de Chirico was painting his first "metaphysical" pictures. Modigliani had perfected his style, blending expressionist fervor with classical grace. In Paris, Futurism, Purism, Orphism,

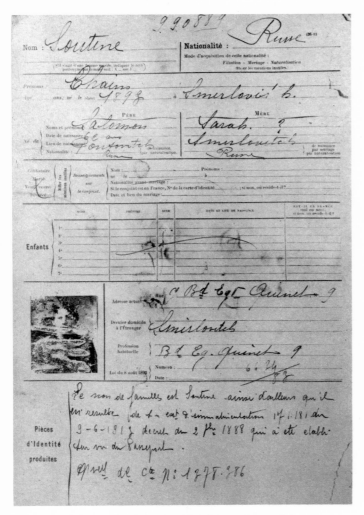

2. Document with photograph of Soutine at his
arrival in Paris in 1912

and a half dozen other movements had found
adherents.

Soutine, the loner, stood apart from all
trends and schools (though it must be con-
ceded that without the bold steps that had been
taken by Paul Gauguin and Van Gogh, and
subsequently by the Fauves, to give color an
emotional value of its own, he might not have
felt as free as he did to transform his anxieties
into chromatic streams of lava, poured onto the
canvas). In a city that had the greatest density
of high-ranking intellectuals, he had no inti-
mate contacts with any of the outstanding
poets, essayists, and critics (except for Elie
Faure, the physician turned *écrivain d'art* who
took a paternal interest in him and who wrote:
"Since Rembrandt, Soutine is perhaps the
painter in whose work the lyrical quality of
matter has most profoundly sprung forth from
it."). At a time when Paris had more Salons,
and more dealers than any other metropolis,
Soutine took advantage of opportunities to
exhibit his work only three times and only
once in an important show, "Les Maîtres de
l'Art Indépendant," at the Petit Palais in 1933.
Very rarely would he open up to writers on art;
to his friends he told only casual stories about
his allegedly grim youth—tales that are con-
tradictory, or mix a bit of truth with a great deal
of fancy.

Perhaps the paucity of information is all for
the better, since it forces the public to pay more
attention to his pictures and to give up all at-
tempts of using his life story as a tool with
which to pry open his works and to wrest from
them "secrets" that might lead to a better un-
derstanding of what he was after. Nevertheless,
an effort must be made to reveal the man as he
really was, and also to reconstruct his biog-
raphy as carefully as possible, if for no other
reason than to counteract *la légende de
Soutine*, the tissue of rumors, or half-truths,
and even downright lies that was woven soon
after his death and may have contributed to
misinterpretations and misunderstandings of
his oeuvre.

What are the facts about the formative years
spent in Russia, and especially about his
childhood milieu? What were his relation-
ships with his contemporaries? Was he as illit-
erate as most of those who knew him claim, or
did he, as others assert, know French poetry
and read philosophy? In the case of his friend
and mentor Modigliani, that artist's daughter
Jeanne pricked the bubble by publishing *Mo-
digliani senza leggenda*. But as for Soutine,
who had no close-knit family to collect and
keep memorabilia, no sophisticated friends on
the level of Jean Cocteau or André Salmon, as
Modigliani did, the problem of getting to the
core of the truth is more difficult. An attempt
must be made, though, before all who knew him
in Paris during the years between the two
World Wars have gone, and before all the evi-
dence has crumbled. One thing seems certain:
he worked outside the mainstream of French
art, as did his drinking companion Maurice
Utrillo, or the *peintres naïfs*, the most cele-
brated of whom was, of course, Henri Rous-
seau.

Like almost everyone else, Soutine did have
some political opinions—it is said that he ap-

proved of the editorials of Charles Maurras of the right-wing *L'Action Française,* defending social inequality because, as Soutine once put it, "It presented magnificent opportunities for everyone." This was a strange thing for a Jewish immigrant of proletarian background to say. But any thoughts he may have had about current conditions were not manifested demonstrably in his work. Georges Rouault expressed his disenchantment with society in images of corrupt judges and exploited prosti-

tutes and his abhorrence of war in the series of etchings and aquatints, *Miserere.* Chagall's work is filled with protests against the horrors of Russian pogroms, and Picasso at one point abandoned his lyrical paradise to create *Guernica.*

Soutine's general political aloofness, however, is less surprising than his complete non-affiliation with any of the numerous trends in art that mushroomed in Paris. He must have been aware of them, though it is known that he

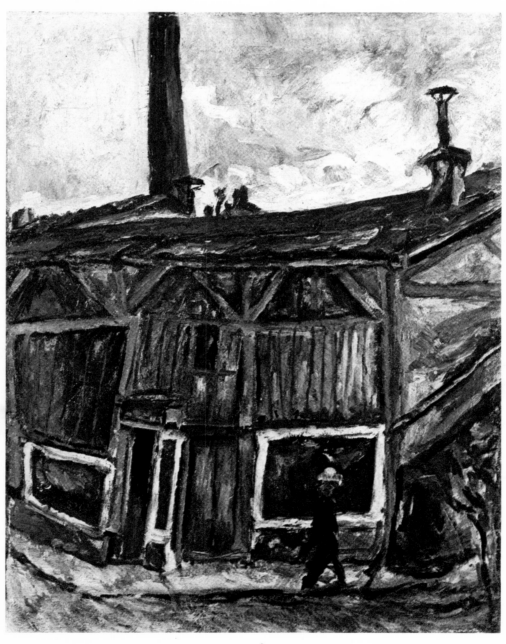

3. THE ARTIST'S STUDIO, CITÉ FALGUIÈRE. 1914. 25⅝ x 19⅝".
Formerly Collection Oscar Miestchaninoff, New York

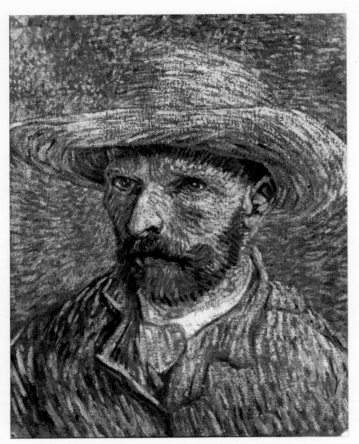

4. Vincent Van Gogh. PORTRAIT OF THE ARTIST.
The Metropolitan Museum of Art, New York.
Bequest of Adelaide Milton de Groot (1876–1967), 1967

visited hardly any exhibitions except those of the very few artists he befriended. He was a "Realist" like his idol, Gustave Courbet, but without any personal aesthetic credo even approximating the militant theoretical manifesto of that nineteenth-century painter. Like Utrillo, he absorbed the visible world around him, and it was enough. The people he knew, the trees and flowers he saw, the landscapes in several regions of France, and certain inanimate objects were all he needed to stimulate his brush. Though his childhood surroundings were very similar to those of Chagall, there are no references to the Smilovitchi ghetto and its denizens in any of his work that has come down to us.

The two World Wars, and the years separating them—the Roaring Twenties, or the Jazz Age, and Turbulent Thirties—cannot be discerned in his work. Autobiography is also totally absent. Chagall presents us with pictures of his parents and other members of his family—his courtship, marriage, the birth of

his daughter, and many other personal events provided artistic inspiration for him. Soutine offers no aid to the biographer—significantly, the only important date we know with absolute certainty is that of his death.

The oils that have come down to us—probably around six hundred, and possibly as many as a thousand—are all that reveal him with a drastic immediacy. For no members of his family could be found by researchers, though he had ten brothers and sisters, and there may be some cousins, nephews, and nieces still living. In any event, they could have told us little more about him that was not just trivial—nothing that one does not sense in his pictures.

I have compared him to Utrillo and to the modern French primitives because of his aloofness to contemporary trends. Yet the one artist whom he most resembles is Van Gogh, though Soutine declared that he did not like him. Conceivably, he was annoyed by the frequency with which the name of Vincent was brought up in connection with his own work. While the lives and the oeuvres of the two are very different in many respects, there is much that they have in common as persons. Both regarded and portrayed themselves as unlovable men with ungainly features. They did not care for the company of the high-born, but felt more at ease in the presence of what used to be called the "lower classes," especially peasants and village people, and, in Soutine's case, also humble employees of hotels and restaurants. Both were born bachelors, solitary men who needed women now and then but were often ill at ease with them. They chose models most other people would have considered ugly, but these two painters saw in them a "beauty" invisible to others. Both identified with the rough, the unhappy, the downtrodden, the blemished, and the gnarled. Just as Vincent called himself a "peasant-painter," so Chaim would have been justified in calling himself a "servant-painter." Neither man cared about anatomy as it was taught in the academies: "I should be desperate if my figures were correct," Vincent once wrote.

They were quite similar in their aesthetics as well as working habits. They painted feverishly, in thick impasto, attacking the canvas like madmen, unmindful of the blobs of

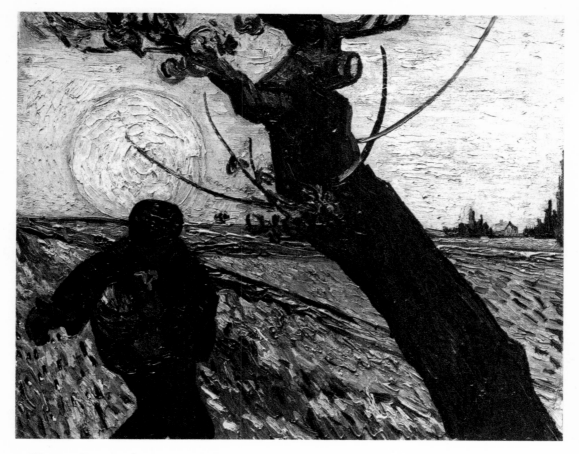

5. Vincent Van Gogh. THE SOWER. *1888. Collection V. W. Van Gogh, Amsterdam*

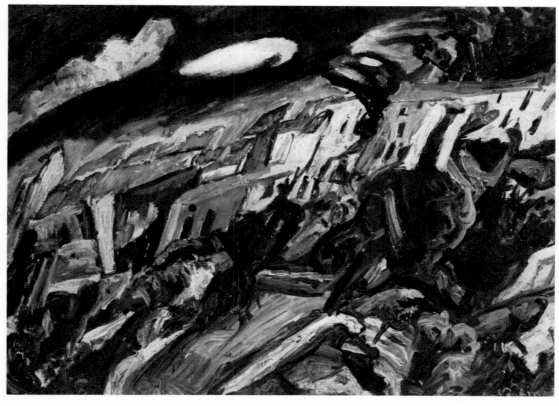

6. VIEW OF CÉRET. *c. 1919–20. 21¼ x 28¾". Collection Nathan Cummings, New York*

paint that made their studios look dirtier than those of most of their colleagues. Both used color quite arbitrarily, and the agitated movements of pigment on their canvases were the means with which they fought recurrent bouts of deep depression.

But whereas Van Gogh left many fine aquarelles, and also used pen, pencil, and crayon with considerable skill, Soutine had no interest in any medium except oil. Van Gogh often put down his colors in conscious and constructive inch-long parallel strokes, sometimes straight, sometimes snake-like, and frequently in circular progressions. Soutine, on the other hand, instinctively avoided anything that might come close to system, method, or order, or that required the minutest discipline or self-restraint.

Nonetheless, they were "brethren" inasmuch as their only concern was the freest expression of their egos, as distant as possible from any traditional uses of color. Hence, their tilted landscapes, agonized trees, their wretched samples of humanity, did not endear them to the more timid art lovers of their day. But those not easily put off by emotional intensity, by unbridled passion, learned to respect and eventually even to love these two painters, who, whatever they did, gave of themselves, and whose pictures in the last analysis are frank and generous self-portraits, whatever the subject matter might seem to be.

OUT OF THE SHTETL

"Soutine generalized from his own experience to include all men and the whole world. His energies mobilized the spirit of rebellion toward the past, the ghetto: he insisted on the primacy of self, of his own total experience, which was to him the highest form of sensation. Thus, Soutine emerges as an artist-hero, the forger of a new style and a new vision, toward which many other Jewish artists in Paris gravitated. Soutine, who had torn himself from his surroundings and his past, created an art which was filled with nervousness, anxiety and fear—the life experience of others who were less articulate in the medium. His work was believed to mirror the situation in which they and all European Jewry found themselves in the period between the two World Wars. It was seen to prefigure the Holocaust."

Avram Kampf (in Jewish Experience in the Art of the Twentieth Century, *1975)*

A phenomenon without precedent in the history of modern art was the sudden emergence, largely in the decade before the outbreak of World War I, of scores of Jewish painters and sculptors from the Pale of Settlement. This term refers to certain provinces in Czarist Russia to which the Jewish masses were confined by a cruel imperial decree, and where most of them lived in abject poverty. The names of Chagall, Soutine, and Lipchitz come first to mind, but there were many others who also did admirable work, even if they did not achieve as much fame. Nearly all tried, and quite a few managed, to leave their native towns to get a decent education in Western centers such as Berlin, Vienna, Munich, Paris, or London. For good reason, these artists never returned to Russia, except, perhaps, for brief visits at the height of their success. Those who never got out of Czarist Russia managed at times to overcome serious difficulties and to enter local art schools and academies, though, being Jews, they were received there with anything but enthusiasm, and they subsequently never rose above mediocrity.

The Versailles Treaty allocated much of the

Pale to Poland and the Baltic states. There, Jewish artists could eke out a rather modest living, largely by selling their works to coreligionists. Eventually, many were to end up in Nazi labor camps or concentration camps like the rest of the Jewish population. Those Jewish artists who did survive in Soviet Russia were swallowed up by the Socialist Realist movement, except for a few rebels who defied Stalinism and its aftermath at any cost.

Whether they moved westward or stayed on in Eastern Europe, all had spent their formative years in milieus inhospitable to art and artists for religious reasons. It was not the dirtiness and drabness of the *shtetl*—the "little town," as the Yiddish-speaking dwellers called a Jewish settlement—that hindered the development of aesthetic feeling and stifled the desire to create what is commonly called beauty. For a true artist, antonymous terms like "beautiful" and "ugly" do not really exist. The British painter John Constable spoke for his colleagues when he declared: "I never saw an ugly thing in my life; in fact, whatever may be the shape of an object, light and shade and perspective make it beautiful." Anyone who has come across photographs of Vitebsk as it looked around 1900 is not likely to be enchanted by this agglomeration of dilapidated timber structures lining unpaved streets. Yet Chagall, nostalgically remembering the city of his youth, called the houses "simple and eternal, like the buildings in the frescoes of Giotto."

Often the general poverty of the ghetto was the overriding factor militating against the pursuit of art—although chroniclers from Giorgio Vasari up to our day have given us countless stories of impecunious young people who through perseverance succeeded in getting training in the arts. But whereas Renaissance Italy was dotted with art centers large and small, Russian art academies, museums, and galleries before the Revolution were confined to a dozen major cities often hundreds of miles away from the nearest *shtetl*. Besides, in the visual arts Russia lagged far behind Germany, Italy, and especially France.

Few Russian Jews outside the sophisticated group of rich merchants and professional men privileged to live in St. Petersburg (now Leningrad) or Moscow even knew what art was

all about and, when it came to their attention, angrily closed their eyes to it. If the Second Commandment originally was directed more against idol worship than against art, as the term is understood today, in its practical application it outlawed art for Jews (and, in certain periods and regions, for some hyperorthodox Christians as well) since, in the last analysis, all works of art are idols.

It is impossible to explain how the desire to make pictures even arose in youngsters like Chagall and Soutine. The childhood homes of Jacob Epstein on Manhattan's Lower East Side and of Max Weber in the Williamsburg section of Brooklyn were probably as bereft of pictures as were the *shtetl* homes of Chagall or Soutine, but a bus ride got these American youngsters to the splendors of the Metropolitan Museum of Art, and while the parents wondered whether their sons could ever make a living from art, they were sufficiently tolerant to allow one to enroll at the Art Students League, the other at the Pratt Institute.

In Czarist Russia, Jewish children with an innate aesthetic bent had an opportunity to develop, up to a point, whatever artistic aptitude they possessed only if they were lucky enough to be admitted to a secular Russian secondary school where elementary drawing was included in the curriculum. Young Chagall was among the fortunate few. A classmate, invited to his home, saw his room decorated with his sketches: having come from a more sophisticated background and thus having heard of Ilya Repin, of Vasily Vasilevich Verestchagin, he told Chagall he was a real artist. "An artist?" Marc asked. "What's that? Who's an artist?" For Marc the very word artist was something "fantastic . . . literary . . . out of this world. . . ."

We are not informed how his father, a worker in a herring-packing plant, felt upon learning of his oldest son's wish to become a painter. But when Marc confided this desire to his mother, her reaction was one of anger: "You're crazy . . . don't bother me." Still, it is to her credit that, upon realizing that she could not count on turning Marc into a clerk, an accountant or even a photographer, eventually she was bold enough to suppress her misgivings and to take him to a local private art school run by a Yehuda Pen.

I have dwelt at length on Chagall because his background was not very dissimilar to that of Soutine and also because we know so much more about Chagall's youth from his autobiography and his talks with many interviewers. Soutine, as we have mentioned, never wrote about himself, and rarely spoke to anyone about his family and his boyhood in Russia. Deprived though Marc's youth may have been compared to that of any son from a middle-class family, it was probably more comfortable than Soutine's, for young Chaim was often treated with blows.

By the same token, little Vitebsk was a big city compared to Smilovitchi, a town of about three thousand inhabitants, on the Berezina River twelve miles southeast of Minsk. Michel Kikoine, himself a noted member of the School of Paris, described it as "a gray mass of wooden houses, overhung by a gray-green sky." Born in 1893, Chaim was the tenth of eleven children of a hard-working clothes-mender. All we have been told about the elder Soutine (or rather Sutin, to use the Russian form) is that, according to Kikoine, he could be seen from the village square, "squatting in a Buddha-like position working at his mending at all hours of the day." Mama Sutin was "old before her time...always worried and uncommunicative."

Chaim showed a precocious disposition to art (Monroe Wheeler relates that the artist would recall "his infant delight in the vari-colored effect of sunlight on the wall beside his bed, before he was able to talk"). Of course his Orthodox father, who considered the pursuit of art both blasphemous and meshugga, and wanted to make a cobbler of his son was utterly displeased. Quite possibly, Zalman Sutin was not as much a tyrant as Chaim described him. Yet the artist even spread the story that his parents were professional beggars who beat him because he did not want to beg. In the same breath, he also complained that his parents punished him by locking him in the chicken coop. By his own account his family was always scornful—and eventually he came to believe his own vindictive slander.

Still, the home situation must have been unpleasant, for even Kikoine, who as a bystander could be more objective, reports that there was not even a warm, indulgent mother to turn to

from the harsh father. She had little time or inclination for affection: "That poor woman was not tender with her numerous offspring." When she was baking the week's bread on Friday, "blows fell thicker than ever on the whole brood."

Chagall often lovingly depicted his parents and did portraits of two of his sisters. In Soutine's work, one will look in vain for any trace of his family, or for that matter, the town of Smilovitchi. His brothers are reported to have taunted and even beaten him frequently, shouting, "A Jew must not paint." Allegedly, he was punished with exaggerated severity by his father when he stole a kitchen utensil and sold it for a few kopecks to buy a colored pencil he much desired. But it has also been said that Zalman Sutin was so proud of Chaim's efforts as to show customers his drawings—probably copies of photos—with paternal pride (this does not quite fit the legend of the "child martyr"!).

Soutine managed to set against himself not only his family, but all of the shtetl's two thousand Jews who disapproved of his peculiar, incomprehensible drawings. He was thrown out of school as a dunce. It is not known how he occupied his time thereafter, except that a dropout would frequently leave home and roam about "in rebellion against his family" (Wheeler). But he was undeterred, it seems, in becoming an artist—though he probably was not quite aware of the full meaning of the word. At any rate, he had the village idiot pose for him. Apparently satisfied with the result, he innocently asked a white-bearded venerable old Jew to sit for him, or so the story goes. Thereupon, the young artist was attacked and severely beaten by the patriarch's sons, either because they considered portraiture sinful, or because Chaim had dared to approach their father after depicting an idiot. The beating sent Chaim to the hospital. At this point his mother intervened, lodged a complaint against the bullies, and got compensation of twenty-five rubles for her son. As soon as he had recovered, Chaim took the money and proceeded to nearby Minsk to get instruction in art. This was in 1909, and he was then only sixteen.

These biographical elements are drawn from the artist's sparse accounts in reminiscing with his friends. Yet while not all of the details need

be authentic, and an element of exaggeration may have crept into his tales of horror, there can be no doubt that he had an unhappy childhood and adolescence.

For even if he later overdramatized his early life, his unceasing traumas were real. He had already achieved international fame when a critic observed that he still had the look of a fugitive. Whatever doubts we might have about his verbal statements, his self-portraits tell the true story, for in all of them he reveals himself as an uncouth, sulky man, with an anguished face, whose bitterness is as palpable as the thick impasto of the pigments. A man with a face like this could not have stayed in Smilovitchi to become a draftsman or a small merchant like his brothers and cousins. Soutine was simply different: he followed the demands of the flame that burned in him and to the purity of that flame he sacrificed life and what is commonly called happiness, as every true artist would.

7. Soutine in 1941

ESCAPE TO FREEDOM

"...There is no specifically Jewish art [in the shtetl]. There is no equivalent of the peasant embroideries, or the elaborate paper cutouts made by the Poles. The reason obviously does not lie in lack of manual facility, for the shtetl has produced many highly skilled craftsmen—goldsmiths, diamond cutters, watchmakers. The free election of the folk, however, appears to be verbal or at least audile rather than visual or tactile."

Mark Zborowski and Elizabeth Herzog (in Life Is with People, 1962)

After Smilovitchi, the Minsk of 1909 with its hundred thousand inhabitants was a metropolis. At a private school there Chaim met another enthusiastic youth, the aforementioned Kikoine, a native of the Russian town of Homel. Krueger, a Jewish artist who ran this school, promised success in three months. There was of course, something fraudulent about this claim, but the youngsters stuck it out

with him since there was nothing better. How they managed to survive is not known, but Minsk had a large Jewish community, and it is likely that the penniless lads had to apply to Jewish organizations or to compassionate Jewish individuals for help. Soutine is also said to have worked as a photographer's assistant retouching or enlarging pictures.

After the sojourn in Minsk, about which we

19

know next to nothing, Chaim decided to move to Vilna which, while not larger than Minsk, had the advantage of possessing a real school of fine arts (the city was a major cultural center, having once been the capital of the kingdom of Lithuania). Again, information about the three years he spent there is pitifully meager. Apparently, Soutine flunked the school's entrance exam. The biographer Henri Serouya (as quoted by Maurice Tuchman) writes: "Soutine was asked to draw a cone, a cube and a pitcher. Being terribly nervous, he made a mistake in perspective which caused him to be refused admission. He wept at the feet of Professor Rebakoff." Both the examining professor and the director of the school were moved by the boy's tears and gave him another chance "this time alone in the classroom. He accomplished the exercise perfectly and became a brilliant student at the school."

Monroe Wheeler, another biographer, narrates that when Soutine failed in the entrance requirement, "one of the teachers gave him private instruction," so that he could be admitted. These two reports suggest that a liberal spirit reigned at the academy. Yet this is contradicted by Emile Szittya who claims that the director was an anti-Semite who tore up the letters Soutine received from his parents because they were written in Yiddish. The stories are not irreconcilable. This director may very well have shown compassion for a gifted Jewish boy at one time, and at another time allowed antagonism to everything Jewish—a trait very common in Czarist Russia even among artists and intellectuals—to win out over human sympathy.

None of Soutine's early drawings and paintings has been shown publicly and it is not known whether anything has survived that he produced before 1912 (that is, before the time that he became a resident of Paris). Tuchman reports that while still in Russia sketching from nature, Soutine "chose subjects evocative of sadness, misery and suffering... He staged a Jewish burial. He had Kikoine lie down and cover himself with a white drape, then encircled the shrouded figure with candles and drew the scene." (By a curious coincidence, Chagall in 1908 painted *The Dead Man*, in which a corpse is seen surrounded by candles on a village street.)

The instruction at Vilna must have emphasized the traditional dry, pedantic manner of accurate drawing and painting that was unaffected by the impact of Impressionists and Post-Impressionists. By 1910, of course, Russia had its crop of modernists, but these vanguard artists lived and worked in Moscow or St. Petersburg only, or preferably, had departed for the more favorable conditions of Germany or France. In provincial cities like Minsk or Vilna, Naturalism of the dullest kind was preached and practiced; its aim was to have art resemble the object or scene depicted and it was concerned with mechanical accuracy and even photographic verisimilitude, often to the point of obscuring the artist's feeling for his subject. The paintings by the teachers at the Vilna Academy, mass-produced for the middle class, were in all likelihood either stiff portraits or chromatically dull genre scenes of peasants engaged in their seasonal tasks. Russia had no artists who could under any circumstances be compared to a color magician like Eugène Delacroix, or to Impressionist pathfinders like Edouard Manet and Claude Monet. Its sole genius in painting, the intense and imaginative Mikhail Vrubel, a sincere individualist haunted by strange visions, died unappreciated in a lunatic asylum in 1911 shortly before Soutine was to leave his native country for good.

But rumors of an entirely new art created in Paris apparently penetrated as far as this Lithuanian city. In 1912, realizing that he had been long enough under the stultifying influence of the local academy, Soutine, aged nineteen, accepted the help of a benevolent physician to finance his long journey to the City of Light. He was accompanied by his friend Michel Kikoine. The youngsters arrived on Bastille Day and immediately rushed to the Louvre even before looking for living quarters. That same evening they were able to attend a free performance of *Aïda* at the Opéra.

While he did not talk about his first reactions to Paris, it is very likely that he was as delighted and flabbergasted as Chagall had been, two years earlier. In *My Life*, Chagall wrote, retrospectively: "...every time I happened to think of Russian art or to speak of it, I experienced the same troubled and confused emotions, full of bitterness and resentment.... The

most genuine Russian Impressionism leaves one perplexed when you compare it with Monet and Pissarro.

"Here, in the Louvre, before the canvases of Manet, Millet and others, I understand why I could not ally myself with Russia and Russian art. Why, my very speech is foreign to them."

The year 1912 was an exciting year in Paris. The avant-garde galleries were hung with works by members of the Fauves (the Wild Beasts), by Cubists and by Futurists, and by those later known as Surrealists—pictures that, with their intensity of color, their elongations, contractions and other "distortions" of natural appearances, and with their disregard for conventional perspective and modeling, must have startled the newcomer who had

seen nothing in his native land even vaguely resembling this anti-traditional art.

Yet he did not plunge into the stream of revolutionary art. Instead, he enrolled at the studio of an Academician, Fernand Cormon, whose greatest claim to fame was that he had once been the teacher of Van Gogh and Henri de Toulouse-Lautrec. Cormon, who painted elaborate "costume" pictures on historical and literary themes, was not a stimulating pedagogue, and Soutine did not stay with him very long. Even if he had wanted to continue this sort of academic instruction, poverty would have prevented it. The eleven years between his arrival in Paris as a penniless immigrant and his discovery by the Philadelphia collector, Dr. Albert C. Barnes, constitute one

8. STILL LIFE WITH LAMP. 1916–17. 21¼ x 25⅝". Formerly Modarco Collection, Geneva

21

9–11. La Ruche, Paris

of the many sad chapters in the lives of modern artists.

Unable to make a profit from selling his pictures—unattractive in subject matter, and unappealing to buyers whose tastes had, as a rule, not matured much beyond Impressionism—he was forced to work as a porter at a railroad station and, during World War I, as a ditch digger. He himself recounted much later, when he had become a celebrity, how he had often waited for hours at the counter of a bistro in the hope that some kind soul would buy him a bit of food or a drink.

For a while he lived in the proletarian Vaugirard district in the southern part of Paris, in the vicinity of vast slaughterhouses. There, at the Dantzig Passage, in the fifteenth arrondissement, stood and still stands a curious tall octagonal structure—*La Ruche*, "the beehive," so nicknamed because of the many tiny, wedge-shaped artists' studios it contains. Alexander Archipenko, Chagall, Henri Laurens, Fernand Léger, Ossip Zadkine, and many others lived there at one time or another, as hope-filled young men, under conditions that only the most idealistic and the most stubborn could endure. Some of its denizens—including many a Jew from an East European *shtetl*—failed to achieve fame and its concomitant economic security, not through lack of talent, but through want of aggressiveness, or a concatenation of several circumstances. Some died prematurely, others felt so oppressed by conditions that they voluntarily put an end to their wretched lives (even Soutine at La Ruche at one desperate moment tried to hang himself, but was rescued by his colleague Pinchus Krémègne). As one witness, Samuel Putnam, well expressed it: "... despite all the tales of the Gay Bohemian life, it is not so gay to go to bed without the few centimes for a café-croissant in the morning. One can *starve* in the Latin Quarter" (*Paris Was Our Mistress*, 1947).

Nearly all sought relief from their misery in sex, alcohol or, less frequently, in drugs. Possibly the worst drunkards in the two bohemian sections of Paris—Montmartre and Montparnasse—were Utrillo, Modigliani, and Soutine. Utrillo and Modigliani were drinking companions for a short while only (the former, his excellence as a painter notwithstanding, had a very low grade of intelligence, and was not well suited to be anybody's friend), but Modigliani and Soutine, his junior by eleven years, became very close. Both were Jews. The first came of a respectable Italian Sephardic (Spanish-Jewish) family, was well-educated and sought to impart some of his knowledge and worldliness to the rather ill-bred *Litvak* (Lithuanian Jew) Soutine. For a time, they shared the same filthy, bug-infested garret (there was one low bed on wheels on which they took turns sleeping, while the other used the floor).

Certain studies show that until recently there was less alcoholism among Jews than in the general population. Yet, among the creative men who flocked to Paris from small Jewish towns in the three decades prior to World War II, quite a few were alcoholics. Perhaps the fact that these artists were uprooted and living as aliens in a culture that was strange to them, and in which they were as a rule unwelcome and unrecognized by the Establishment, contributed to their seeking relief in the "artificial paradise" created by inebriety.

Of the two friends, Modigliani virtually drank himself to death (if it was not alcohol alone that killed him at the age of thirty-five, it certainly helped destroy a body afflicted with

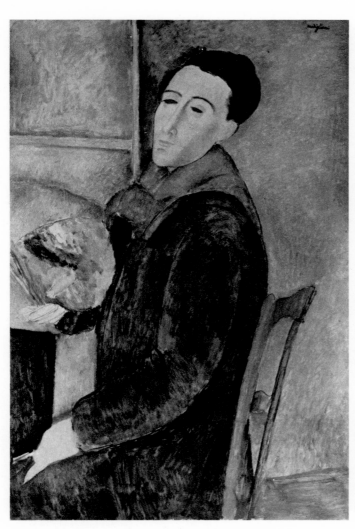

12. Amedeo Modigliani. SELF-PORTRAIT. *1919.*
Collection Mrs. Yolanda Penteado Matarazzo,
São Paulo, Brazil

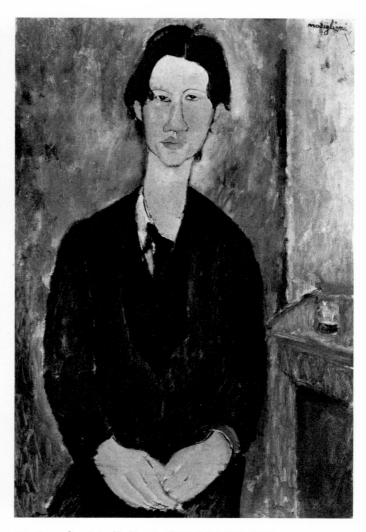

13. Amedeo Modigliani. CHAIM SOUTINE. *1917.*
The National Gallery, Washington, D.C.
Chester Dale Collection

23

14. Amedeo Modigliani

tuberculosis and weakened by overwork and malnutrition). When Soutine learned that the life of his closest friend had ended abruptly in a charity hospital, the terrible news had a sobering effect upon him. He abandoned his self-destructive way of life and became a teetotaler. But he was unable to recover perfect health, however carefully he henceforth chose his food and however much his standard of living increased with the growth of his reputation as a painter. The years of severe deprivation had implanted in him the sort of nervous tension that often leads to ulcers. He did in fact develop stomach ulcers, the classical symptom of inner suffering, we have been told. While he avoided all excesses, he never stopped working furiously. But if his eagerness to surpass himself, his madly critical attitude toward his own work, contributed strongly to his death at fifty, this drive for perfection in the way that Soutine understood it also resulted in the creation of masterpieces that are the pride of many museums in countries all over the world.

ALIEN IN PARIS

"More painting has been done in France in this century by immigrants from Eastern European ghettos than the Jewish nation has produced in all the centuries gone by....Suddenly, there they were in the vanguard, uprooted but quickly digging in everywhere, mixing in everywhere, playing a great role in civilization."

Monroe Wheeler (in Soutine, 1950)

Two terms have entered the art historian's jargon: *École de Paris* and *École Juive*. Both refer to groups of artists who, in the first half of the twentieth century, lived and worked in the French capital. Yet there was never a real "School," and there is certainly none today. *École de Paris* was a misnomer even in the period of peak activity, from about 1910 to 1939; today's artists are certainly connected by little more than the fact that their studios are located somewhere in the French capital.

It is with the same reluctance that one still speaks of a Jewish School in Paris, though it is true that many creative Jewish men and women with similar backgrounds began flock-

ing there soon after 1900, and that in the 1930s Jewish artists from Central Europe came there in the hope of finding the "liberty, equality, fraternity" that had been swept away by the Nazis. But what had Modigliani and Soutine in common except for their Jewish origin? Even artistically, they were miles apart. Nevertheless, on the verge of death Modigliani recommended his friend as a "man of genius" to the dealer, Léopold Zborowski.

The French critics were baffled by Modigliani's very personal, very individualistic version of sixteenth-century Italian Mannerism. But their remarks about him were free of xenophobia and certainly of anti-Semitism.

15. THE VILLAGE IDIOT. *1920–21. 36¼ x 25⅝″. Musée Calvet, Avignon, France*

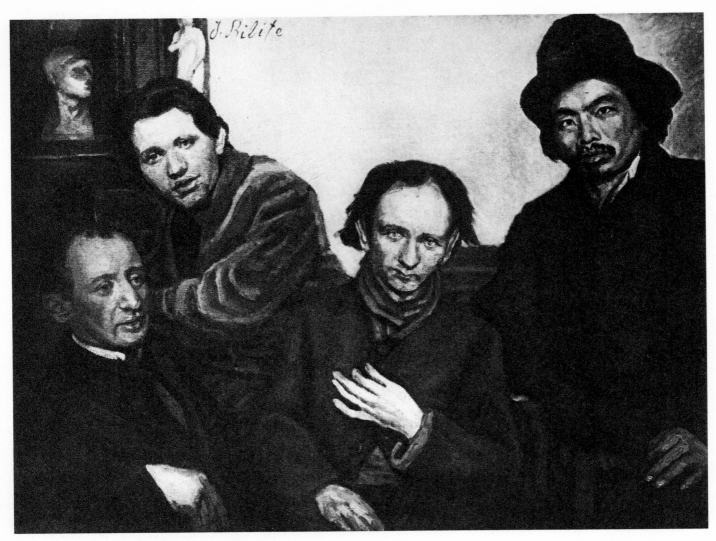

16. Jean Bilité. REUNION OF PAINTERS. *c.1925.*
From left to right: Henri Epstein, Soutine, Pinchus Krémègne, Yashi.
Whereabouts unknown

Though they knew that he was Jewish—the artist never hid his ancestry and, in fact, peddled his drawings to tourists in Montparnasse with the introduction, "Modigliani, Juif"—they accepted him as the educated Italian he was, one who could recite by heart many stanzas from Dante's epic poem, and who retained something almost aristocratic even when down to his last *centime*. These same critics did not object to Chagall too much, for while his fantastic and perhaps even absurd visions were incompatible with the French ideal of "clarity," he was so much of an exotic, rooted in the dreamworld of East European Jewry, that he posed no threat to Gallic traditions or to Latin aesthetics (only once did French national arrogance turn against him—when he exhibited a series of gouaches made as studies for

etchings to illustrate a special edition of *The Fables of La Fontaine*: how dared this "Oriental" concern himself with the work of a French classical author!).

By contrast, Soutine made the French art establishment uneasy by his alien ways. He had gallicized his family name, but kept the first name "Chaim," the Hebrew for "life." He eventually spoke French fluently enough, though with a heavy Slavic accent, but in his behavior and appearance resembled a *moujik* or, worse yet, a perpetual refugee. Yet there was nothing "alien" about his subject matter—portraits, still lifes, and a great many renderings of the French countryside he loved fanatically to his end.

For the three decades he resided in France —from 1912 to his death in 1943—there was

no one among the immigrant artists as conservative as Soutine in choice of motifs (often similar to those preferred by his two idols, Camille Corot and Courbet). If the other members of the *École Juive* usually pursued the latest revolutionary trends—for instance there are Cubist borrowings in the work of the young Chagall, who has also been claimed by the Surrealists—Soutine, in the last analysis, was an old-fashioned Realist. He painted only what he saw before him, had no links with the dozens of avant-garde groups that mushroomed in his era, and ardently loved the Old Master Rembrandt. He was even fond of a fifteenth-century French miniature painter like Jean Fouquet whose work is remarkable for the extreme accuracy of drawing, the elaborate finish of all the details. Lipchitz remembered that his friend Soutine once showed him a photograph of Fouquet's *Portrait of Charles VII* and excitedly called it "the greatest picture in the Louvre." Lipchitz said that this Fouquet was "just about as tightly painted and precise as Soutine is loose and frantic," and added, philosophically, "an artist may like what is least like him."

For some years, Soutine's own way of painting infuriated nearly everyone. By comparison, even Van Gogh was tame. The Swiss psychoanalyst, Oskar Pfister, could not have known of Soutine when he wrote his book, *Expressionism in Art* (the English edition appeared in 1922), for Chaim was then still an obscure artist whose work could be viewed nowhere except in his Left Bank cubicle. Yet Pfister's description of Expressionism as "a cry of distress, like a stream of lava forcing itself forward by the soul's misery, and a ravenous hunger after life" can be applied to nearly all of Soutine's work (only the pictures he painted in his final years are a bit calmer in mood than for instance the almost chaotic renderings of landscapes he did around 1920 when living in extreme solitude in Céret).

Expressionism is often considered Central Europe's major contribution to the visual arts in the twentieth century. It is true that Ernst Ludwig Kirchner and his associates in northern Germany, and Oskar Kokoschka and Egon Schiele in Vienna often painted pictures almost as tempestuous and turbulent as those that Soutine flung on the canvas with a loaded

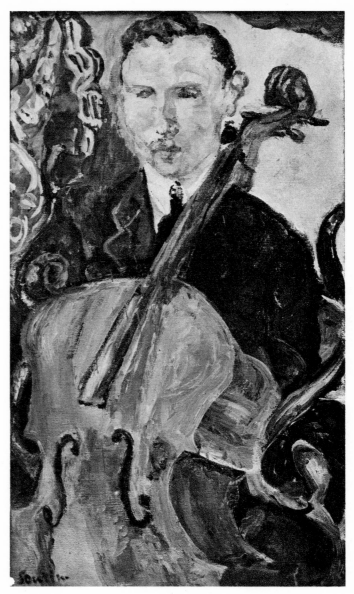

17. THE MUSICIAN. 1924–25. *Private Collection*

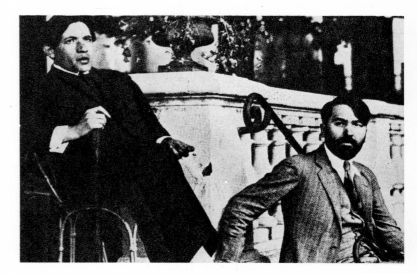

18. Soutine and Léopold Zborowski
at the Luxembourg Gardens, Paris

27

brush. But he was probably unaware of what the men of the *Brücke* or the Austrians had created. Expressionism was "in the air" so to speak. On the whole, however, it was unknown in France. The French critics, who so violently overreacted to Soutine's offerings—and even those writers who grudgingly acknowledged his genius—knew only vaguely of the contemporary developments in Dresden, Berlin, or Munich, or, if they were familiar with them, dismissed all that originated in German ateliers as something a *boche* might appreciate, but hardly a cultured Frenchman.

The *boche* label could not possibly be used for so unequivocally a Russian Jew as Soutine. Yet whatever he may have been ethnically, to most of the French critics of his time he was the epitome of the non-French and even anti-French developments in art. There were of course the real bigots, but anti-Semitism or even xenophobia cannot be ascribed to the distinguished curator-in-chief of the Louvre, René Huyghe. Yet his admiration of Soutine was mixed with resentment of "the vampire, the painter tipsy with blood." Huyghe insisted that the gap between Soutine and traditional art was unbridgeable: "The style of this artist weakens the great tradition of French painting. This unpruned style, flamboyant Gothic, asymmetric Baroque, is opposed to the slender, graceful, precise French style."

To Maurice Raynal, Soutine's art also represented the "very antithesis of French tradition." Raynal was a liberal, a progressive, yet while he appreciated Soutine's "strange talent," he was ill at ease when confronting any manifestation of art that was contrary to what educated Frenchmen all too uncompromisingly held to be the French psychology, or the French character. Talking about Soutine's "feverish, disconcerting hyperbolic art," Raynal observed, "The art of Soutine is the expression of a kind of Jewish mysticism through appallingly violent detonations of color. His

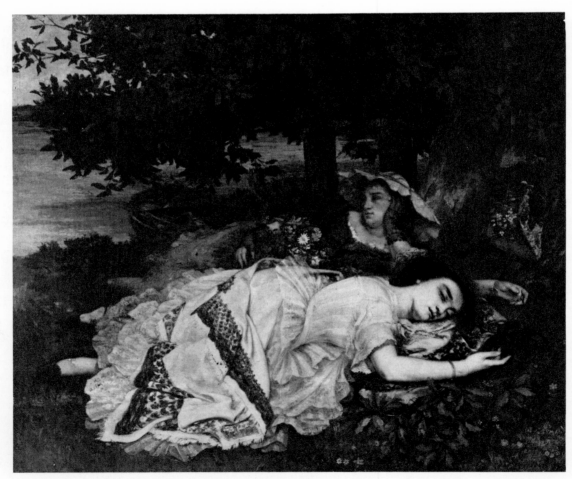

19. Gustave Courbet. LES DEMOISELLES AUX BORDS DE LA SEINE. *1856. Petit Palais, Paris*

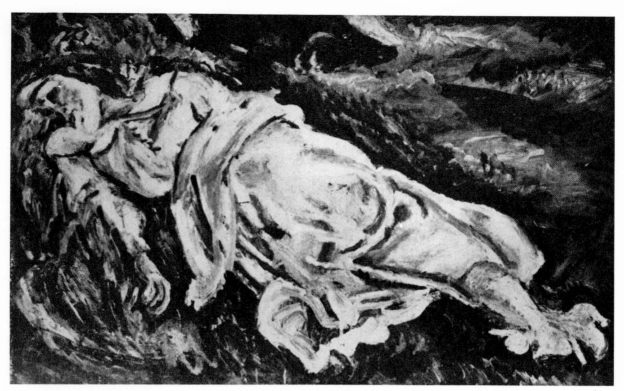

20. RECLINING WOMAN. *c.1917. 23¼ x 36⅝". Private Collection, New York*

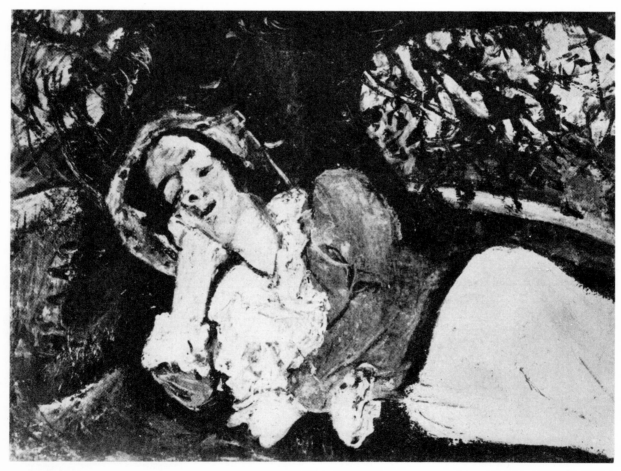

21. THE SIESTA. *1934. 28⅜ x 35⅞". Collection Madeleine Castaing, Paris*

22. Gustave Courbet. THE TROUT. *1871. Kunsthaus, Zurich*

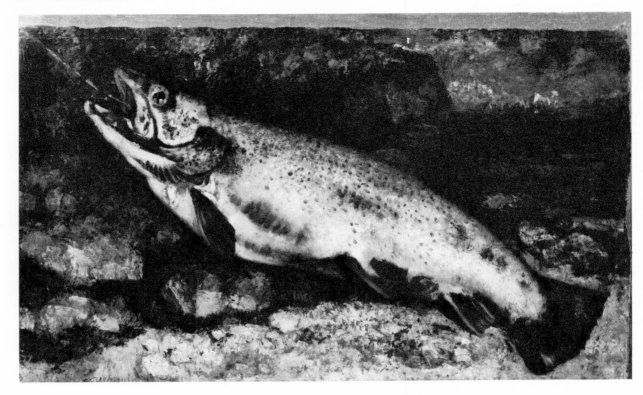

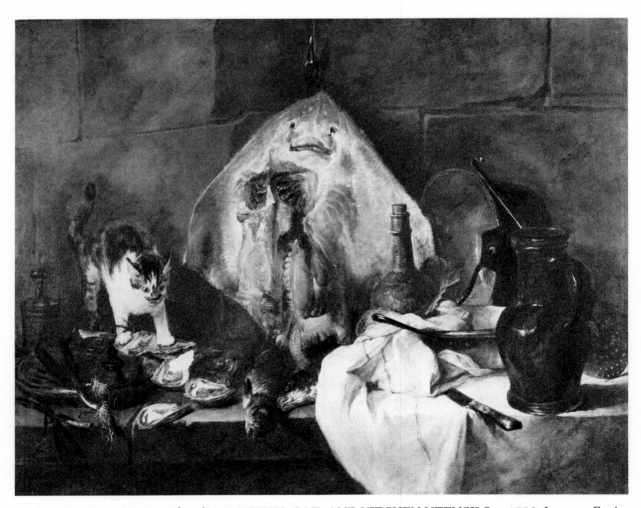

23. Jean Baptiste-Siméon Chardin. RAYFISH, CAT, AND KITCHEN UTENSILS. *c.1728. Louvre, Paris*

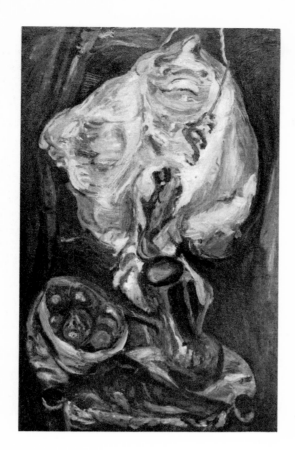

24. THE RAY.
Musée Calvet,
Avignon, France

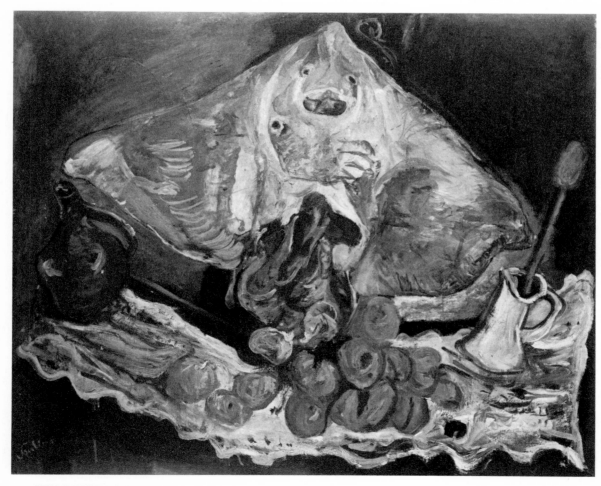

25. STILL LIFE WITH RAY. *c.1924. 32 x 39½". Collection Mrs. Paul Todd Makler, Philadelphia*

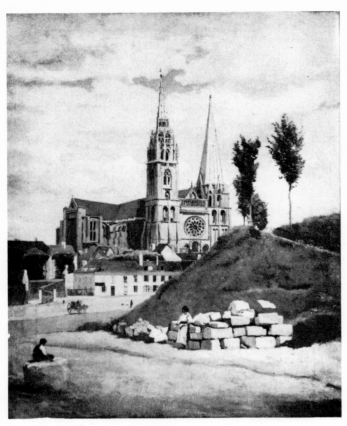

26. Camille Corot. CHARTRES CATHEDRAL. 1830.
Louvre, Paris. Collection Moreau-Nelaton

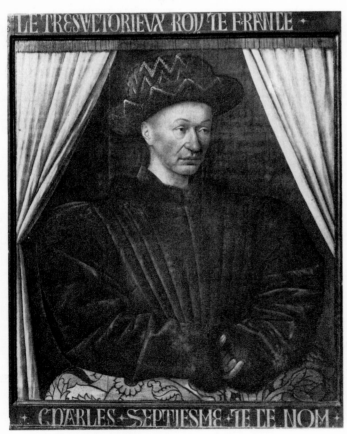

27. Jean Fouquet. PORTRAIT OF CHARLES VII.
c.1451. Louvre, Paris

work is a pictorial cataclysm...its impetuosity, its paroxysms, its fury, its eruptions of colors savagely confused, compounded and juxtaposed, are not lacking in power, but they sting and blind the visual sense like a passing tornado, like a scorching *mistral*."

He ended by saying: "...all those distorted, devastated, unbalanced landscapes, all those appalling, inhuman figures, treated in a stew of unheard of colors, must be regarded as the strange ebullition of an elementary Jewish mentality which, weary of the yoke of its rigorous Talmud, has kicked over the Tables of the Law, liberating an unbridled temperament and indulging at last in an orgy of criticism, destruction and reconstruction of Nature—cursing the while, and cursing very copiously, its Creator."

Unquestionably, Soutine's manner of painting is well characterized here, and his work is fully recognizable in the description given. But evoking the "rigorous Talmud" and the Ten Commandments in this context is foolish, and one wonders how the Expressionist quality of his work can be reduced, in a simplistic manner, to "an elementary Jewish mentality" when scores of artists, most of them non-Jewish, availed themselves of the Expressionist idiom. Raynal made an amusing error when he called Kostia Terechkovitch a Jew because this Russian-born member of the School of Paris painted in a style somewhat related to that of Soutine: "We may easily detect the trend of Terechkovitch's art by remarking first that, due to his Israelite origin, he conceives of art as a method of dramatic expression ... Terechkovitch is one of the most gifted and proficient representatives of...what Adolphe Basler calls the 'dirty dishrag' manner, a manner common to many Jewish artists of today."

The dealer and writer Basler, who loathed Expressionist painting, was a Jew; obviously the aesthetic camps were not divided according to ethnic or religious lines. In the Third Republic, anti-Semitism hardly penetrated the art establishment; among Soutine's admirers was even Pierre Drieu La Rochelle, the gifted author identified with the extreme right, a fascist before fascism (Drieu La Rochelle eventually collaborated with the Nazis, and committed suicide as he was about to be judged by his compatriots). At any rate, even Judaeophiles

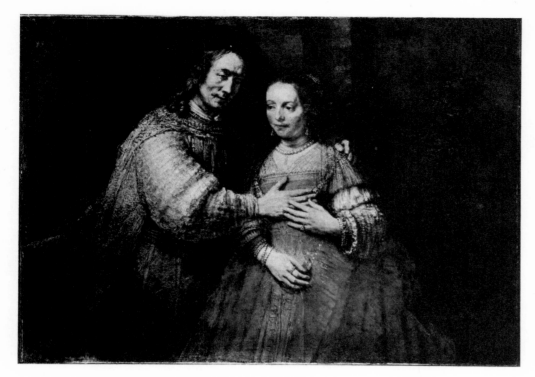

28. Rembrandt.
THE JEWISH BRIDE. *c.1665.*
Rijksmuseum, Amsterdam

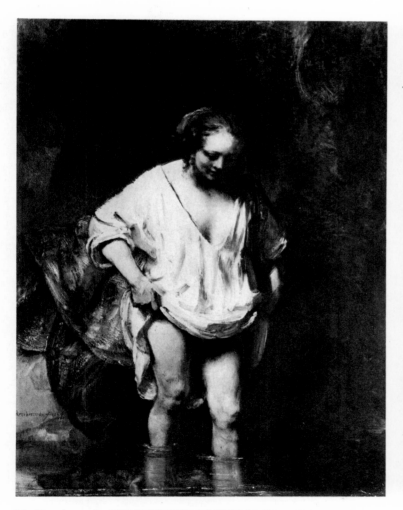

29. Rembrandt. HENDRICKJE BATHING IN A STREAM.
1654. *The National Gallery, London*

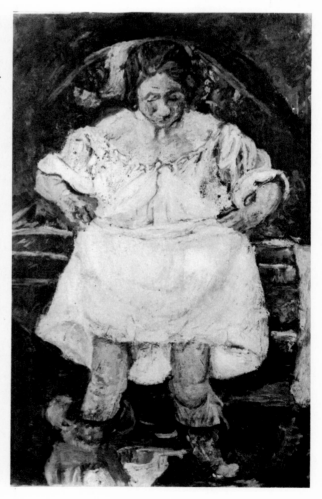

30. A WOMAN WADING. 1931. 44½ x 28½".
Collection Madeleine Castaing, Paris

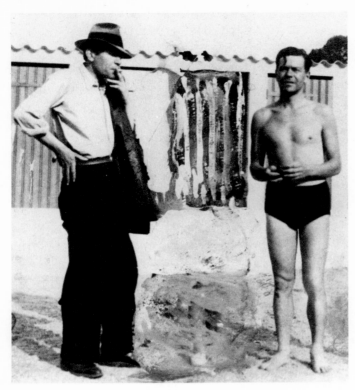

31. Soutine and Kostia Terechkovitch on a Normandy beach in August 1938

felt that if there were *peintres juifs*, there must also be a *peinture juive*. There was, and there still is, confusion in many quarters about the impact of an artist's national origin on the character of his creations. Repudiating exaggerated claims made by chauvinists, Chagall valiantly tried to put the record straight: "If a painter is Jewish and paints life, how can he help having Jewish elements in his work? But if he is a good painter, there will be more than that. The Jewish element will be there, but his art will tend to approach the universal."

All this can be applied to Chagall. But what about Soutine? If his art has any Jewish elements, they are not noticeable to any unbiased observer. Far from being a strictly Jewish phenomenon, Soutine's work belonged to the international movement called Expressionism, whose range and scope we can, from the vantage point of the 1970s, estimate better than could Raynal (who, by the way, never used the term when in 1927 he published *Anthologie de la Peinture en France*). The Expressionists who, according to a very serviceable Museum of Modern Art definition, "reject the imitation of the outer world of reality for the expression of an inner world of feeling and imagination,"

include a Parisian-born Catholic of petit-bourgeois origins like Rouault along with Soutine, the son of a poor Jewish clothes-mender from a small *shtetl*. Prominent among the "ancestors" of this Expressionism are the Dutch Van Gogh, son of a Calvinist pastor, and the Norwegian Edvard Munch, son of a Lutheran physician.

The term "Expressionism" was coined in Germany about 1911. Politically it was never a monolithic phenomenon—among the German Expressionist painters was the anti-Nazi Max Beckmann, who fled from Hitler's Reich because he loathed its regime, as well as Emil Nolde, a member of the Nazi Party who desperately tried to convince its leaders that they had gravely wronged him by including his works with those of Republicans, Bolsheviks, Internationalists, and Jews in the category "Degenerate Art."

Expressionism was no more a strictly Germanic phenomenon than it was an exclusively Jewish one. Europe's ghettos contributed many gifted men who were to rise to eminence in Paris or, like Weber and Abraham Walkowitz, in New York around 1920, yet not all the artists in this Jewish group became Expressionists. Moise Kisling had a background similar to Soutine, but his work is without the suggestive distortions of form, color, and space, without the violent emotionalism of his colleague. Calm and serene, his pictures are painted carefully in cool, restrained colors.

The truth is that there was an ocean of difference in character between the prudent, well-balanced, family man Kisling, and the unbalanced bohemian and bachelor Soutine. In a recent book (New York, 1973), Jean Kisling writes about his father's sense of humor (a trait totally missing in Soutine), while in the same book the novelist Joseph Kessel sums up the artist's character by saying: "Kisling loved life and life loved him." The same cannot be said of Soutine.

Perhaps Bernard Dorival was right in *Twentieth Century Painters* when he created a category for Soutine and those of similar disposition: "The Painters of Anguish." Unlike Raynal, who tried to equate Frenchmen with Cartesian rationality and logic, Dorival was aware that there were Frenchmen also filled with "indignation, fear and anxiety." He as-

sociates Soutine with other mavericks, who were Frenchmen, such as Marcel Gromaire (whose satirical painting, he says, expresses utter scorn of humanity, and is "full of biting irony...all sarcasm and denunciation") and the much younger Francis Gruber ("the sick painter whose constitution is undermined by asthma and alcoholism").

Gromaire gave shape to his abhorrence of war, and so did Gruber. Both artists presented many of the ugly aspects of the time, whereas Soutine's anguish seems to be strictly based on his own personal experiences. Soutine's work tells us nothing about the pogroms that rav-

aged Czarist Russia, nothing about the evils of World War I, about the social upheavals in the 1920s and 1930s, about Hitlerism—nothing, yet, in a very indirect way, everything. It offers us glimpses into the soul of a non-political being, a *déraciné*, a loner, a misfit (which Soutine remained even after having become successful) who felt most uncomfortable in a world not of his own making. In a sense, Soutine is entirely autobiographical in his work, despite his notorious unwillingness to talk about himself, his wretched childhood in Russia, or his years of starvation in Paris.

A few trusted friends, among them the

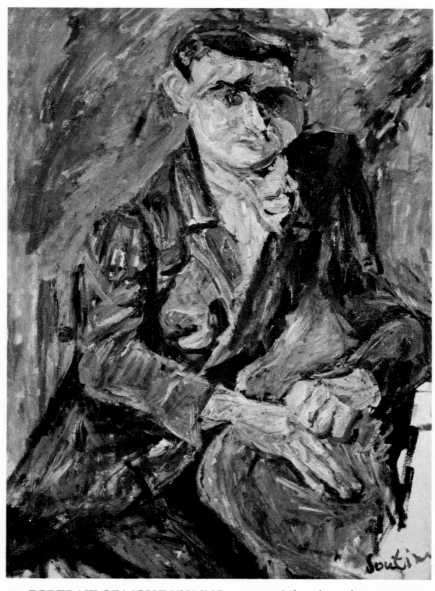

32. PORTRAIT OF MOISE KISLING. c.1925. Oil on board, 39 x 27¼".
Philadelphia Museum of Art. Gift of Arthur Wiesenberger

sculptor Lipchitz, did learn some sparse details about his experiences in Smilovitchi (if the story is true, not only his family, but the entire *kehillah,* or Jewish community, strongly disapproved of the eccentric boy who seemingly violated the Second Commandment), and about his frustrating years as an art student in Minsk and Vilna.

Of course, his pictures do not reflect his story in a straightforward narrative. Smilovitchi, his parents, brothers, sisters, neighbors never appear. While Chagall, for the past sixty and more years, has been recreating the memories of his childhood in Vitebsk, Soutine tried to obliterate all traces of his traumatic years. But he was unable to suppress the pain. "It was like touching a wound," Lipchitz recalled, describing his attempt to induce Soutine to send food parcels to his parents when Russia was swept by famine during the 1920s: "I wouldn't lift a finger for them!" was the angry reply.

Although basically kind, Soutine was difficult and irascible and often antagonized people without meaning to. Nevertheless at least three women decided to share in one way or another this difficult man's life for lengthy periods. Unlike Modigliani, however, he did not give us any likenesses of his women and, had he done so, Soutine would have shown them to us as repulsive hags. Degas, asked why he made all his women look so ugly, replied, "Women generally *are* ugly." Soutine was not really a misogynist like Degas—to him *all* creatures were symbols through which to express his dread of life, his fear of death. Nor did he flatter himself when painting his own features. In 1917, he showed himself as an uncouth, defiant young man. The self-portrait of 1922 or 1923 almost looks like a *Stuermer* caricature, with the enormous nose and deep-red protruding lower lip.

Altogether he was an unhappy man—a *peintre maudit,* under a curse like two other members of the *École Juive*—Modigliani and Pascin. Poor Soutine, we are inclined to say. But when the novelist Andrée Collie once alluded to the great unhappiness he had suffered, he stopped her to protest, "I have always been a happy man!" Oddly, the answer was sincere and, if we do not quibble with the word "always," unchallengeable. A creative person can never be entirely unhappy. Beethoven, isolated from his fellow-men by his deafness, wrote that only the artist, or the scholar, was able to "carry his happiness within him." Soutine was glad to have created a few paintings strong enough to satisfy his abnormally stern self-criticism. These have earned him the admiration of thousands. He has rightly been compared to Van Gogh, and even to Rembrandt. Like these tortured painters he worked with a dedication that made him an inspiration for many a younger man with similar ambitions.

33. Soutine's last palette. *The Museum of Modern Art, New York. Gift of Pierre Loeb*

TRIUMPH AND TRIBULATION

*"He's a star rising in the firmament of modern art. Canvases,
which a year ago couldn't find a dealer, are sold these days in the
ten-thousand [franc] bracket and are going up every day. He is
small, sturdy, with a thick shock of hair whirling around his head.
He has deep, round hooded eyes; they are of hard stone.
Zborowski told me he's a man in torment. He paints a great deal,
but he will suddenly slash the canvas, tear at it, like one
possessed."*

René Gimpel (in Diary of an Art Dealer, *posthumously published
in 1966)*

Despite more than thirty years of research, *la
légende de Soutine* has not yet been laid to
rest. Even now, we can verify little about
Soutine's life and, in addition, some of his
work presents problems of authentication be-
cause of the existence of forgeries.

It is not even quite clear how he spent the
decade prior to World War II when he was
already internationally known—in the 1930s
he had one-man shows in Chicago, New York,
and London—and his oils fetched good
prices. Some who knew him claimed that he
painted very little, idled in cafés, or shut him-
self in his room trying to read philosophy.
Others, however, say he worked as furiously
as before, and was rarely away from his com-
bination atelier and home.

Some critics are not enthusiastic about his
late works, calmer and more "classical" than
those of his younger years (even an admirer
like Wheeler, who organized the Soutine
memorial exhibition at New York's Museum
of Modern Art in 1950, asserts that "to some
slight extent he had fallen into formula").
Others, including the present writer, feel that
many of the pictures from his final decade—
from *Chartres Cathedral* to the renderings of
wind-tossed trees he produced shortly before
his death—are as glorious as anything he had
painted before.

The little we do know about the Soutine of
the 1933 to 1943 period is based largely on
reports by several women who, each in her
own way, contributed to making life more
pleasant, more livable for this moody, shy,
awkward, and basically lonely man. One was

a shrewd and eccentric interior decorator,
Madeleine Castaing, who first spotted "her
genius" in 1919 and forty-odd years later told
a contributor to *Réalités* how she had met
him: "My husband [Marcellin Castaing] and I
often went to the *Rotonde*. In those days, it
was the café of hungry young painters who
had not yet broken through…One day I was
introduced to a haggard young man wearing a
hat which he jammed down on to his head as
soon as anyone looked at him. It was Soutine.

34. ALLEY OF TREES. 1936. 29½ x 26½".
Collection Miss Pamela T. Colin, New York

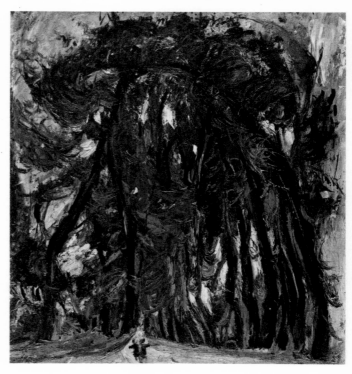

35. Mademoiselle Garde (Gerda Groth)

'You should buy a picture from him, he hasn't eaten for a week,' a friend told me."

But their first attempt at a purchase came to naught, as the hypersensitive artist, feeling that the offer was prompted by charity, angrily walked out. Five years later, in 1924, the couple met him again. By that time he had been discovered by Dr. Barnes, had installed himself in a new studio on the fashionable Right Bank and, through his dedicated dealer, Zborowski, was demanding high prices for his oils—prices that luckily the Castaings were able and willing to pay. A sort of friendship began, and between 1931 and 1935 Soutine spent all his summers at the couple's spacious country home near Chartres.

His hosts had to be very tactful, diplomatic and even self-effacing in their dealings with their irascible, inconsiderate and morbidly ungregarious guest who invariably hid whenever they entertained friends: "He was a character out of Dostoevsky."

One is reluctant to believe Madame Castaing's claim that she had to "force" Soutine to paint, as he is known to have been a glutton for work. But it is very likely that it did require "monumental patience" to comfort and encourage him. It was hard to find models that pleased him among the farm girls in the neighborhood. Since he insisted on painting on very old canvas, Madame Castaing had to "scour all Paris" to get him seventeenth-century pictures which he would scrape and then cover with his own compositions. While accepting the generosity of his hostess, he did not let her have his works for a penny less than what they would fetch on the market! Eventually, Monsieur Castaing was annoyed

36. Soutine in 1934—35

by his guest's countless whims and asked his wife to get rid of him. She refused: "Let's be patient, he is a genius."

She continued her loyalty to him and frequently visited his studio in Paris, even after another woman, Garde, came into his life. Madame Castaing kept on buying his works. Some say that she actually had locked up Soutine at the country mansion and even exploited him "shamefully," but this is probably slander. It is true, however, that the Castaings kept their treasures to themselves and that it is likely that we still have not seen everything in the collection of the widowed Mme. Castaing. They have thus created a gap in our knowledge of the master's oeuvre (a number of Soutines, promised for the Museum of Modern Art show of 1950, were listed in the catalogue, but eventually with-

held by the couple; they were reproduced much later in a sumptuous volume, co-authored by Marcellin Castaing and the critic Jean Leymarie).

In 1937 "Mademoiselle Garde" (this is what Soutine renamed Gerda Groth, née Michaelis, the Jewish refugee from Nazi Germany to whom he was introduced at the Café du Dôme) entered Soutine's life. Garde was appalled by the humble way the artist lived even though by this time he was financially well off. He made no attempt to create a more personal atmosphere in the dingily furnished apartment he rented. As for his adjoining studio, its floor was covered with tubes, palette knives, and loaded brushes he had carelessly thrown aside. While not stingy, he was very irrational in his use of money. On the one hand, he had "a real obsession" about

37. Soutine model. Photo taken in Cagnes in 1959

gray hats and fancy ties and spent a great deal for them; on the other hand, "He never had enough clothes. When his shoes were worn out, he stayed in bed all day until they were repaired." Among his numerous idiosyncrasies was an unwarranted fear that he would lose his thick, black hair—a fear that led him to try every kind of scalp treatment.

He had extremely conservative notions about a woman's role—he thought that her place was in the home and that she should not stay out late in cafés—prejudices he seems to have brought with him from the *shtetl*. On top of this, he was beset by a morbid fear of a recurrence of poverty—he would take a taxi only if he had just sold a painting.

He did not like to go out alone after dinner (he feared sudden stomach cramps). On account of his gastric ulcers he observed a strict diet, which of course excluded alcohol. He did not like people, especially strangers, to come to his studio. The American novelist Henry Miller lived upstairs, and occasionally dropped in to borrow a kitchen utensil—but Soutine would not accept invitations to visit him. In a little known work by Miller, *The Waters Reglitterized* (1950), one finds this characterization of Soutine: "He seems tame now [in the 1930s], as if trying to recover from the wild life of other days. Hesitates to salute you in the open street, for fear you will get too close to him. When he opens his trap it's to say how warm or cold it is—and does the neighbor's radio bother you as it does him?" Madame Castaing, of course, was a frequent caller. A few colleagues showed up now and then, and so did a foreign businessman who would drive Soutine and Garde to wrestling matches.

Indeed, Soutine's interests seem to have been limited to wrestling matches and to the neighborhood movies. He and Garde never went to the theater, although it should be mentioned that Soutine, son of a Russian-Jewish clothes-mender, and Constantin Brancusi, son of a Rumanian shepherd, loved to go together to music halls. (While some describe him as an ardent reader of good literature, Garde recalls his owning only a few works by Balzac, some Russian novels, and Montaigne's essays, and his religiously devouring the plebeian *Paris Soir*.) He also listened to rec-

40

ords of Bach and Mozart. He never attended gala openings. Taking Garde to the Louvre, he would keep her looking for a long time at Egyptian and Greek sculpture and would talk to her only about art of the distant past.

She never saw him avail himself of preliminary drawings, although she saw him smear colors onto the canvas with his fingers (his nails were never clean). He always used a model but, having difficulties with professionals, eventually confined his figure painting to children or peasants. He would paint a segment of nature in the open air. Invariably, he studied his subject intently before putting the first stroke of color on the canvas. Shy about his unfinished work, he did not allow even Garde to see his oils before they were completed.

Various sources agree that he habitually destroyed his own works that no longer pleased him. Garde reported his mania for retrieving as many of his earlier works as possible: "This hunt for his old canvases in the galleries on the Right Bank was one of the great pleasures of his life. How many paintings he destroyed or reworked as a result!" (from "My Years with Soutine as told by Mademoiselle Garde to Michel Ragon," *The Selective Eye*, 1956/1957).

Yet he was aware of his growing reputation in art-loving circles. Specialists whom he consulted about his deteriorating health refused to accept fees from so celebrated a painter. When a country policeman arrested him for what seemed peculiar behavior—Soutine had been running excitedly back and forth between his residence and a group of trees he intended to paint—a telephone call to Albert Sarraut, an ex-premier of France, convinced the guardians of the law that, far from being a dangerous madman, Soutine was indeed a "great painter."

The outbreak of World War II put an end to Soutine's security. It is often claimed that the painter spurned an opportunity to flee to the United States. His close friend, the sculptor Chana Orloff, one of the *École Juive* artists to survive the Nazi period, tells a different story. At one point he seems to have realized that after the fall of France it was imperative to leave Europe while it was still possible. He was not listed among the few celebrities to be

38. PORTRAIT OF A WOMAN. *36 x 26".*
© *The Barnes Foundation, Merion, Pennsylvania*

39. Mlle Garde in 1937

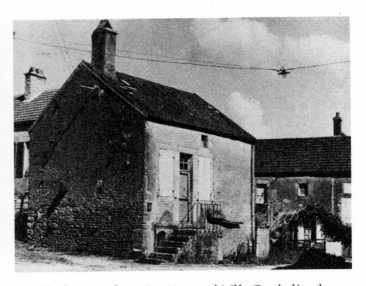

41. The house where Soutine and Mlle Garde lived in Civry, 1939–40

40. Soutine in 1939

42. Mlle Garde in Carcassone during the Nazi Occupation of France

saved through the collaboration of New York's Museum of Modern Art and the U.S. Emergency Rescue Committee. Apparently, there were enough American admirers to provide him with an affidavit, but his approaches to the U.S. Embassy were fruitless because he could not produce a single identity paper.

Garde and Soutine were staying in the countryside at Civry-sur-Serein, about 150 miles south of Paris, when the war broke out. Although they were forbidden to leave, they clandestinely returned to Paris. As a German national, on May 15, 1940, Gerda Groth was seized with many other refugees and taken to the concentration camp at Gurs in the Pyrenées. Soutine could do nothing in her behalf, except to send her money. At first, to judge by the recollections of his friend Orloff, he himself was not in terror. Like other Jews, he complied with the Nazi order to register. "I met him as he was coming out of the police office, 'Look,' he said, showing me the card, which had been badly stamped, 'they have smudged my Jew'... He told me there was nothing to fear and showed me his blue hat. In his naïveté he thought his clothing made him unrecognizable" (Chana Orloff, "My friend Soutine," *Jewish Chronicle*, November 1, 1963).

In May 1940, Marie-Berthe Aurenche, ex-wife of the Surrealist painter Max Ernst, saw Soutine calmly sipping his linden-blossom tea at the Café du Dôme that had been virtually abandoned by its clientele and they soon became intimate friends. Twelve years later, in an article published in the Parisian weekly newspaper *Arts*, she wrote about her three-year relationship with Soutine. When she met him, he was forty-seven, and he still looked youthful. He had the round face of a "*moujik, lit up by genius,*" and reminded her of Rembrandt's self-portrait in the Louvre. She admired the beauty of his white, muscular hands. His voice exuded sincerity. Polite and dignified, he was the opposite of the notion she had had of him—that of a brusque and wild man.

Paris was no longer safe for Jews, so, to protect Soutine, the two moved to a village. Marie-Berthe chose Champigny-sur-Veude, near Tours, in west-central France. At first Soutine was unhappy: "Oh that flat land, those straight trees—I need twisted trees!" But he eventually fell in love with the landscape and he would paint it for ten or eleven hours at a time, day after day, undeterred by cold weather or rainstorms.

Even there, the nearness of German troops made them change their lodgings six times. Once their host was a cabinet-maker. At mealtime they sat around the table where one seat was kept empty in honor of a son who was a prisoner of the Germans. In the evening, they listened to the Free French broadcasts from London, and to the Voice of America (there the couple even recognized the voice of their

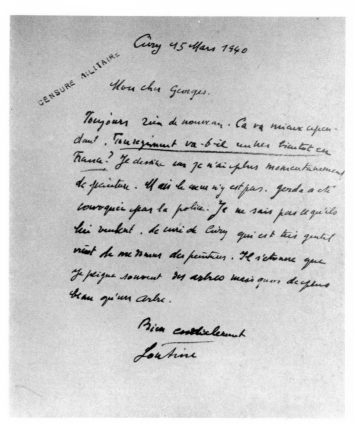

43. Letter from Soutine to Georges Grogh:

Civry, March 15, 1940

Dear Georges,
 Still nothing new. But things are better anyway. Will your regiment return to France soon? I am drawing because at the moment I have no more paints. But my heart isn't in it. Gerda was summoned by the police. I don't know what they want with her. The curé of Civry, who is very kind has just given me some paints. He is surprised that I often paint trees, but what is more beautiful than a tree?
 Very cordially,
 Soutine

acquaintance, the Surrealist poet André Breton, who had fled to the United States). Soutine disapproved of the Soviet regime, yet the recital of the immense sufferings of the Russian people shook him profoundly.

One day, a village policeman uneasily presented Marie-Berthe with a paper on which Soutine had to attest that he was not Jewish. She tore it up, but could not keep her friend from learning of it. At one place, the hotel clerk knocked at their door in warning: "The Germans are here, quick, hide!"

The tensions caused by fear of detection had a terrible effect on Soutine's ulcers. He was taken to a local hospital, but the surgeon did not want to risk an operation. Marie-Berthe, who was convent-educated and a devout Catholic, asked for some water from the shrine of Lourdes, but all the nurse could produce was some other "blessed" water. Soutine drank it, and his condition appeared to improve temporarily.

Nevertheless, Soutine's health continued to

44. Max Ernst. MARIE-BERTHE AURENCHE.
Whereabouts unknown

deteriorate. Doctors were consulted in several cities. Finally the couple decided that the recommended operation had to be performed in Paris and they are said to have made the long trip from central France in a hearse so that they would not be stopped by German troops. The diagnosis at the clinic was perforated ulcers with internal hemorrhage. Surgery was performed, but it had come too late. A few hours thereafter he passed away without having regained consciousness. On the ninth of April, 1943, Soutine was dead at the age of fifty. At least he was spared the fate of so many French-Jewish artists—deportation to, and death in, a concentration camp. He was buried in the Montparnasse Cemetery in a plot owned by Marie-Berthe's family. The coffin was followed by Marie-Berthe and also by Mlle. Garde (who had found refuge in the house of Madame Castaing's brother). The other mourners included the poet Jean Cocteau and the deceased man's famous colleague, Picasso. Soutine's grave remained unmarked until the war was over. Subsequently, Marie-Berthe had it covered with a large stone slab on which a cross and inscription were carved. Unfortunately, the artist's first name was misspelled as Chaime and the date of his birth was wrongly stated (it should be 1893 instead of 1894). In 1960 Marie-Berthe committed suicide and by her last will her remains were interred next to her lover's.

As a person Soutine was never able to shed what he considered a burden—his Jewish heritage—and it is significant that all who knew him noted how very Jewish or at least how un-French he was in appearance. To the writer Maurice Sachs he looked like a "mournful Jew." Many have even endeavored to detect "Jewish" qualities in his work. Typical of several efforts of this sort is a statement by the American artist Morris Davidson (*Understanding Modern Art*, 1936): "They [Soutine's works] are the expression of a neurotic who is saturated with the savage, childish mysticism of his Hebrew heritage. The frenzied rituals and superstitions of his Jewish environment in Vilna [sic!] have left in him a morbid urge to express his emotional fancies by means of distorted figures ... Soutine was more poet than painter, and most of all, high priest of the synagogue."

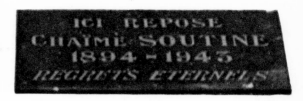

46. Soutine's tombstone with the inscription:

Ici Repose
Chaïme Soutine
1894–1943
Regrets Eternels

Two mistakes can be noted: the spelling of the artist's first name and his date of birth

45. Montparnasse cemetery, with Soutine's tomb in the center foreground

47. Soutine's death certificate with his "Jewish number" shown in the lower left

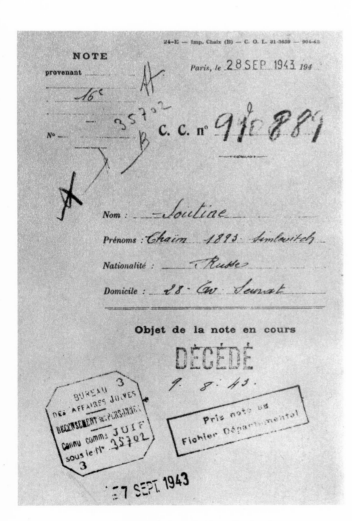

48. Notification of Soutine's death sent by Marie-Berthe Aurenche. The name of the cemetery was changed at the last minute and Soutine's age is given incorrectly

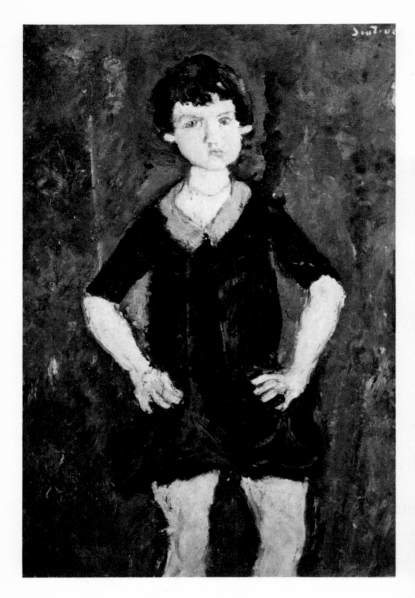

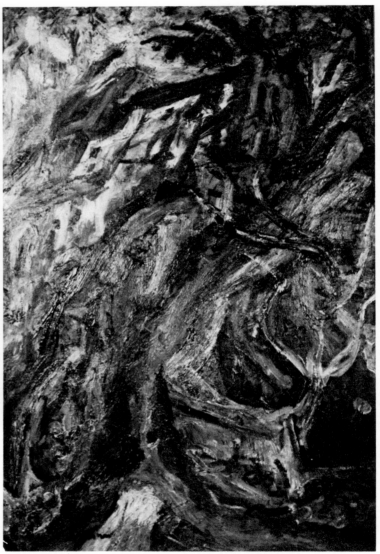

49. PORTRAIT OF A CHILD IN BLUE. 1928.
39¼ x 25½". The Metropolitan Museum of Art, New York.
Gift of Mr. and Mrs. Nate Spingold, 1956

50. GNARLED TREES. 1921.
38 x 25". Collection Mr. and Mrs. Ralph F. Colin, New York

Personally, I do not believe in racial mysticism. As already noted, Soutine's work is closely related to that of the Dutchman Van Gogh, the Frenchman Rouault, the German Emil Nolde, the Austrian Oskar Kokoschka, the Englishman Matthew Smith, all of them Expressionists. They, no less than the uprooted *Litvak* Soutine, refused to be bound by the traditional, the Greek concept of art. Moreover, he was as radically opposed to mere Impressionism as any of them. He saw the dread, the frenzy, and the forces beneath the surface—the pinched wretchedness of the page boy, the uneasiness of the school girl, the gusts of wind tossing and tearing the branches and foliage of an old tree. He omitted details, and used strong, sensuous, almost orgiastic colors, which Waldemar George called a "torrent of lava foaming in stormy billows." It is the contrast between the contorted, "unnatural" forms and the juicy, vital colors that constitutes the essential character of his art.

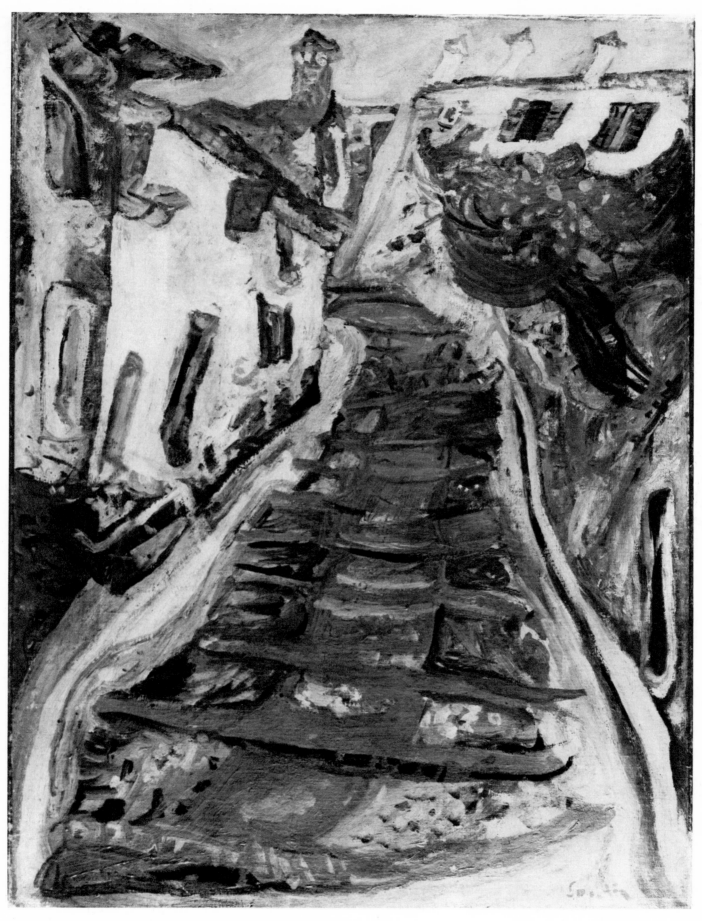

51. RED STAIRWAY. 1923. 29⅛ x 21¼". Private Collection

A STREAM OF LAVA

"...he considered all preparation not only useless but even harmful, because it involved the risk of dispensing and shattering his inspiration. He never drew, in the traditional sense of the word...."

Jacques Lassaigne (in Soutine, 1954)

The 1973 memorial exhibition of paintings by Soutine, organized by Le Musée National d'Art Moderne and shown at the Orangerie in Paris, constituted a somewhat belated posthumous triumph for this artist, who spent about thirty of his fifty years in France but never before had a representative showing of his works in any French public institution. Indeed, of all the great painters active in Paris in the first half of this century Soutine was, until recently, the least famous; the books about him are still few, and they are usually short and often marred by errors of fact. In recent years, however, a valiant effort was made by Pierre Courthion to construct a catalogue raisonné, by tracing and, as much as possible, reproducing, the artist's pictures, scattered all over the world. Yet Courthion is honest enough to admit that there are still many gaps in his knowledge. Indeed, considering the circumstances of Soutine's er-

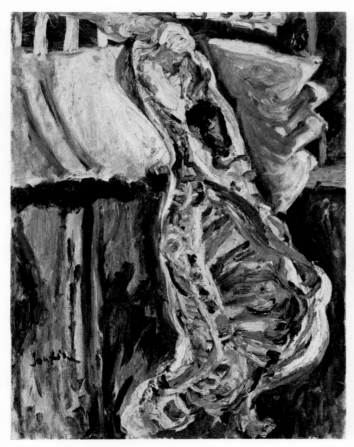

52. SIDE OF BEEF. 1922–23.
27½ x 20½".
Collection Mr. and Mrs. Ralph F. Colin, New York

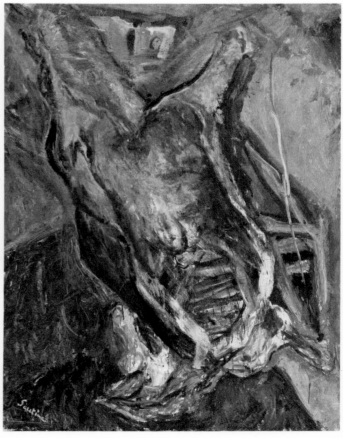

53. SIDE OF BEEF. c.1925.
55¼ x 42⅜".
The Albright-Knox Art Gallery, Buffalo, New York

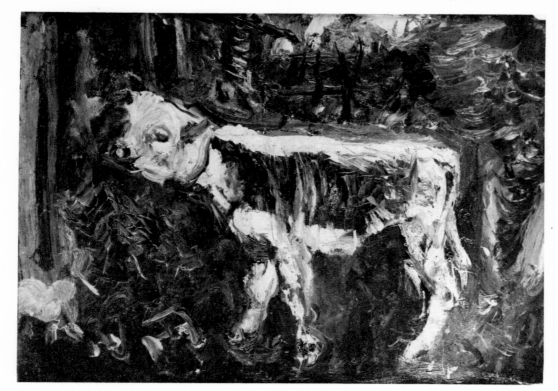

54. THE LITTLE CALF. 1933–34. *Oil on wood, 16⅛ x 21⅝". Collection Madeleine Castaing, Paris*

ratic life and lava-like productivity (interrupted by spells of despondency and idleness), and the fact that many a good picture by one of his friends had the original signature erased and "Soutine" substituted for it, not to mention the numerous outright fakes, a "Compleat Soutine" will always remain a Utopian dream.

In 1977 authentic Soutines sold for sums around $250,000 (far less than a good Modigliani would fetch) and even not fully authenticated ones fetched considerable sums at auctions. No history of the School of Paris could possibly be complete without him, although, of the thousands of painters in modern Montmartre and Montparnasse, Soutine was the least connected with any of the groups and movements within the so-called *École de Paris*. He kept away from the coteries, remained apart from the battles, displayed no interest in the work of any of his contemporaries except Rouault, and, like him, can be included among the Expressionists only in the loosest sense of the term. His admiration for Rembrandt was boundless. His only trips abroad were three to Amsterdam where he stood fascinated for hours before the master's works in the Rijksmuseum, especially the so-called *Nightwatch* and *The Jewish Bride*; his

own numerous versions of *Carcass of Beef* were inspired by Rembrandt's *Slaughtered Ox* (The Louvre); his *Woman Wading* emulated Rembrandt's *Hendrickje Bathing in a Stream* (which he could have known only from a reproduction, since he never visited London, where the celebrated picture hangs in the National Gallery). Among artists of a closer era, only Courbet exerted a strong and unmistakable influence upon him.

The 1931 *Woman Wading* perhaps represents a peak in Soutine's career and it is one of his finest pictures. He, however, had also produced remarkable works during his period of misery—from his arrival in Paris in 1912 to 1923. Among those that survive is a *Self-Portrait*, owned by the Pearlman Foundation, New York. It seems to present him and his character exactly as he was at the age of twenty-five. In this work, painted in his favorite colors, stark reds and greens, he appears truculent and even savage. His not particularly refined features—he had a flat face, a large spatulate nose, and thick lips—are deliberately made to appear even coarser than they actually were. "Take me as I am," the picture shouts, "or, better still, don't bother me." He tries to frighten us away—yet he himself is

55. Café de la Rotonde, Paris

frightened by any spectator. In this "Portrait of the Artist as a Malcontent" the hypnotizer is mesmerized himself. In the ungainly face, there is tension, but there is also the strength and vigor of a young man, ready to go through hell to arrive at the desired goal of his painterly vision.

Soutine might have gone on living and working the way he did without ever achieving status and fame during his lifetime. A loner, naive in the ways of commerce, without a wife to care for him, without anyone to thrust open for him the door to success (except the not immensely practical Polish-born poet-turned-dealer Zborowski) he might have joined the legions of frustrated bohemians who crowded the Café du Dôme, the Café de la Rotonde and the other artists' rendezvous, whenever they had a franc or two at their disposal. But, as mentioned before, there was the chance discovery, in 1923, by the astute American collector, Dr. Barnes, who in 1924 published an enthusiastic article about his protégé in *Arts à Paris.*

This marked the turn of his fortunes. Within a couple of years, Soutine found himself famous, pampered by collectors ready to pay fortunes for his pictures. Success did not affect his work. There is no downward trend in quality, as there is in so many of his contemporaries. The sudden availability of money may have caused Soutine to squander it on absurd and unnecessary luxuries. On occasion he even tried to look respectable.

As a painter, Soutine had calmed down a bit. Earlier, during his sojourn in southern France—about 1919 to 1923—financed by the faithful Zborowski, he had painted, in Cagnes-sur-Mer and then in Céret, landscapes of a kind the world had never seen before, and would never see again: houses, trees, hills are whirled around as if uprooted by an earthquake. (Describing his feelings during a drunken spree, Modigliani once quipped, "Everything is dancing before my eyes as in a landscape by Soutine.") In his final years, from about 1939 to 1943, Soutine also created many landscapes with strollers—usually small

children—who are seen moving toward us on a country road. The tall trees are no longer uprooted, but stand firmly on the ground. Yet their leafy crowns are still shaken furiously by terrific storms!

The fate of Utrillo—who was transformed into a domesticated, abstemious and even devoutly religious squire whose works became only very weak echoes of what he had created in his turbulent years—does not repeat itself in Soutine. Curiously, however, as a celebrity, he began to hate the pictures he had painted before 1923 and bought them back whenever he could, in order to hack them to pieces. It is possible that he now felt a dread of the wildness that had characterized his early efforts. For along with the negation of what he had done as a *peintre maudit*, as a *peintre tragique* with his work went an increasing worship of the Old Masters in the Louvre that was morbidly exaggerated.

But Soutine was too wise to try to become an imitator of the Masters, and he somehow continued in his own manner. In the 1930s, his output may have been smaller than ever before.

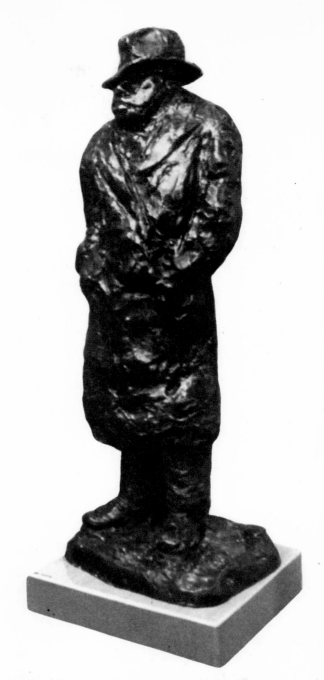

57. Arbit Blatas. PORTRAIT OF SOUTINE. *1939. Musée de l'Orangerie, Paris*

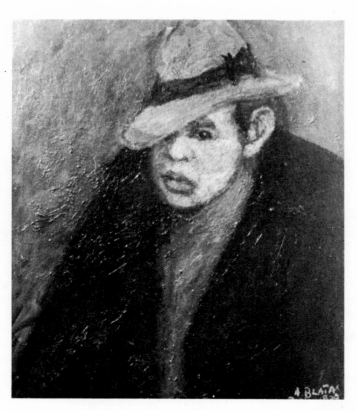

56. Arbit Blatas. PORTRAIT OF SOUTINE. *1939. Private Collection*

Although he had achieved a certain facility that would have made possible a mass production of pastry cooks and choir boys which a host of eager collectors were waiting to snap up, he did not follow in the footsteps of his contemporary Pascin. Aware that his brilliantly painted pictures of half-dressed little girls had become a commodity much in demand, Pascin allowed himself to be pressed by his dealers into a large-scale manufacture of these salable works. One of the thoughts that led Pascin to his suicide was the realization that he had lost interest in the only thing that had sustained him—the quality of his paint-

58. HAUNTED HOUSE. *c. 1920. 28¾ x 21¼".*
Perls Galleries, New York

ing—and that, by repeating himself mindlessly, he had surrendered his artistic freedom. Pascin knew that he was morally and artistically bankrupt when he hanged himself in his Montmartre studio.

Soutine apparently overcame a temporary fatigue and listlessness, for the pictures he painted toward the end of his life are again as strong, as virile, as those of his youth, though much firmer in composition and design. The strange thing about them is that they were done at a time when, as a foreign-born Jew and, to the Nazis, a "degenerate artist," he was in constant danger of being arrested and shipped to a death camp (which was what happened to many of the members of the so-called *École Juive*).

Soutine would certainly have given us many additional fine pictures had Fate allowed him a few more decades. Canvases like *Windy Day, Auxerre* and *Return from School after the Storm,* both painted about 1939, are no less moving than *Still Life with Fish* or *View of Céret* painted much earlier in the years of hunger and neglect.

Unfortunately, most French critics failed to recognize his greatness. In the 1920s and even

59. LANDSCAPE
AT CÉRET. *1919.*
27 x 32⅝".
Formerly Modarco Collection,
Geneva

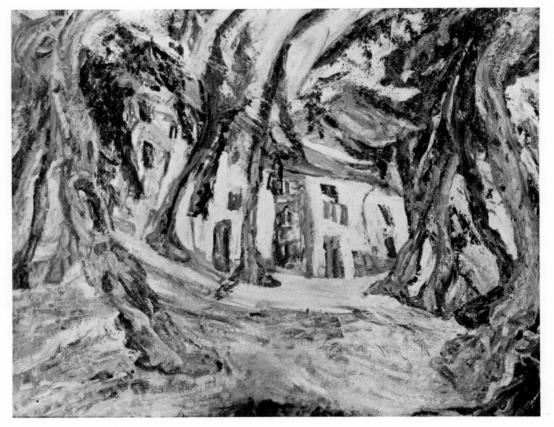

in the 1930s, they were at best ambivalent about him. These intellectuals conveniently forgot that France, in addition to what Matisse called "an art of balance, of purity and serenity," also harbored masters whose painting could not possibly be compared to "a good armchair in which to rest from physical fatigue."

After World War II—whose victims included Soutine, if one considers the effect on his ailment of the mounting tension—French critics were more willing to acknowledge Expressionism. As already mentioned, Bernard Dorival even created a category for Soutine and those of similar disposition: "The Painters of Anguish."

Long years of poverty of course played a great role in the development of Soutine's character. Significantly, edibles loom large in Soutine's works (which also often depict the preparers or servers of food, such as cooks and waiters). Yet the food he painted—tomatoes, eggs, beef, fish, rabbits, and all kinds of fowl—is often presented in an unappetizing or decayed state. These still lifes betray Soutine's bitterness: as a young man he hated all food

61–62. Landscapes at Céret

60. Fountain at Céret

63. THE FISHES. *c.1917.*
15 x 18".
Collection Mr. and Mrs. Kirk Douglas,
Beverly Hills, California

64. STILL LIFE WITH DUCK.
c. 1924. 21½ x 29½".
Collection Edward A. Bragaline,
New York

that was beyond his means, and when he was finally able to afford any kind of delicacy, his ulcers made necessary a rigid diet of bland and tasteless dishes. By the same token, travel in the fields and woods of Russia was an impossibility for an impecunious Jewish youngster of his era. Settled in France, he could roam the countryside; he enjoyed best placing his easel in the meadows and, especially, near rows of majestic tall trees. Yet in his pictures, even the "calmer" ones of his final stage, *la douce France* is not as recognizable as it is in the pleasant smiling plein-air paintings of Monet, Sisley, Renoir, or Pissarro. Van Gogh's land-

65. FISH AND TOMATOES.
c.1925. 25¼ x 33½".
Private Collection, New York

66. STILL LIFE WITH FISH.
1926–27. 25⅝ x 32".
Courtesy Perls Galleries,
New York

scapes are hardly what one might call static, yet they are quiet and controlled compared with the "worst" of Soutine, which appear to be violent convulsions, the enactment of nightmares, the disturbing echoes of the storms that gathered in the unhappy painter's psyche. Referring to one early landscape by Soutine, Duncan Phillips, founder of The Phillips Collection in Washington, D.C., astutely wrote in 1943: "Many years ago Soutine painted this cataclysmic upheaval as if he had a premonition of our world's agony of total war."

Mr. Phillips was one of the earliest American

67. PASTRY COOK WITH BLUE HAT. 1922–23.
25⅝ x 19⅝".
Collection Jacques Guérin, Paris

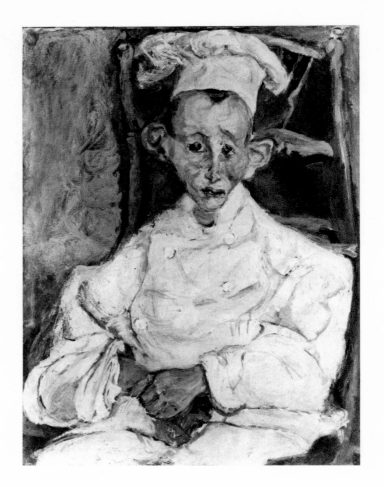

68. YOUNG PASTRY COOK. 1927. 27¼ x 9⅛".
Private Collection, New York

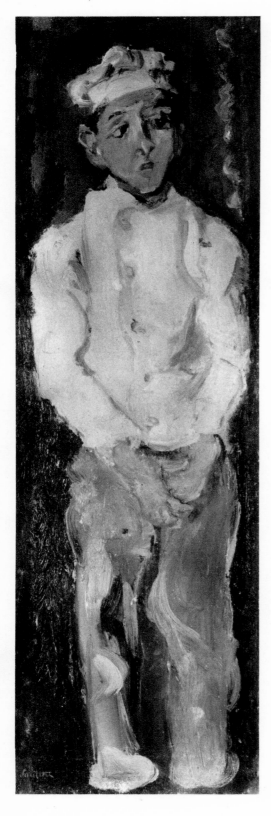

collectors to be infatuated with Soutine's strange genius. But, in this country, the painter was admired even in the 1930s by artists like Darrel Austin, Hyman Bloom, Jack Levine, and Abraham Rattner (actually a Parisian expatriate). In the 1950s, he was idolized by the Action painters, or Abstract Expressionists, among them William de Kooning and Jack Tworkov (who wrote a glowing tribute to him in *Art News*). His work was seen in memorial shows at New York's Museum of Modern Art and at museums in Cleveland and Los Angeles.

It is to be hoped that the present monograph will help deepen our understanding of an unusual oeuvre which does not reveal its depths very easily, and requires a prolonged study to open up to the baffled viewer. The viewer is, in a sense, present at a constant battle that is being fought on the canvas, one between mind and matter, idea and reality, with the artist having been honest enough not to patch up a "compromise" but to emphasize the eternity of this never-ending struggle.

THE ARTIST'S OWN IMAGE

"...Chaim Soutine was frightening; he was like a wild beast in a circus who knows that he will be deprived of food if he does not do what is required of him...

"...a wild animal, half-tamed by the tenacious, demanding, imperious nature of painting, who contained himself when he was at work amid the disgusting disorder of his studio, but as soon as he laid his brushes down he hurtled out, hairy, wild, spiteful-looking, through La Ruche, terrorizing the tenants with his brutal ways and his unintelligible conversation...

"...Soutine was the most monstrous incarnation of that irresistible mysticism that threw so many painters from all over the world into the bubbling melting-pot of Paris to get on as best they might...."

Pierre Cabanne (in Outlaws of Art, n.d.)

Three major self-portraits, whose authenticity cannot be disputed, are known to us. They do not give us an objective notion of what Soutine looked like, although they tell us a great deal about his alienation, his self-hatred. Soutine was painted by at least three colleagues, and there are also several photographic snapshots. There is a vast gap between, say, the third self-portrait—aptly described by Tuchman as "a pitiless, ruthless work, ridden with self-contempt"—and Modigliani's likenesses of his friend. Modigliani has left us several drawings and, more importantly, four oil portraits of his then twenty-four-year-old *copain*. They present the sitter in a peaceful and, twice, even in a meditative mood, either because the older man exerted a pacifying, soothing influence on the excitable Russian immigrant or, more likely, because Modigliani endowed all he saw with his own grace, elegance, and sweetness. "Modigliani saw only that which was beautiful and pure," his friend Madame Lunia Czechovska commented. Unlike Soutine, Modigliani nearly always stopped well this side of caricature, and never allowed malice to enter a portrait.

All four Modigliani portraits are from the year 1917, that is, roughly a year before the Pearlman picture was painted. The least developed Modigliani is the one painted on wood—on the door that separated Soutine's atelier from that of his friend at No. 3 Rue Joseph Bara. Soutine is seen standing. He wears a broad-brimmed hat, has a young girlish face, slit pupil-less eyes, and a spatulate nose, and his head is tilted to the right. It is in the nature of a sketch, based on irregular splotches of color, and is faintly reminiscent of the Neo-Impressionist technique which Modigliani adapted to his purposes while painting his portrait of the collector Frank Burty Haviland.

Two of Modigliani's portraits of Soutine, however, are as complete as any Modigliani can be. In the one in a private collection in Paris, Soutine is sitting with his hands, palms down, resting on his knees. He wears a coarse, brownish workman's jacket, buttoned up to the collar. The long hair comes down to his ears; he appears to have masculine strength, and his face has a certain ruggedness. More famous is the other, similar painting once owned by Chester Dale (whose wife was among the first to write about Modigliani) and now in the Chester Dale Collection of the National Gallery of Art in Washington, D.C. Soutine wears a dark suit, a black pullover, a white shirt with the collar half open, and a carelessly knotted tie. He sits with his hands folded in his lap. For a change, accessories—a table and a glass half filled with liquor—have been introduced, as much for compositional needs as for sugges-

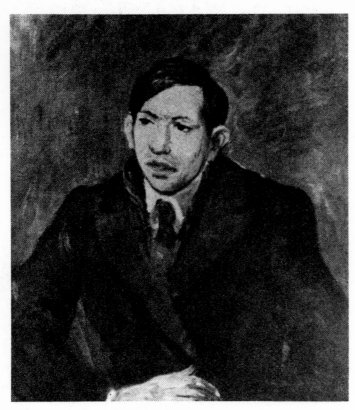

69. Kostia Terechkovitch. PORTRAIT OF SOUTINE. 1933. Musée de Menton, France

tion of ambience. There is a certain formality about this picture as though the model were posing, a bit stiffly, for a photographer. All of Modigliani's stylistic mannerisms are present: the thinned-out body, with long neck and lengthy, narrow head, is posed against a nondescript green background. Indeed, there is a lot of green and red in this picture—these were Soutine's favorite colors.

The Staatsgalerie in Stuttgart owns a fourth Modigliani portrait of Soutine. Unlike the others, it shows only head and neck, both vastly elongated in the mature Modigliani style. Here, Soutine's usually solemn, pouting mouth is shown in a half-smile.

The portraits by Modigliani make Soutine appear to have been rather slender. In reality, Soutine was a bit short and stocky. He had a rounded face. The portrait of him done by Terechkovitch is probably closer to the exact physical reality. The sitter, now forty (the picture is dated 1933), has a flat, oval face, thick lips, and small, protruding eyes. Clearly prosperous, he is wearing a fashionable dark suit, with a colorful scarf tucked inside, revealing a

conservative white dress-shirt and a good tie. Yet fame and money were unable to heal the wounds inflicted upon him by society and by his own unfortunate disposition. He is seen dreaming, but without even the faintest indication of a smile.

Another Russian who painted Soutine was Arbit Blatas. Soutine was something of an idol to the much younger man, who encountered his now famous compatriot in Paris in the mid-1930s. One of the several portraits of Soutine that Blatas painted is now in the Washington County Museum of Fine Arts, Hagerstown, Maryland. In this half-length portrait, the sitter's face is not much different from that in Terechkovitch's painting. But here the artist wears a gray felt slouch hat pulled down over his right eye, a heavy overcoat, and a dark shirt. The mouth is sullen and the eyes look wary. The entire effect is that of a wanted criminal.

Another portrait by Blatas shows Soutine standing. He appears furtive, his hands are in his pockets, his shoulders are hunched, he is leaning against a wall for support. Except for the clothing, which is of good quality and not ragged, one might take him for a *clochard* who does not like to be looked at. Blatas gives this psychologically admirable description of his late friend: "His dark face and burning eyes created a tormented expression; his body huddled into his coat, he seemed a frightened, suspicious man imprisoned within himself, wanting only to be left alone, distrustful of everyone now that sudden recognition had come to him, after years of inner struggle. But I soon realized that he still desperately needed association with people, that he wanted friends, that he was curious about and interested in even those whom he had pushed away from him in his search for solitude " (in Blatas' introduction to the group show, *Soutine and His Circle in Paris*, London, 1959).

Of the surviving photographs—they are not numerous—at least two show Soutine smiling. In both he wears coarse workmen's clothes, the kind of attire Picasso had made "fashionable" on Montmartre in the not-so-good old days of the Bateau-Lavoir. In one of them Soutine is seen standing beside a dead rooster that is hanging from a wall hook (the rooster theme frequently appears in his work). In the second,

he and an unidentified young woman are at the corner of a brick building, each holding a forepaw of a small dog that is raised up on its hind legs as if it were a child standing between them. A third photograph is surprising. Soutine is now, for a change—and for a short while only, one suspects—assuming the role of a bourgeois. He is well groomed and elegantly clad in an immaculate suit with sharp-peaked lapels. A handkerchief is tucked into his breast pocket. He wears a fine-textured tie over a starched white shirt, and seems absorbed in the act of drinking from a long-stemmed glass, held daintily in his hand with the little finger crooked.

There is no lack of verbal portraits! Though Soutine was certainly not gregarious, even after his importance had been trumpeted about

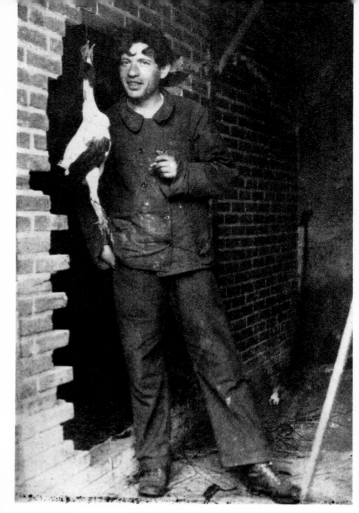

71. Soutine with dead rooster.

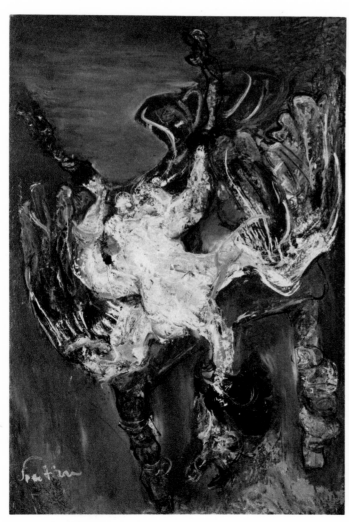

70. DEAD FOWL (ROOSTER). c.1926–27.
38½ x 24½". The Art Institute of Chicago.
Joseph Winterbotham Collection

72. HANGING TURKEY. 1926.
36 x 28½".
Collection Richard S. Zeisler, New York

by Albert C. Barnes, Georges Charensol, Elie Faure, Waldemar George, and other astute connoisseurs, there is an amazingly large number of people who knew him or claimed to have known him despite his notorious solitariness. Unquestionably, the sculptor Lipchitz knew him well, and for more years than Blatas. Lipchitz repeatedly talked about Soutine to his own biographers. Irene Patai observes (in *Encounters; The Life of Jacques Lipchitz*, 1961): "For Lipchitz Soutine was always an enigma, a mixture of such idiosyncratic impulses that he found himself constantly asking the question, Is Soutine good or bad or just neurotic? Not quite sure whether to like him or to pity him, continually perplexed by the protean faculty of the painter."

Mlle. Garde was aware of her friend's idiosyncratic impulses. Long after Soutine's death she told a Parisian critic: "Soutine was extremely sensitive and also extremely diabolic...I had the luck, if that is the way to put it, of finding him when he was ill and when he needed me. If that had not been the case, I doubt very much whether he would have been capable of attaching himself to a woman." Garde, who seems to have loved him very much, nevertheless once summed him up thus: "Soutine was a savage who fled from all worldliness."

The writer Maurice Sachs watched Soutine walking in the garden of the Castaing estate: "With his bent back, his drooping shoulders, his rumpled hair, his work trousers," Sachs tells us, Soutine had "the appearance of some mournful Jew who, concealing his fine pale hands, was fleeing to the security of the Ghetto."

Sachs' observation was incorrect in one respect, though. Soutine wished to flee away from the ghetto, not back to it. There can be no doubt that the miserable childhood he spent at Smilovitchi—with its prohibitions, restrictions, outmoded rituals, poverty, and medieval backwardness—had a profound impact upon the painter. He was still "in the ghetto" when Monroe Wheeler met him in Paris. Wheeler saw him in the late 1920s: "He was pale and slender, hypochondriacal, and under doctor's orders as to his food and drink...The expression of his face varied a great deal, sullen or suspicious, timorous or arrogant, but upon occasion as friendly as a child's. A man of slight stature, he moved in an uneasy or evasive way, a little onesidedly. His small and delicate hands suggested a more meticulous way of painting than he ever practiced. Occasionally he took pains to be well dressed, but his clothes soon became shabby and dirty. At the end of his life his cheeks grew hollow, his full lips drooped with a suggestion of boredom or bitterness, but when he spoke his black eyes still glittered with romanticism about himself and his art" (from the Museum of Modern Art *Soutine* catalogue). His host at Champigny, the painter Marcel Lalo, who generously aided him and Marie-Berthe, thus characterized him: "He is a prince...even in his working smock, the material of which was stiffened by innumerable smears of paint, he had a lordly appearance...he was a true aristocrat."

Despite these and other attempts by his friends and acquaintances to shed light on his character, Soutine remained inscrutable to the very end. His paintings are the only real clues to his puzzling personality.

SOUTINE IN THE UNITED STATES

*"One by one the Soutine paintings that first converted the
Parisian connoisseurs and shook them out of their original dislike
are coming to this country, and the more of them we see the more
evident it becomes that Soutine must be ranked with the
great.... No richer painting is to be found in our Metropolitan
Museum, not even among the ancients. Every inch of the canvas is
'painted.'"*
Henry McBride in the New York Sun

*"Your grandchildren, I predict, will take Chaim Soutine as
readily for granted as you do Gauguin and Van Gogh..."*
Jerome Klein in the New York Post

*(Excerpts from reviews that appeared after the third Soutine show
at the Valentine Gallery, New York, March 20 to April 8, 1939)*

In the 1970s, it would be hard to find in the United States many people in the art world ready to utter an unkind word about Soutine and his work. Even a magazine like *American Artist* that prefers Andrew Wyeth and those who emulate his cool, sober manner, commissioned this writer to do a piece on Soutine (December 1973 issue) and chose to illustrate it with pictures that may have caused some consternation among its small-town subscribers. In a large loan show, *Modern Portraits: The Self & Others*, organized by Columbia University's Department of Art History and Archaeology and mounted at the Wildenstein Galleries (New York, 1976), Soutine's *Self-Portrait* (Pearlman Foundation) shared honors with works by Pierre Bonnard, De Chirico, Robert Delaunay, Roger de la Fresnaye, Matisse, Modigliani, Picasso, and Edouard Vuillard, to name only the more prominent practitioners of art who were Soutine's contemporaries. The catalogue entry contained a clever evaluation of the picture's place within the artist's work: "Normally, Soutine's emotional vision rips apart the entire physical world—including the artist's own physiognomy—in the process of its manifestation. Yet here, on the eve of the full development of Soutine's fervid expres-

sionism, there is an unusual steadiness in the representation of his own features, differentiating them from the uprootedness around him: hence, the portrait's compelling sense of isolation and alienation."

As I indicated in an earlier chapter, Soutine, for a number of years, lacked an undivided appreciative audience, however small, even among the cognoscenti of New York and the other large American cities. Even so informed a dealer and author as Samuel M. Kootz, who was hardly a reactionary, and who eventually became the major promoter of Hans Hofmann, wrote: "The mystic quality so glowingly recognized in Soutine today is merely rotten painting. He paints in thick layers, throwing on paint like a drunken man. There is no appreciation of form, no clear definition of values, no architectural qualities that would denote orderly thinking."

Kootz was still a young man when he wrote this. But Thomas Craven was one of the powerful forces in American art when, in the second edition of *Modern Art* (1940), he damned Soutine, though he did so with an attempt to be merciful. An isolationist, Craven looked down on what he called "foreign mannerisms" and the "esoteric nonsense of Modernists," and fa-

vored those who calmly took their themes from rural America. He scorned what he called "the cult of true feeling" that "flourishes among sorrowing and humorless artists," such as Chagall and Soutine, and, referring to the latter, continued: "... a Lithuanian Jew, whose mind is afire with something mystic and inexpressible. A shy, kindly, poverty-ridden man, he paints in solitude, with an intensity worthy of Van Gogh, and with an impasto as thick as plaster, figures distorted beyond the bounds of reason, and landscapes which might be slag heaps of hell. About all that can be said of his work is that it indicates some sort of tragic experience—what, I do not know. His art is supposed to be rich in plastic values."

Luckily, there were no Soutines in the German museums to be confiscated, otherwise he would have joined the company of Chagall, Lovis Corinth, Picasso, Kokoschka, Nolde, and others who were featured in Munich's "Degenerate Art" exhibition of 1937. Meanwhile, in the United States valiant efforts to present and sell Soutine's works were being made by several dealers in New York, especially Valentine Dudensing and Mrs. Cornelius J. Sullivan, while in Chicago the Arts Club displayed twenty of his works in a one-man show. By 1942, there was at least one Soutine in a major U.S. museum—the Museum of Modern Art in New York—his portrait of Madame Castaing loaned by Adelaide M. de Groot. It was transferred to the Metropolitan Museum of Art after Miss de Groot's death.

Barbara Rose traces the "smeared impasto and writhing, melting forms" in Hyman Bloom's "fantastic visions in brilliant, visceral forms" to the influence of Soutine. He was also favored by a group of New York avant-garde artists who were known as The Ten, and included Adolph Gottlieb and Mark Rothko. But Soutine was not, as is claimed so often, a forerunner of the Action Painters, or Abstract Expressionists. Along with their spokesman Clement Greenberg they all came to the large memorial show at New York's Museum of Modern Art (1950), but by that time they had formed their own styles and techniques. All they did was to nod approvingly. They discovered in the late artist the same kind of spontaneity, the same intoxication with texture and color of heavily applied pigment. One of them, Jack Tworkov, probably expressed the thoughts of all when, in an *Art News* essay ("The Wandering Soutine," November 1950), he hailed Soutine's work for its "impenetrability to logical analysis," for "that quality of surface which appears as if it had happened rather than as if it had been made." He liked "the way his painting moves toward the edges in centrifugal waves filling it to the brim; his completely impulsive use of pigment in a material, generally thick, slow flowing, viscous, with a sensual attitude toward it, as if it were the primordial material, with deep and vibratory color, the absence of any effacing of the tracks bearing the imprint of the energy passing over the surface."

Tworkov continued in the same enthusiastic manner: "The combined effect is of a full, packed, dense picture of enormous seriousness and grandeur, lacking all embellishment or any concession to decoration."

Yet Tworkov also knew that, Soutine's proto-Abstract Expressionist "gestures" notwithstanding, he was fundamentally a Realist, a traditionalist. Eighteen years later, in a postscript appended to the Los Angeles Museum catalogue, Tworkov categorically declared: "I personally know of no abstract expressionist painters whose work showed a Soutine influence." Unquestionably, however, he was right in asserting that, on the other hand, "Abstract Expressionism influenced a deeper penetration of Soutine."

So far, the last exhibition of a considerable number of Soutines of great merit in a private gallery in New York was held in 1969 in the Perls Galleries, whose scholarly owner, Klaus Perls, did not allow the interest in the strangest of all Expressionists to simmer down. But Perls, who had his first Soutine show as far back as 1953, need not fear any slackening in the public's fascination with the master. The good thing is that Soutine was never "fashionable" and never will be. He was not a mere fad even in the mid-1920s when his cycle of pictures of liveried hotel employees sold quite well. He was never a real celebrity in Paris, and would not have become one here either, had he ever managed to reach the United States (he does not seem to have pushed himself in his efforts to escape from France, though he was quite aware of the mortal danger he was ex-

73. Soutine as an "ex-Bohemian"

posed to in Nazi-occupied Paris, as a foreign-born Jew and as a "degenerate" artist to boot). Here, he would never have become the social lion a Marcel Duchamp turned into.

American clinics might have rid him of his terrible disease, or at least prolonged his life for a few more years. But he would have felt completely lost at cocktail parties, and without the French countryside, the French trees, the simple French *bonhommes* who were his models. After the liberation of France, he would have taken the first boat back to Europe. For he was entirely bound to his milieu, to his topics, even to the disorderliness of his studio. It is hard to think of anyone else as rustic as he and at the same time capable of reaching the heights of human endeavor.

Perhaps the best summing-up of what Soutine was all about comes, not from a historian, nor from a critic, collector or dealer, but from a personal friend—not a close one—who, as a gentlemanly well-educated artist, was the very opposite of that child of misfortune, Soutine. Breaking his usual philosophical reserve, the sculptor Lipchitz wrote: "He was one of the rare examples in our day of a painter who could make his pigments breathe light. It is something which cannot be learned or acquired. It is a gift of God. There was a quality in his painting that one has not seen for generations—this power to translate life into paint—paint into life...[His pictures] are not all completely realized, but in spots he has the strength one finds in Rembrandt, the life one finds in Rubens. He breathed into his pigments: his work is radiant with light...."

CHRONOLOGY

1893 Chaim Soutine, born in Smilovitchi, near Minsk, in what is now the White Russian Soviet Socialist Republic (the exact date of his birth is unknown; 1894 is no longer accepted as the year of his birth). He was the tenth of eleven children of a poor Jewish clothes-mender, Zalman (Solomon) Sutin, and his wife Sarah.

1909 Goes to Minsk, where he is taught the rudiments of art by a private instructor named Krueger. Meets another young art student, Michel Kikoine, who becomes his friend.

1910 Moves to Vilna. Ekes out a living by doing retouching for a local photographer. Fails the entrance examination at the Academy of Fine Arts, but is admitted after a second try. Is supported by a physician.

1912 Emigrates to Paris. Stays with Kikoine in a residence for indigent artists, nicknamed La Ruche (the beehive), in Rue Dantzig on the Left Bank. Subsequently lives at another colony of artists, Cité Falguière, in the same district. Meets Amedeo Modigliani, who becomes his close friend and introduces him to his own dealer, Léopold Zborowski. Volunteers for work in the French army. Is employed as a ditch-digger.

1918 Lives and works in the south of France, largely in Céret and Cagnes-sur-Mer. At Cagnes, at the end of January, 1920, he is shattered by the news of the death in Paris of Modigliani.

1923 One of his paintings is seen in the gallery of Paul Guillaume and admired by the American collector Albert C. Barnes, who visits his studios in Paris and Céret and buys a large number of his canvases.

1924 Has a studio in the Rue du Mont St-Gothard, Paris. Lives with, but soon abandons, Dvoira Melnik, whom he had met in Vilna, where she studied music.

1925 Refuses to acknowledge paternity of a daughter Aimée, who was alleged by Melnik to be the offspring of their liaison.

1927 Has a one-man show at the Galerie Bing, Paris.

1929 First monograph written about him by Elie Faure.

1931–1935 Spends the summers at Lèves, near Chartres, as a guest of Marcellin and Madeleine Castaing, who had become his major collectors.

1932 Death of Léopold Zborowski.

1937 After having lived at various addresses in Paris, moves to an apartment on a street called Villa Seurat. Meets Mlle. Gerda Groth, a refugee from Nazi Germany, whom he calls "Mlle. Garde," and who becomes his companion.

1939 On September 3, at the outbreak of World War II, Soutine and Mlle. Garde are in the village of Civry-sur-Surein, in the Department of Yonne, in central France and decide to remain there. Soutine makes several trips to Paris to consult doctors about his gastric ulcers.

1940 On May 15, Mademoiselle Garde is deported to the concentration camp of Gurs. Soutine spends most of his time in small villages in the Department of Indre-et-Loire, in west-central France, where he and a new companion, Marie-Berthe Aurenche, hide from the German invaders.

1943 On August 7, he is rushed to a hospital in Paris where a belated operation is performed. He dies there on August 9. He is buried in the Montparnasse Cemetery in Paris on August 11.

EXHIBITIONS

(Major Group Shows and One-Man Shows)

1927 Paris, Galerie Bing

1935 Chicago, The Arts Club of Chicago

1936 New York, Valentine Gallery

1936 New York, Mrs. Cornelius J. Sullivan Gallery

1937 New York, Mrs. Cornelius J. Sullivan Gallery

1937 New York, Valentine Gallery

1937 London, Leicester Galleries

1937 Paris, Musée du Petit Palais

1938 London, Storran Gallery

1939 New York, Valentine Gallery

1940 New York, Carstairs Gallery

1943 Washington, D.C., Phillips Memorial Gallery (now The Phillips Collection)

1943 New York, Bignou Gallery

1944 New York, Niveau Gallery

1944 Paris, Salon d'Automne

1945 Paris, Galerie de France

1945 Boston, Institute of Modern Art

1947 London, Gimpel Fils

1947 Paris, Galerie Zack

1949 New York, Van Diemen-Lilienfeld Galleries

1950–1951 New York, The Museum of Modern Art
Cleveland, The Cleveland Museum of Art

1952 Venice, Biennale

1953 New York, Perls Galleries

1956 Paris, Maison de la Pensée Française

1959 Paris, Galerie Charpentier

1963 London and Edinburgh, The Arts Council

1966 Paris, Orangerie des Tuileries

1966 New York, Perls Galleries

1968 Los Angeles, The Los Angeles County Museum of Art

1968 Jerusalem, The Israel Museum

1969 New York, Perls Galleries

1973 Paris, Orangerie des Tuileries

COLORPLATES

2. STILL LIFE WITH SOUP TUREEN

Painted 1916. Oil on canvas, 24 x 29"
Collection Mr. and Mrs. Ralph F. Colin, New York

By the time he painted this picture, Soutine must have made numerous visits to the Louvre and observed the many *bodegones*—studies of various foodstuffs and utensils in kitchen interiors—done by Italian and Spanish artists in the sixteenth and seventeenth centuries. Like them, Soutine's early series of kitchen still lifes is characterized by the somber tones dominant in much of European painting before the Impressionist revolution. But while the Old Masters cared for traditional perspective and sought to render the individual textures, young Soutine placed all the objects—the tureen, the plate with the giant fork on it, the two spoons, the wine bottle (whose dark shade balances the lighter objects) and the empty glass—on a table and viewed them in an almost Cubistic manner, both from the front and from the top. Cézanne's sober, darkish early still lifes also come to mind. Both masters, the Post-Impressionist and the Expressionist, share a certain graveness as well as a touch of stiffness.

This early Soutine demonstrates the timidity of a young painter who does not wish to imitate the meticulous naturalism of yesterday's masters—though he makes concessions to them by putting white highlights on the glass bottle—but still has a long way to go before he can dash paint on to the canvas freely in a personal fashion. While the French term *nature morte* does not really do justice to some of the vibrant still lifes Soutine saw in the Parisian museums and galleries, here the inanimate objects, clumsily arranged on the table, look dead indeed, with the exception of the crude iron fork that somehow suggests a big human hand. The general mood is one of despair.

Conceivably, the painter's interest in all kinds of foods, in tableware, and in the men who handle food—cooks and waiter—has psychological roots in the tormenting deprivations of his youth and his early years in Paris. In this painting it may be symbolic that the plate is bare, that the bowl and wine glass are empty. It must have been at the time he painted the series of still lifes that he was "driven by hunger to commit a theft of bottles which he exchanged for bread." (Monroe Wheeler)

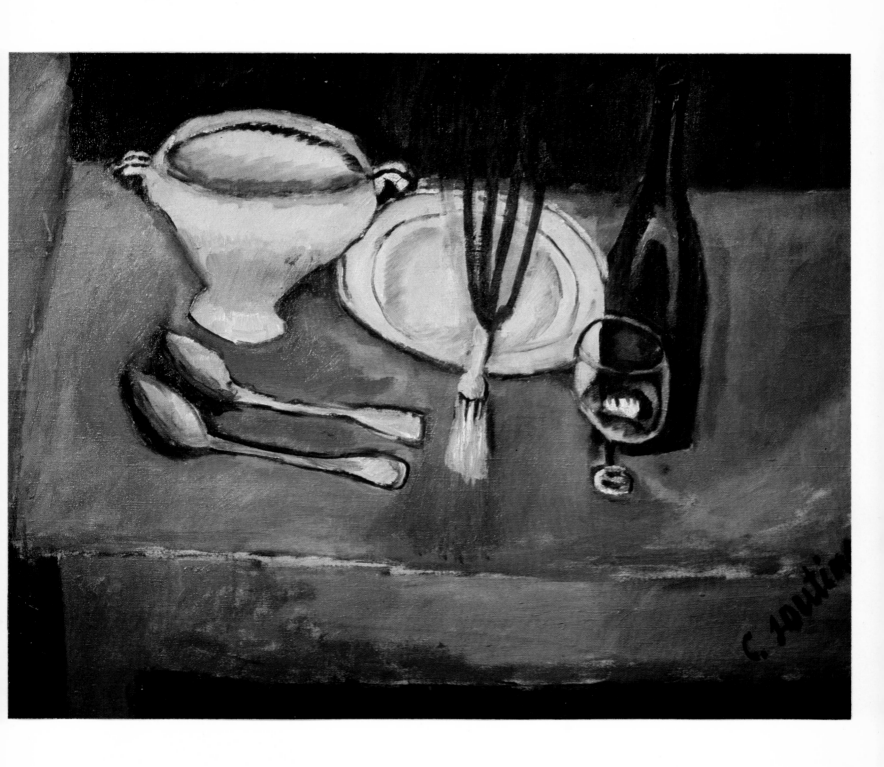

3. PORTRAIT OF A NURSE

Painted c. 1916. Oil on canvas, 25½ x 19½"
The Los Angeles County Museum of Art

One of the accusations frequently hurled by conservative critics at Expressionists—a group of artists among whom Soutine must be counted—was that they were incapable of drawing and painting "correctly," that is in an academic manner. Yet most of these artists received rigidly formal training as did Soutine at the Academy of Fine Arts in Vilna, where students were required to study drawing intensively, working first from plaster casts and then from nude models, and where they enjoyed none of the freedom of unlimited self-expression granted to art students in the Western world in later decades.

Compared to the portraits Soutine was to create in the 1920s and 1930s, this one looks rather tame. There are no anatomical deformations in the face, except that the eyes appear to be rather large and simplified in design (one recalls the huge-eyed frontal soulful portraits of Fayum, Pompeii, and Byzantine art). Neither the body nor the arm is distorted into the S-shape seen in later pictures, and the coloration of the skin is rather "natural." As a matter of fact, this work does not yet give us an indication of the direction in which the artist's style was soon to develop. But as in all of Soutine's portraits, early or late, the face has an ambiguous expression.

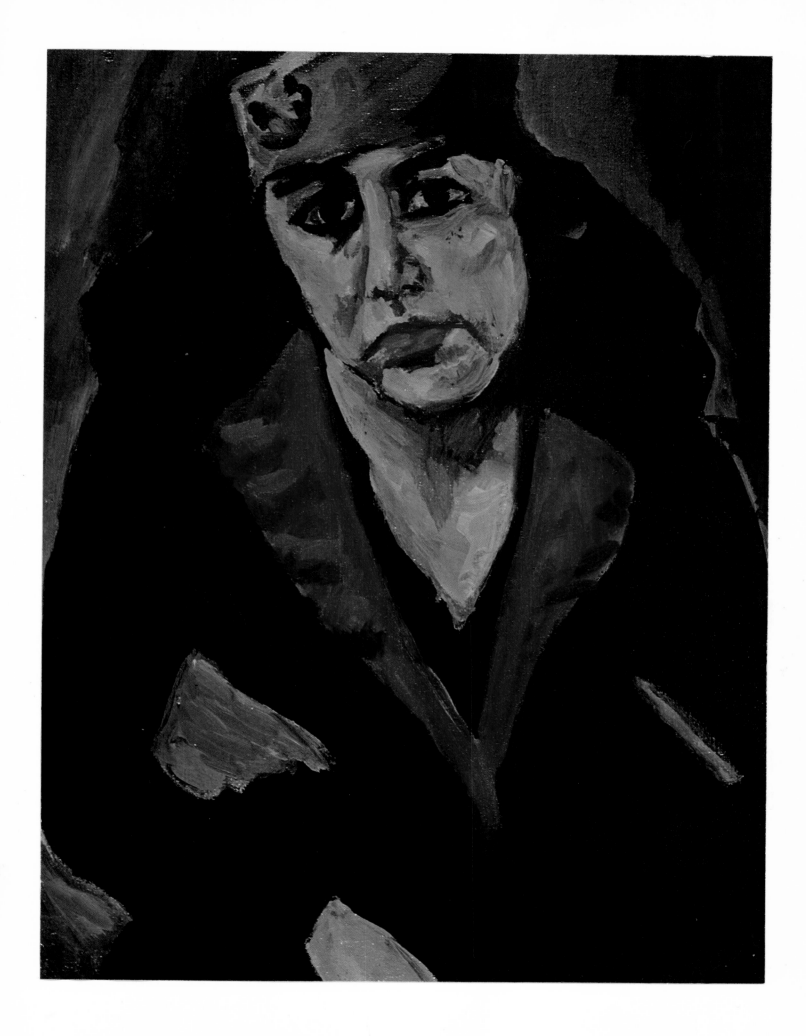

4. STILL LIFE WITH LEMONS

Painted c. 1916. Oil on canvas, 25¾ x 21½"
Collection Mr. and Mrs. Irving Levick, Buffalo, New York

This is another of the earliest Soutines known and, like other works of the same period, naive, timid and somewhat two-dimensional. Anyone acquainted only with the "wild" Soutines of the 1920s, or the quasi-classical pictures of the 1930s, would find it hard to connect this painting with the same master, occupied as he still is with form, with line. In the still lifes done soon after his arrival in Paris, Soutine often placed objects in a careful, yet almost awkward, manner on a slanted tabletop. This simple and severe canvas is characterized by the dominant bitter brown tones, from which emerge a few bright color areas—especially the uniform yellow of the lemons and the white of the plate beneath. While the objects are flattened, and no attempt is made to achieve academic verisimilitude or *trompe-l'oeil,* the conventional white highlights still appear on all of the vessels.

The performance is, altogether, a frightening one. But there is a Soutinesque element to linger over for a while—the big fork, which, as has been said, "quivers and trembles as if alive." These implements of Soutine have a personality of their own; they look like grasping, emaciated proletarian hands, eager to secure bits of food. By introducing one or two forks, Soutine puts in a personal appearance, saying as it were : "Here I am, at my skimpy meal."

There is a definite link between Soutine's early still lifes—in which a table, laden with objects, is viewed from above—and some of the *natures mortes* Cézanne painted. Cézanne's works are nearly always based on real objects or real persons; imaginary subjects, dreams, or speculations are rare. Soutine, too, was a realist rather than a visionary. He, too, for a number of years used dark, robust colors thickly applied. He, too, differed from the Impressionists in not trying to paint light and in making much use of blacks that have a striking plasticity. The early Cézanne and the early Soutine often achieve monumentality by dint of a stern combination of verticals and horizontals that creates an admirable calmness and stability.

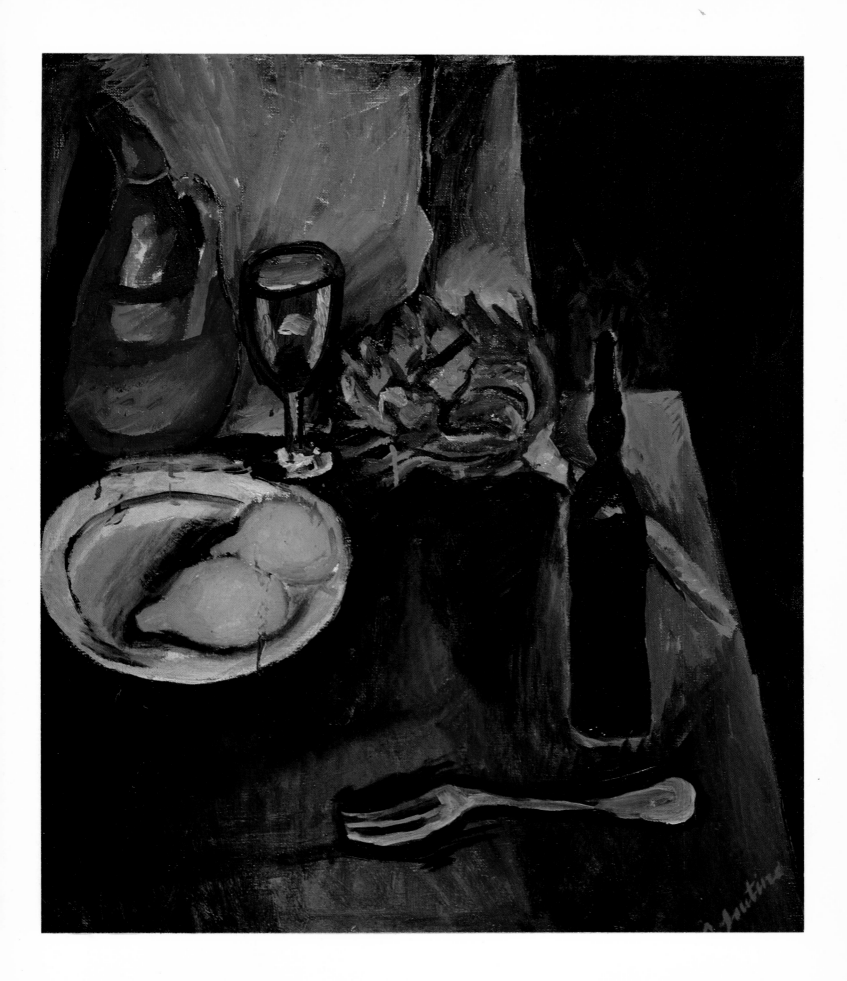

5. STILL LIFE WITH PHEASANT

Painted c. 1918. Oil on canvas, 44 x 31¼"
Collection Mrs. Frederic R. Mann, Philadelphia

While this picture was painted around 1918, some reminiscences of Michel-Georges Michel, as retold by Maurice Tuchman, are relevant, though they refer to a slightly later period:

"In Paris during the twenties he [Soutine] would search the poultry shops with a friend for a particular chicken, one with a 'long neck and blue skin'...On one occasion, the poulterer offered him a fat chicken, out of sympathy for Soutine's appearance, but Soutine insisted on buying an emaciated fowl: 'I want a very lean chicken with a long neck and flaccid skin.' Finally, much to the poulterer's bewilderment, he found the wretched specimen he wanted. On the street he held up the bird admiringly and said, 'I'm going to hang it up by the beak with a nail. In a few days it should be perfect.''

Here, a scrawny pheasant has been used. The carcass hangs over several apples on what appears to be a marble tabletop. The large window on the right reduces the possibility of any overemphasis on the bird. The execution is forceful, the brushwork vigorous.

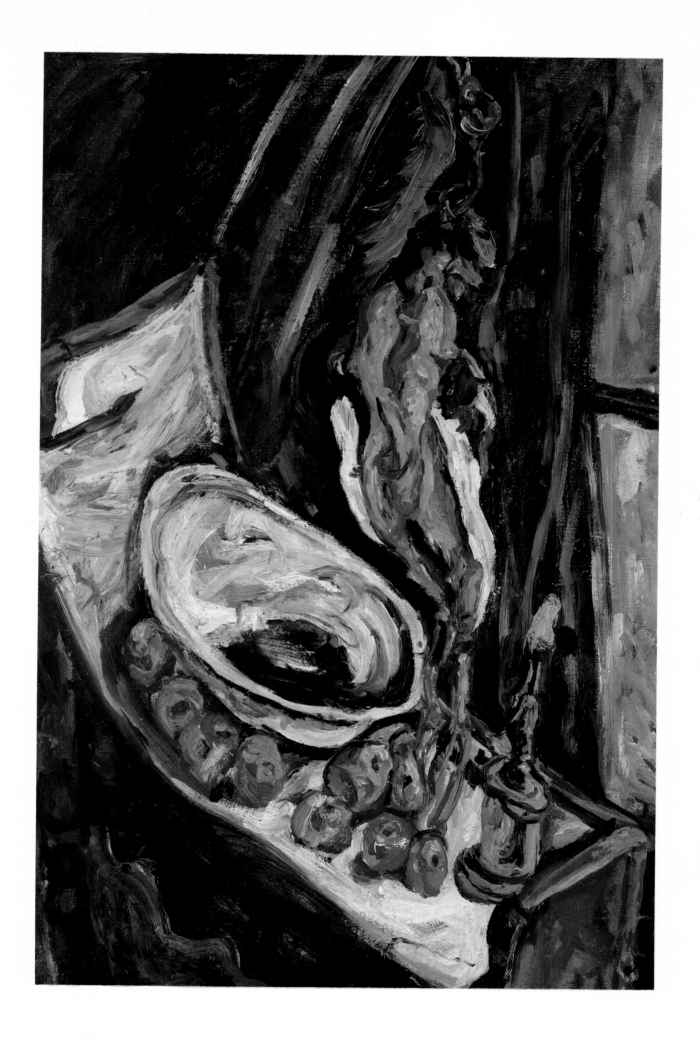

6. STILL LIFE WITH FISH

Painted c.1918. Oil on canvas, 16⅛ x 25¼"
The Metropolitan Museum of Art, New York.
Bequest of Miss Adelaide Milton de Groot (1876–1967), 1967

Fish appear in many pictures by Netherlandish masters—
Holland, after all, derived much of its protein from the sea. But
nowhere in seventeenth-century Dutch paintings do we find fish
rendered the way they are here by Soutine—with staring eyes and
gaping mouths, their bodies still writhing as if they had just been
pulled from the water. There is something frightening about
them—their eyes pop out, as if they were undergoing some sort of
cruel punishment. The fish are, of course, dead, yet they appear to
be moving with a fearful intensity as though trying to escape from
a big, rapacious predator.

Soutine's earliest still lifes have a certain stiffness about them,
but here is an anticipation of his later dramatic treatment of
carcasses in serpentine curves. The impression is created that
these fish are in deep water rather than on a slanting table.
Unpleasant greens, yellows and browns prevail; the strong red at
the top provides chromatic balance; it also seems to compensate
for the otherwise drab coloration.

About the time this was painted, Soutine was living miserably
in a wretched little cell of *La Ruche* (the beehive) a residence for
impecunious artists in a proletarian quarter of Paris. In this
canvas, he confronted a traditional theme of painting and
reshaped it boldly, giving profound expression to his own
disquiet and woe.

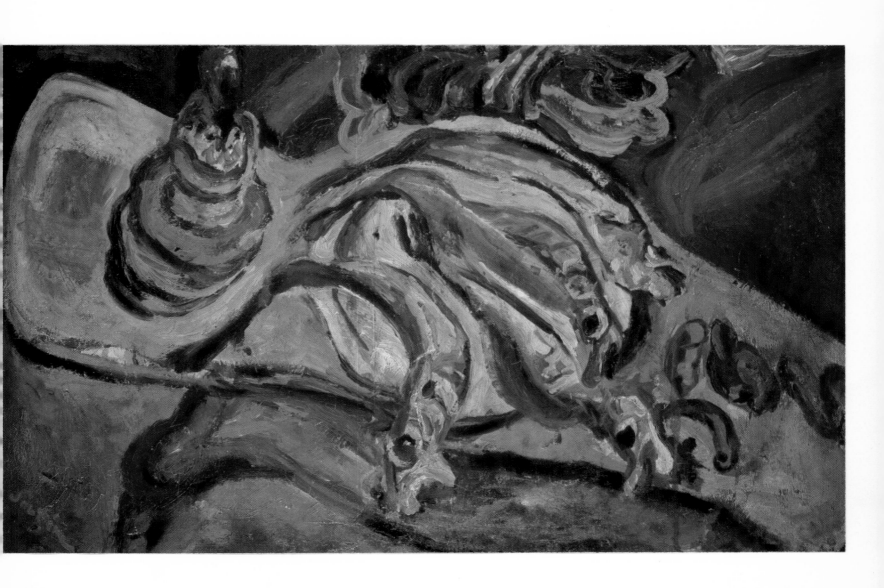

7. RED GLADIOLI

Painted c.1919. Oil on canvas, 21½ x 18"
The Lydia and Harry Lewis Winston Collection
(Mrs. Barnett Malbin), Birmingham, Michigan

Up to the time of the Post-Impressionists, most paintings of flowers were characterized by great care for botanical accuracy. The artist was so concerned with the exact appearance of the flowers that he meticulously retained all the naturalistic details to the point of surrendering his personal style rather than omitting any objective data.

The last school of painters to render flowers so exactly that their pictures might almost serve as illustrations for botanical texts were the Impressionists. All of this changed with Van Gogh, who, without necessarily suppressing every detail, transformed the motif to reveal his own restless, bursting personality and forceful individuality. Quivering with vitality and moving in broad, slashing strokes, his brush invented sunflowers that are actually solar blazes. One recalls that Matisse once warned his fellow-painters, "Exactitude is not truth." He wanted the "inherent truth" to be disengaged from the "outward appearance of the object."

This is what Soutine did in the wretchedness of his *La Ruche* atelier when he extracted from the gladioli (meaning, by the way, "small swords") before him veritable paroxysms of color—the canvas becomes a battleground of cadmium reds fighting with Prussian blues! The blossoms spread like dreadful talons and whip back and forth savagely. Many writers have paid tribute to these truly expressionistic experiments in paint: "It may not have been so much the true forms of the leaves and petals which appealed to him," wrote Monroe Wheeler, "as the blood-redness, fire-redness, which he rendered like little licking flames." And Germain Bazin remarked: "Soutine made the gladiolus, the flower of love, into a flower of blood."

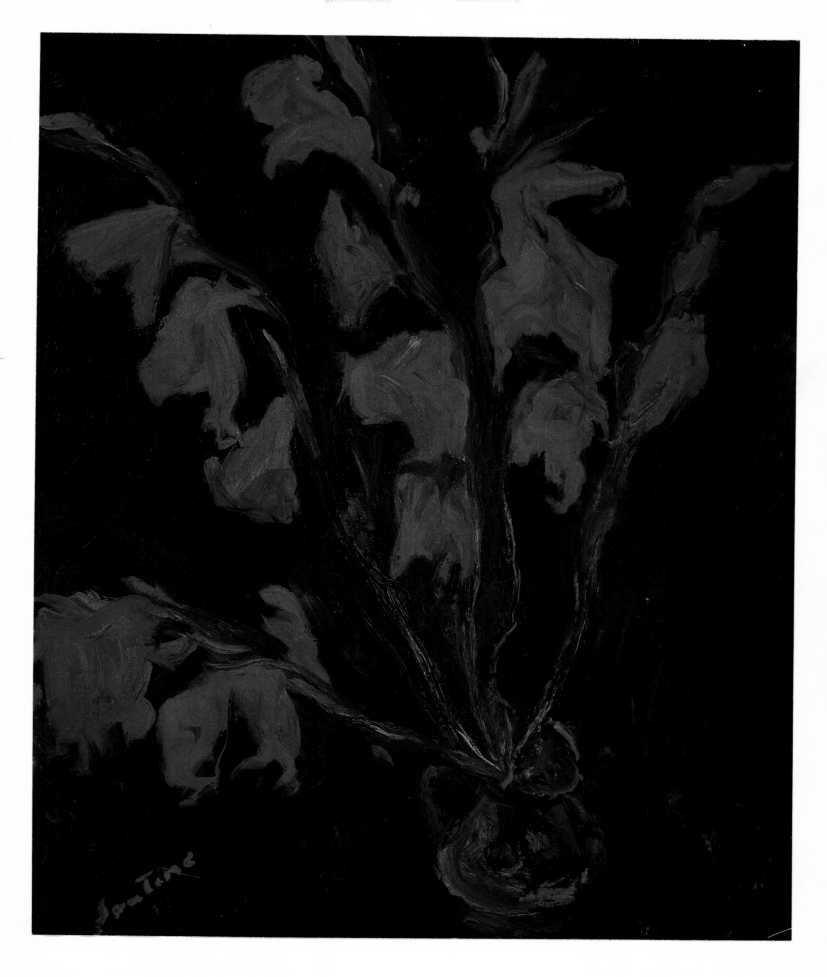

8. THE MADWOMAN

Painted after 1920. Oil on canvas, 37¾ x 23¾"
The National Museum of Western Art, Tokyo

Artists often do not bother to give titles to their pictures; hence, these are frequently supplied by friends, dealers, or patrons. Thus, the title *The Madwoman* need not be taken to mean that the subject was really insane in the clinical sense. In his *Self-Portrait* of about 1923 (colorplate 18), Soutine makes himself look like a cretin. As a rule, he could not help "distorting" the countenances of his sitters, though among his early pictures are a few in which the exaggerations are not as strongly marked as they are here.

But if this image really represents a mentally disturbed person, rather than an ordinary sitter seen through exceptionally "misanthropic" eyes, Soutine would not have been the first artist to be attracted by the psychotic. In Magnasco's pictures, people of abnormal personality are included. In Hogarth's series of engravings *The Rake's Progress*, the hero is finally committed to Bedlam. Goya studied patients suffering from demonic obsession in an asylum at Saragossa. Invited by the resident alienist, Géricault set up his easel in the Salpêtrière hospital in Paris, and painted several studies of the inmates (one of which, *Insane Woman*, Soutine may have seen at the Louvre).

Edmund Burke Feldman (in *Art as Image and Idea*, 1967) compares Géricault's madwoman to the one by Soutine: "Here the artist [Soutine] attempts to convey to the viewer the *experience* of the sick person. She is presented as trembling with fear, and there is no question in our minds that she is mentally ill. Although Géricault maintains his objectivity about the subject, Soutine employs his painterly technique to enter into the life of the subject.... The frightened eyes and tortured hands of Soutine's woman bespeak her illness but also transcend it, as we recognize in her a suffering human being."

With *Page Boy at Maxim's* (Collection Baroness Alix de Rothschild), *The Madwoman* was included in the exhibition "50 Years of Modern Art," which formed a part of the Brussels World's Fair of 1958.

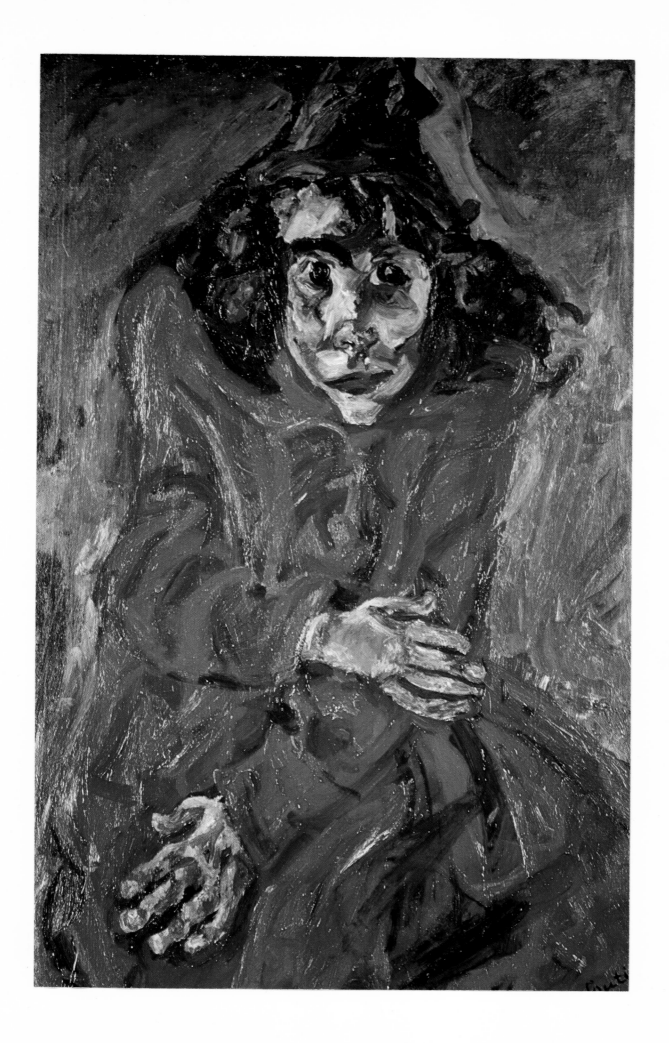

9. PRAYING MAN

Painted 1921. Oil on canvas, 35⅜ x 21¼"
Collection Mrs. Paul Todd Makler, Philadelphia

This is one of a series of Praying Men, exceptional in Soutine's production, as the subjects are seen in profile, whereas his portraits are generally frontal or near frontal.

This tilted backward head, with a long nose, closely resembles the attenuated sculptures Alberto Giacometti fashioned from the late 1930s onward. Of the entire body, nothing but the elongated head with the half-shut eye and the extraordinarily long, schematically sketched hand can be seen (the second hand is barely indicated, like a shadow of the first).

If the picture really represents a man at prayer, one wonders whether the image is influenced by the artist's recollection of *davenen* (the expression used by Ashkenazic Jews for praying) in the orthodox synagogue of his native town, where the congregants swung backward and forward in the ecstasy of religious worship. As elsewhere in Soutine's work, bone structure, flesh, muscles are obliterated by the clothing; this, too, might be related to the attitude of the Ghetto Jew, who often treated everything strictly corporeal as unimportant and even irritating, and put the stress on the immaterial, the intellectual, the spiritual.

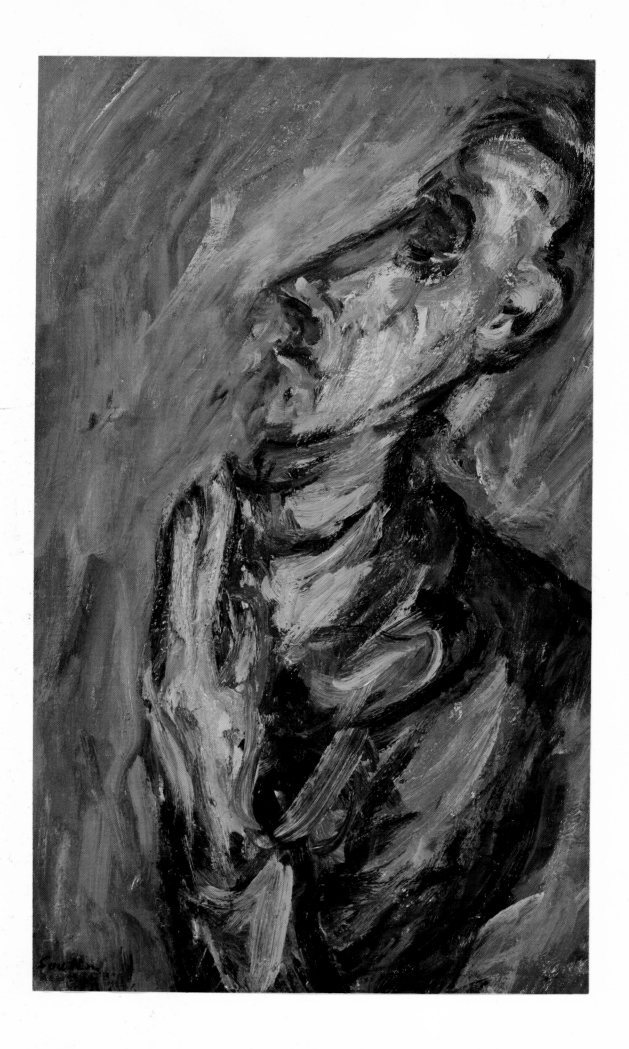

10. WOMAN IN PINK

Painted 1921–22. Oil on canvas, 28½ x 21¼"
Collection Mr. and Mrs. S. J. Levin, Miami

The somewhat later *Woman in Red* (colorplate 12) seems to be a pendant to this picture. There, the S-curve is reversed and the sitter wears an enormous black hat. Here, snake-like, the woman seems to be crawling over the canvas, her body aggressively and even violently in motion. The lips are full and her face puffed. Her arms look boneless, as if their sole function were to echo the movements of the torso. The chair, with its baroque bent arms and stiff red back, has the appearance of a throne.

The viewer is inevitably reminded of the sculpture, *The Old Courtesan*, for which Rodin used an 80-year-old model. This decrepit nude, mourning the ruin of her once fair body, was a proclamation of the principle that only that which possesses no character is ugly in art. Both the Rodin sculpture and the Soutine painting anticipate the *art brut*, or "raw art," of Jean Dubuffet which is totally uninterested in formal aesthetics and related to the instinctive art of children, savages, and the mentally ill. Another outstanding example might be Willem de Kooning's series of women, done in the 1950s.

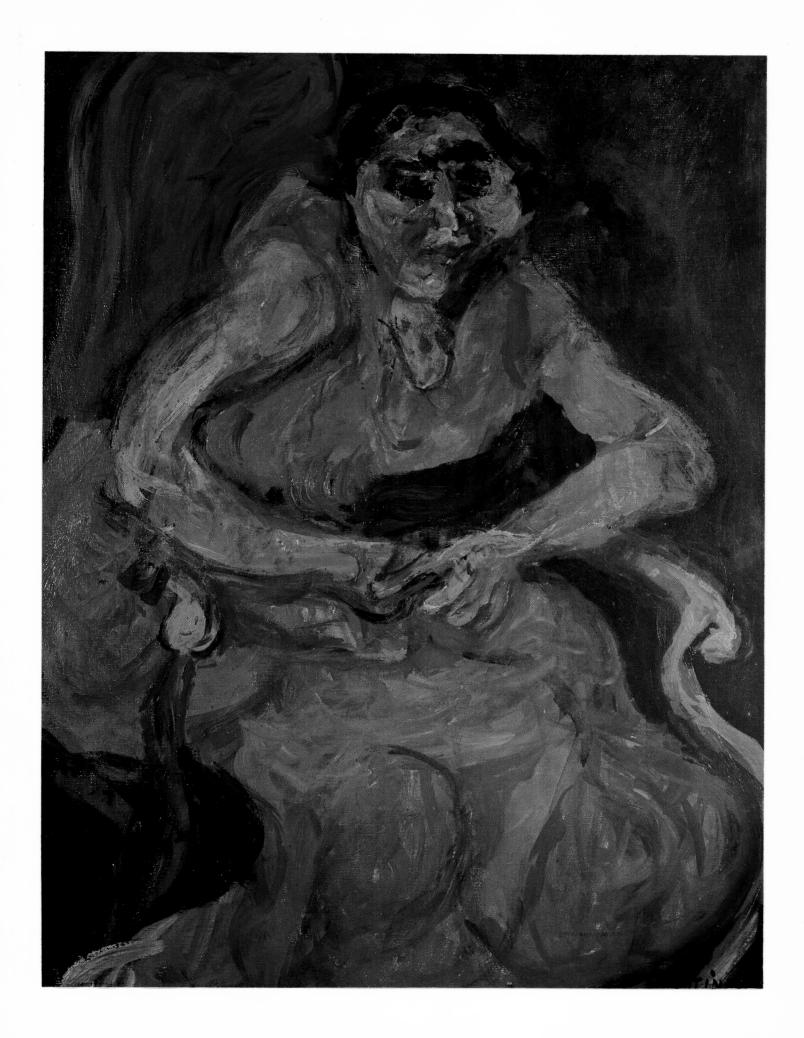

11. FARM GIRL

Painted 1922. Oil on canvas, 31½ x 17½"
Collection Dr. Ruth Bakwin, New York

The tradition of painting the "common people" goes back at least to the Dutch masters of the seventeenth century. More recently Jean-François Millet, and after him Camille Pissarro, rendered peasants realistically—plainly, without ornament or any other embellishment in a manner indicative of their hard, simple lives.

Though domiciled in Paris, Soutine often left the capital for weeks or even months to spend time in rural France. While he was a guest of the Castaings at Lèves near Chartres, it was his hosts' assignment to find him models among the villagers, a difficult task because the artist was so hard to please. Apparently, he disliked using the professional models who filled Montparnasse, particularly those with fine, elegant bodies. As Mlle. Garde recalled, he "preferred children and peasants."

This particular model is representative of *la France qui travaille*. Nothing about her is romanticized. She works hard, remaining on her feet from daybreak till late in the evening, and normally always wearing the same simple clothing in which she is depicted here. Her chores leave her as fatigued and as untidy as she is shown in this sympathetic rendering, which intimates that there is little in life this frail creature can look forward to. The artist had greater rapport with the unsophisticated and unaffected people in the provinces than with the intellectuals with whom his friend Modigliani had mingled. For Soutine never shook off the heritage of the dismal Eastern European village where he spent his childhood. With little formal education, without the good manners (which Modigliani tried to teach him in vain), or the worldliness most Montparnos came to acquire at one point or another, Soutine remained to his end a "man of the people," a *moujik* in outlook, temperament and even, one might say, in his preferred way of living.

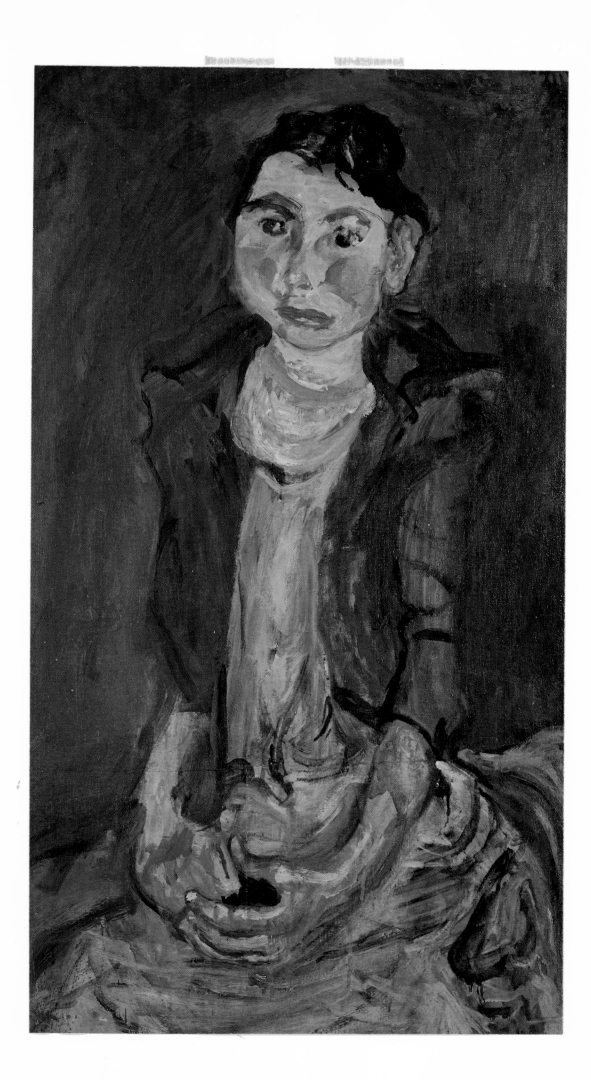

12. WOMAN IN RED

Painted 1922. Oil on canvas, 36 x 25"
Collection Dr. Ruth Bakwin, New York

Soutine's troubled soul is here betrayed more by his colors than by his manner of painting. Especially in early canvases, a distinct strong red is conspicuous. This color, commonly associated with blood, is indicative of temperamental outbursts and signifies anger, cruelty, martyrdom, and other intense feelings. But even in so late a picture as *Chartres Cathedral* (colorplate 42) the foreground is painted in deep red, as though the artist had spat blood before this monument of Gallic glory. One recalls Van Gogh, for whom red signified "those terrible things, men's passions."

This picture is dominated by two colors—the rich red of the dress and the black of the old, enormous hat. Just as the S-shape of the body is exaggerated to the point of rendering the bone structure and anatomy impossible, so the face is a caricature as well, as demonstrated by the abnormal curve of the nose, the asymmetricality of the eyes, the unusual length of the mouth. The left arm is elongated beyond probability (a precedent had been created by Cézanne in the unusually long left arm of the *Boy in a Red Vest;* this was defended by Max Liebermann, who exclaimed: "Such a beautifully painted arm can't be long enough!"). Yet it is conceivable that Soutine, with all his apparently merciless exaggeration, approaching grotesquerie, somehow caught the sitter's real personality (her identity is unknown). Her raised left eyebrow, her coy glance to her left, lend her a roguish look. Hers is a mysterious smile that one might characterize as pathetically ironic. One might even venture to say that the artist expressed some sort of compassion for old age and decay, in the quality of the skin, the arthritic deformation of the hands. Ungainly though this woman is, she has none of the truly monstrous features presented by De Kooning's series of females in the 1950s.

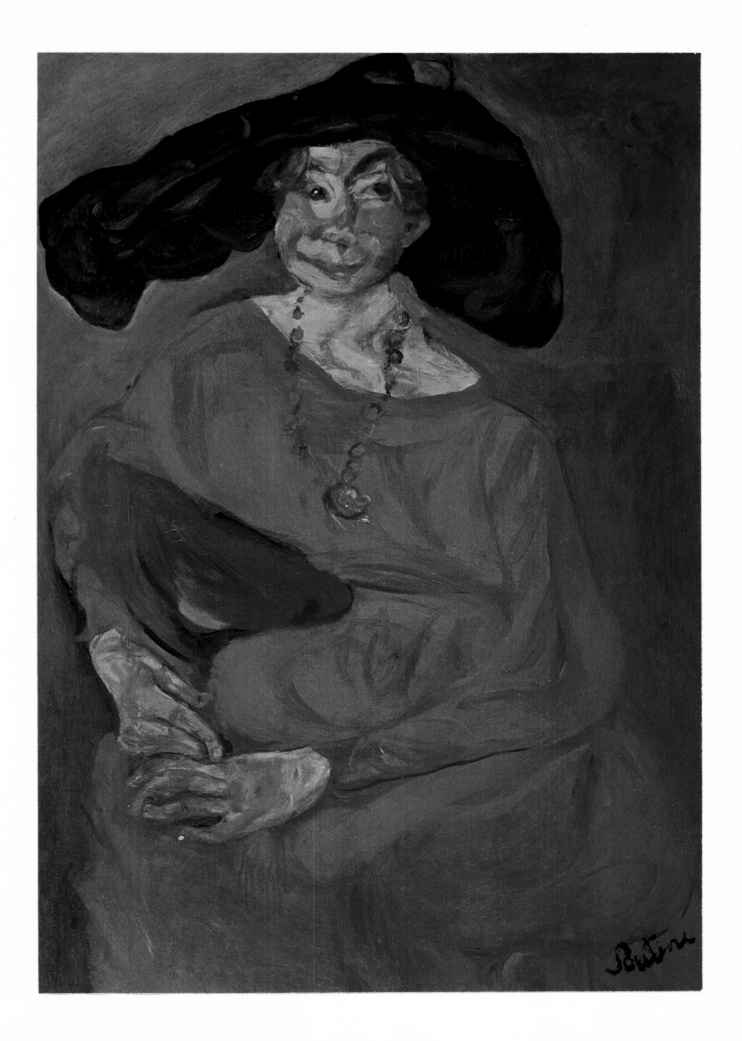

13. PORTRAIT OF A WOMAN

Painted 1922. Oil on canvas, 47 x 22"
Collection Dr. and Mrs. Daniel B. Drachman, Stevenson, Maryland

The picture is also known as "The Widow." Some of the tragic figures of Edvard Munch come to mind. The face of the old woman has something mask-like about it; the hands have the shape of claws, ready to scratch. There is very little attempt at three-dimensional modeling, hence the figure appears flat, almost as if made of cardboard. The brilliant red wall-hanging behind the woman accentuates the "widow's" figure and makes plausible the bits of red that deepen the black of her clothing.

The paint is slapped on thickly, and Soutine does not shrink from the most grotesque distortions. Nevertheless the viewer is granted a real insight into the woman. Here we have a prime instance of the difference between the camera, which offers external knowledge *about* a thing, and the artist, who gives us knowledge *of* the thing.

Gabriel Talphir thus characterizes Soutine: "His voice was the voice that spoke from the burning bush, he was suddenly taken in thrall by phantoms and hallucinations. For Soutine painted only when in a state of complete exaltation, when he had lost all control of his senses, and was intent only upon the hidden voice that impelled him with a mysterious obsession to put paint on canvas." (*Gazith*, Tel Aviv, Vol. 17, No. 195-6)

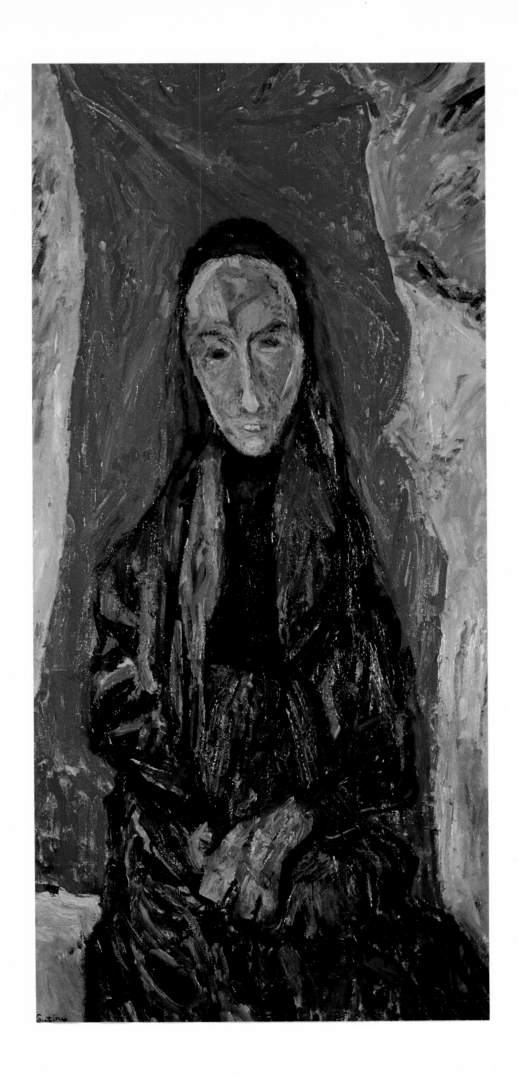

14. THE OLD MILL

Painted c. 1922. Oil on canvas, 26⅛ x 32⅜"
The Museum of Modern Art, New York.
Vladimir Horowitz and Bernard Davis Funds

Although one would be inclined to believe the contrary, Soutine always painted from nature, reserving the freedom to distort features at will. Like his other pictures, this one is undated on the canvas. While it is considered to be a work of 1922, and thus to represent a landscape near Céret, in all likelihood it was painted a year or even two years later and was inspired by Soutine's less troublesome sojourn at Cannes-sur-Mer. For in this landscape the houses and trees appear slightly more stable and less uprooted and thrown in all directions. The objects are seen as through a distorting lens, but the mill sits heavily on the ground although slightly off center. Soutine rendered distance by placing far-away objects nearer to the top of the canvas. The great mass of white plays the dominant role. The three trees to the left lead the eye to this old building and to the much smaller structures above it. A bit of sky appears—the sky is usually absent from the earlier landscapes done in Céret. Note, too, the rich yellow-orange of the road to the right.

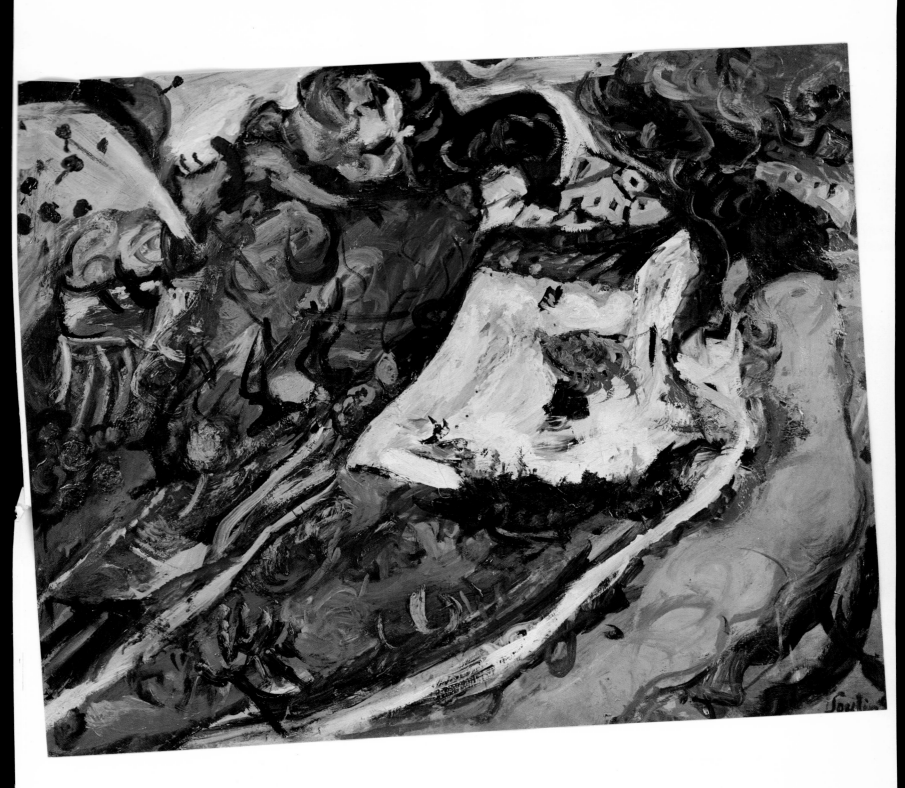

15. LITTLE PASTRY COOK

Painted c. 1922. Oil on canvas, 60¼ x 22"
Portland Art Museum, Oregon

The picture is dominated by a vast sweep of Soutine's favorite color, cadmium red, evoking some glorious curtain or wall hanging. For a change, a carefully drawn chair is visible (the brown shape at the right of the picture is not sufficiently defined to allow any identification of the object). As for the cook, he is a raffish little creature, slightly ridiculous, though the baker's cap, shaped like a crown, lends him a degree of dignity. He stands in a free and easy pose—one leg is put forward, the other stabilizes the figure (and, by implication, the canvas itself). The white jacket looks dirty, but the red shadows may be a reflection of the surroundings.

Soutine's idol, Rembrandt, was criticized for associating with "the lower orders," for enjoying the company of mostly "common people." If Soutine did not actually seek close personal contacts with them, he certainly liked them to pose for him. It is, perhaps, significant that when the Musée National d'Art Moderne in Paris gave Soutine his first large memorial show in France—at the Orangerie, 1973—they selected, for the cover of the catalogue, a picture of a pastry cook similar to this one owned by the Portland Museum. Used also for the show's poster, the *pâtissier* could be seen all over the metropolis.

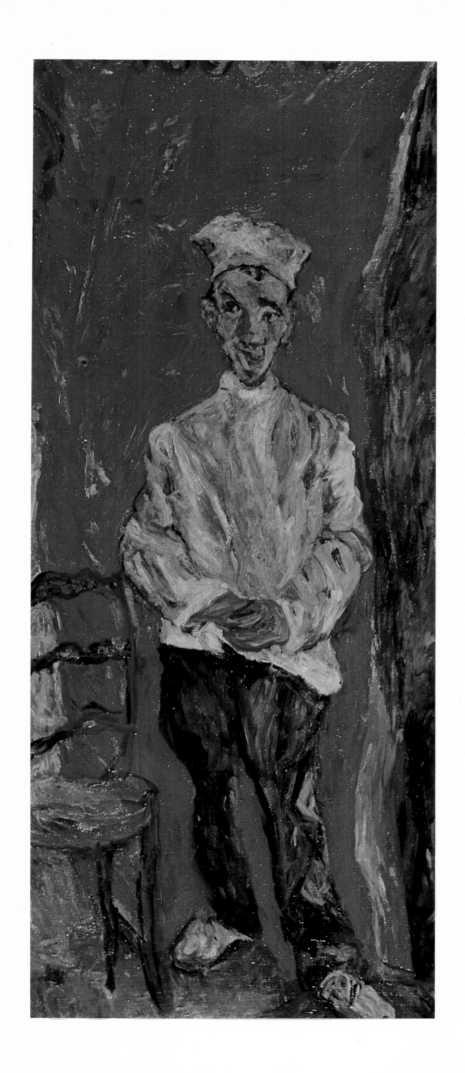

16. VIEW OF CÉRET

Painted c. 1922. Oil on canvas, 29⅛ x 29½"
The Baltimore Museum of Art

Céret, in the foothills of the Pyrenées Orientales, close to the border between France and Spain, is a smiling town with many trees in its winding streets and occasional squares. What a pity it was not discovered by the Impressionists, who could have rendered its charms in a recognizable manner! Picasso, Braque and Juan Gris worked there for a while, but, at the height of the Cubist movement, they were not interested in topographical accuracy in their "landscapes." A painting by Picasso, dated 1911, was thought by one of its owners to be a landscape, because the artist had written "Céret" on the back of the canvas, yet the picture is now called *Accordionist* (Guggenheim Museum, New York). Referring to the fact that many of the lines and shapes in the Picasso work cannot be identified clearly, Alfred H. Barr wrote: "The mysterious tension between the painted image and 'reality' remains."

The same might be said of Soutine's *View of Céret*. While houses, hills and tree branches can be discerned, many details defy definition, and some of the colors, such as the strident reds and oranges, could only have their origins in the artist's pained soul. Everything seems shaken as by an earthquake; there is little space left for the menacingly dark sky. Yet this picture is not as novel in its execution as one might think. D. H. Lawrence wrote about a late Cézanne, which must have been rather tame in comparison: "We are fascinated by the mysterious shiftiness of the scene under our eyes; it shifts about as we watch it … It is not still. It has its own weird *anima* and to our wide-eyed perception it changes like a living animal under our gaze." In Van Gogh's late landscapes everything moves, everything seems to writhe, to coil. Here is also a similarity to works by the masters of the German *Brücke*. Yet, though only loosely connected with the specific subject matter, this oil, with its feverish colors erupting like lava, fully conveys the artist's fervently burning emotions.

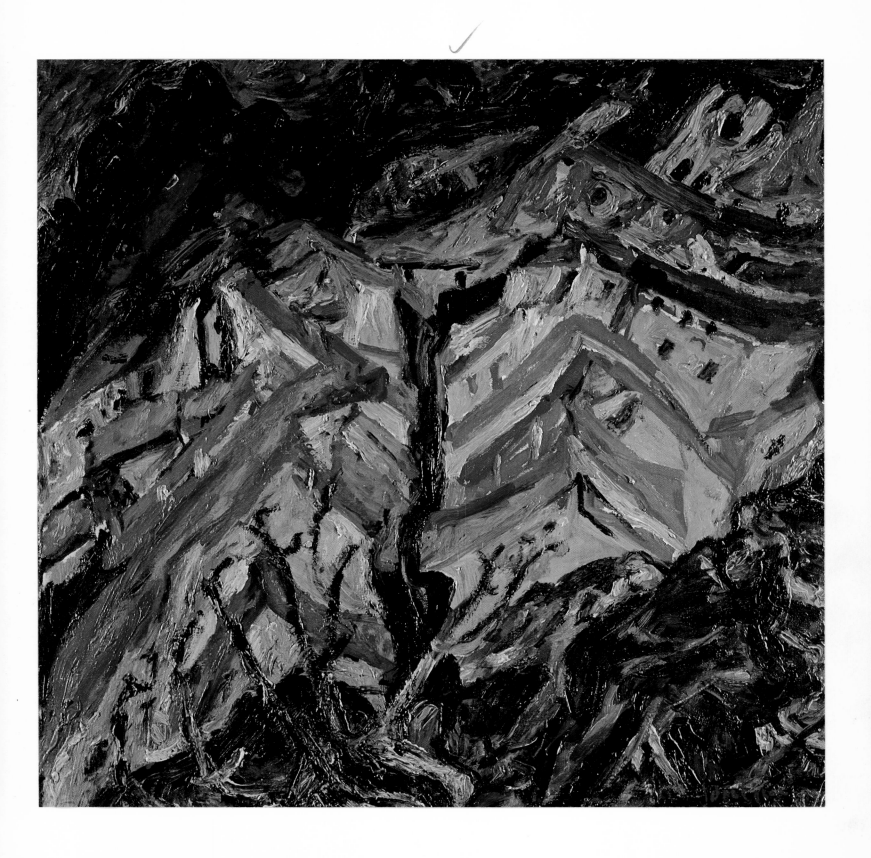

17. LANDSCAPE AT CÉRET

Painted 1922. Oil on canvas, 28 x 41"
Harry N. Abrams Family Collection, New York

This is one of approximately two hundred pictures, most of them landscapes, that Soutine produced during his prolonged stay in Céret in the French Pyrenées. This particular painting is a bit more quiet than other works of the same period; at least the houses and trees are not uprooted, separated from *terra firma*. Still, a demoniacal element appears to have taken possession of the trees, which are like fantastic beings engaged in some weird ritual dance.

This landscape was singled out by the eminent German critic Will Grohmann in his small book, *Expressionists* (New York, 1957). Grohmann's comments are well worth repeating here:

"The *Furioso* of the brushstrokes continues Van Gogh of the late period, the Fauve influence comes later. But Soutine has less faith than the Dutchman. He does not rip up the surface to get to the bottom of the truth; he plows through nature like one pursued. The proximity of the ultimate and his fear of it makes Soutine forget the firm ground of reality."

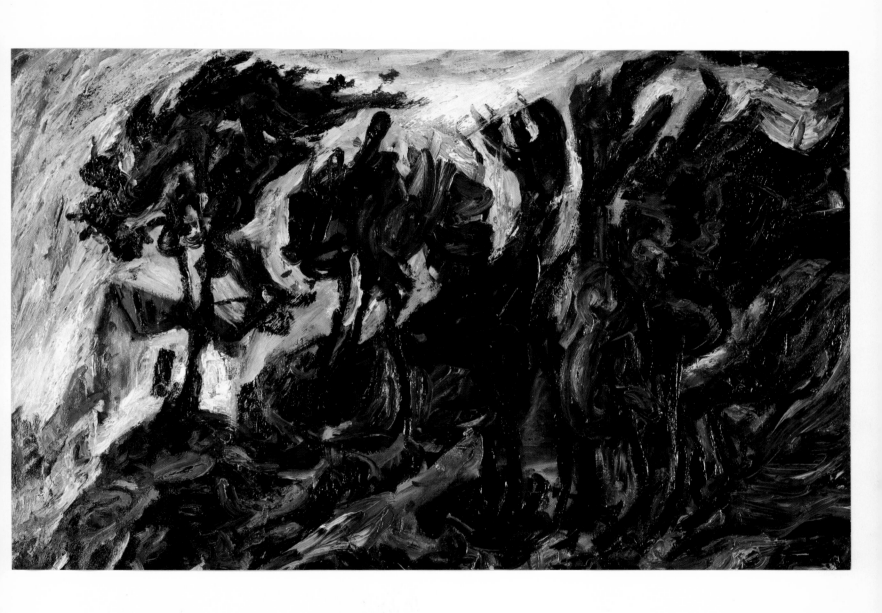

18. SELF-PORTRAIT

Painted c. 1922-1923. Oil on canvas, 31⅞ x 16⅞"
Musée Municipal d'Art Moderne, Paris

This is the second of the two major self-portraits that have survived and whose current ownership is known; a third authentic self-portrait has been reproduced by both Tuchman and Courthion, but in neither case is the whereabouts mentioned. Several other self-portraits (whose authenticity has not been established beyond all doubt) are in French private collections. This one was painted five years after the one in the Pearlman Foundation collection (color-plate 1).

In the earlier painting, the artist stands before a canvas, with an unidentified figure on the back. Here, no object can be discerned. The artist is seated against an indistinct greenish and brownish background. His hands—of whose delicacy Soutine was known to have been proud—are not included in the picture area. Disquieting reds, yellows and greens prevail. The nose is enormous and deformed. The protruding lower lip, painted in a strong red, is as slack as in pictures portraying idiots. The eyes are small and piggish. The one visible ear stands out from the head like a wing. The shoulders are hunched, the arm is unusually long.

Maurice Tuchman has aptly described this picture as "a pitiless, ruthless work, ridden with self-contempt." To judge by surviving photographs, the artist, while not conventionally handsome, was nevertheless not repulsive-looking. Yet this painting is like an outpouring of unmitigated self-hatred, like an ideological suicide. Still, one must bear in mind that Soutine "caricatured" all his sitters, including his benefactress Mme. Castaing and his very few close friends. Hence there was no reason to spare himself if in all his "portraits" he stressed the commonplace, the misshapen and the clumsy, and inserted these elements even where they were not actually to be found. It is the very "ugliness" of this picture that makes it a work of art which cannot easily be forgotten. And while it expresses discontent, it also exudes the energy and strength needed to face the hardships of life and art.

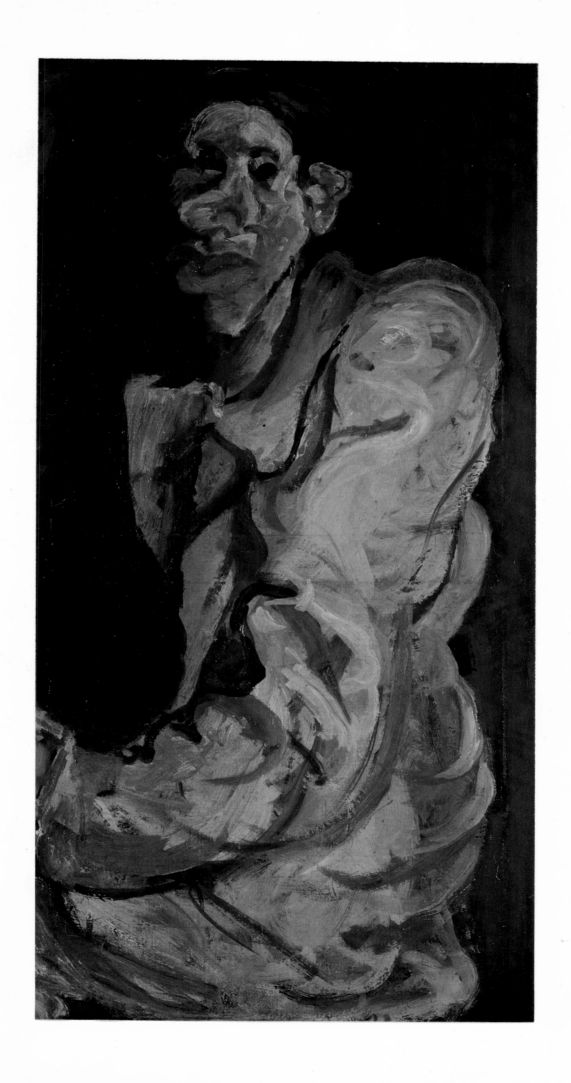

19. STILL LIFE WITH FISH, EGGS, AND LEMONS

Painted 1923. Oil on canvas, 25½ x 31⅞"
Marlborough Fine Art, Ltd., London

Most still-life paintings that involve food present it in a manner that arouses the viewer's appetite, so that he feels like seizing the fruit or other edibles so deliciously displayed. The food Soutine painted, however, is usually unappealing. His early canvases reveal the bitterness of a poverty-stricken artist who hated the food he could not obtain, and his later ones the revulsion of the ulcer sufferer who was unable to eat what he could now afford (he might also have felt some guilt about his starving relatives in Smilovitchi whom he had refused to support).

Here, the fish look very, very dead—almost mutilated. The eggs in their shells and the lemons are understated, less realistically rendered than the small fish. The beauty of this work lies in the brushwork, in the richness of the impasto, the bravura of the use of pigment (note the bits of ultramarine blue around the eye of one of the fish). Tension is created by the contrast between the oval form of the table and the diagonal thrust of the objects upon it.

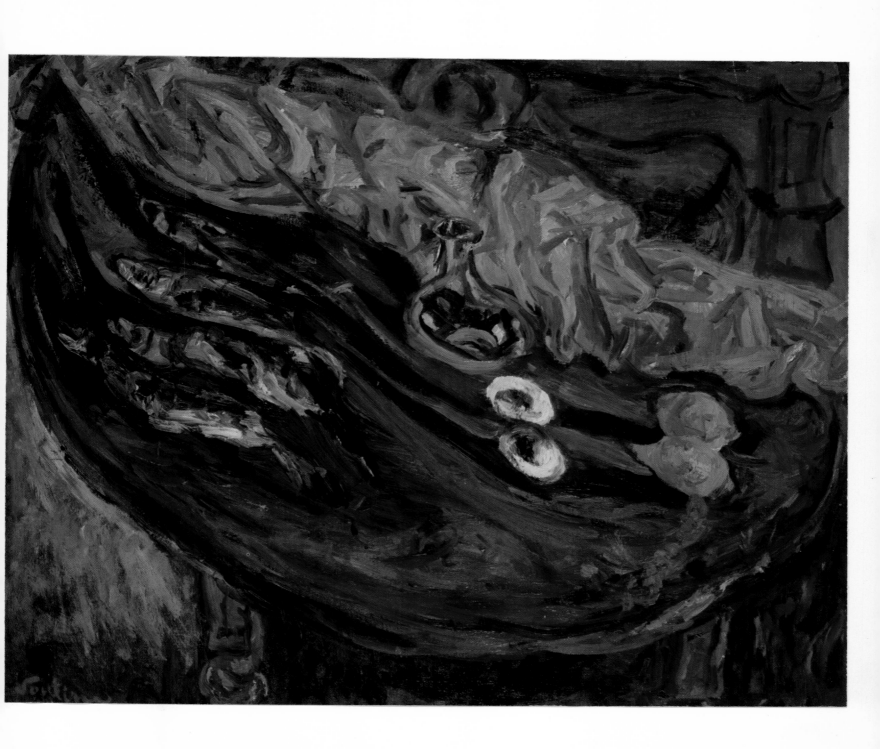

20. PORTRAIT OF THE SCULPTOR MIESTCHANINOFF

Painted 1923. Oil on canvas, 32⅝ x 25½
Musée National d'Art Moderne,
Centre National d'Art et de Culture Georges Pompidou, Paris

Soutine was not usually concerned with the character of the people who sat for him (in this respect he was very different from another Expressionist, Oskar Kokoschka, who tried to uncover the souls of his sitters). The so-called "portraits" were to Soutine mainly pegs on which to hang his own innermost feelings. Yet this particular picture required some twenty sittings over a period of several months!

A sturdy, solidly built man, the sculptor is seated on an ornate armchair as if it were a royal throne. The expression is benign, although the lips protrude, as if to express sullen discontent or sulkiness. The nose is painted in vermilion. The hands are powerful and strong. He is arrayed in sky blue; snowy linen is crumpled around his neck. The whole arrangement is reminiscent of certain pictures by Modigliani, among them his 1917 *Portrait of Jean Cocteau.*

Oscar Miestchaninoff was born in Vitebsk, Russia, in 1886. After studies at the academy in Odessa, he arrived in Paris in 1906 or 1907. He was a member of the Salon d'Automne, and his creations were acquired by several museums. A good craftsman, he clung to the old tradition, using marble, granite, terracotta, and bronze to make graceful pieces of academic sculpture, among them many figures of young women. His work, utterly classicistic, was a far cry from the passionate outpouring of Soutine. Yet Soutine was on as friendly terms with him as the distrustful, suspicious painter could be with anyone. Miestchaninoff spent his final years in the United States, where he raised a family. He died in California in 1969.

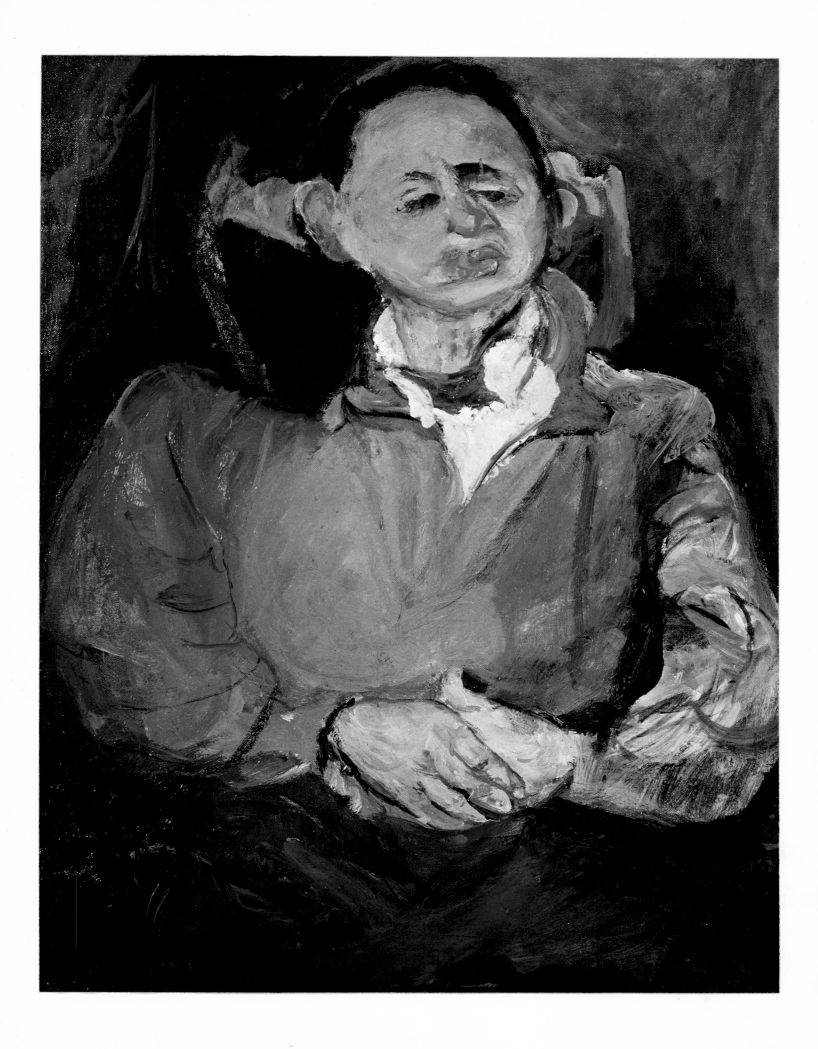

21. LANDSCAPE AT CAGNES

Painted c. 1923–24. Oil on canvas, 21½ x 25¾ "
Collection Mr. and Mrs. Martin Stone, Los Angeles

Cagnes-sur-Mer is a village on the Riviera, in the foothills of the Alpes Maritimes. Delighted with its warmth, the arthritic Renoir had a house built there, in which he spent the last fourteen years of his life. In 1919, the very year that Renoir died, Modigliani and Soutine visited Cagnes. Soutine went back there often between 1922 and 1925. The landscapes he painted at Cagnes are calmer than those he had created at Céret. While they do not exude the charm of a Renoir, they are at least free of the spasms that turn everything topsy-turvy, as if the region had suffered a series of seismic shocks.

In the pictures painted only a couple of years earlier, claustrophobia prevails. Now every object has plenty of space for itself, is surrounded by air, exposed to strong daylight. The white houses, with red-tiled roofs, seem to be moving up a hill crowned with trees. On the road that leads to the summit, the figure of a woman appears to be crawling like an insect rather than walking erect. While in the Céret series objects are almost impossible to define, hardly any sky is visible, and the whole canvas is filled to the edges with centrifugal waves of color, this *Landscape at Cagnes* to some extent returns to the traditions of pre-Expressionist art.

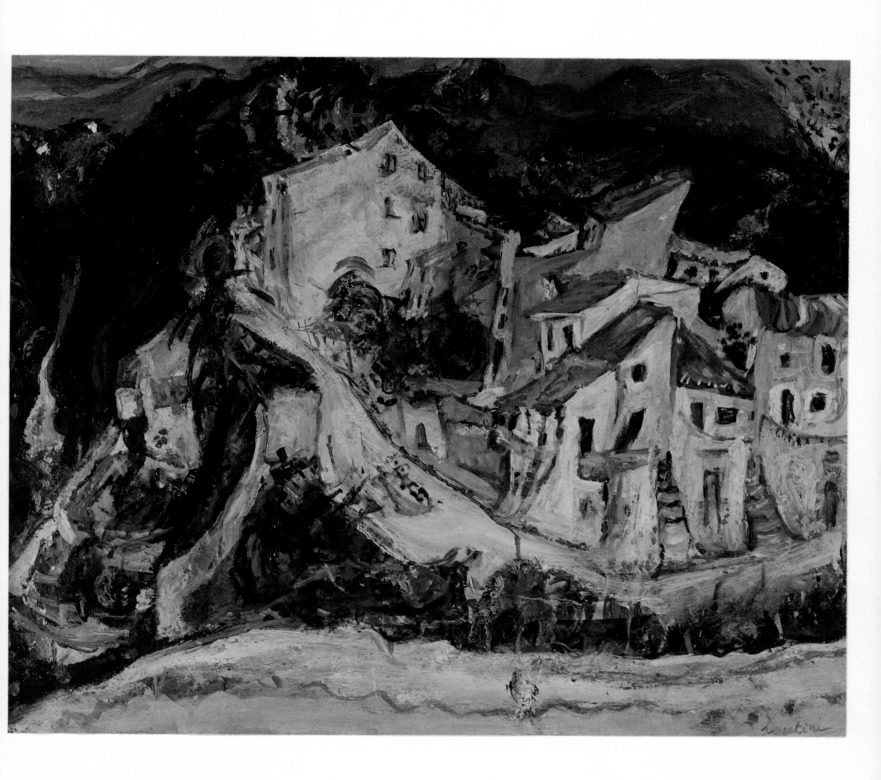

22. STILL LIFE WITH RAY

Painted 1924. Oil on canvas, 32 x 39½"
Perls Galleries, New York

The ray, also known as the skate, is a fish that has long attracted painters with its weird, unforgettable features. Chardin painted several kitchen still lifes with rays, one of which, *Rayfish, Cat, and Kitchen Utensils* exhibited in 1728 on the Place Dauphine, so impressed the Academicians that they invited him to stand as a candidate for the Academy with this particular picture. There, the fish is observed carefully and even the most minute detail is rendered with Chardin's characteristic precision; yet despite the discreet and restrained manner of painting, the dead creature somehow comes alive.

The Belgian painter James Ensor was also fond of portraying this fish. Describing his painting *The Skate* of 1882, Charles Sterling says that it looks "like a strange tissue of asbestos fibers, a shapeless mass of white fluorescence from which two bright, upturned eyes stare out piercingly." Discussing an Ensor on the same motif, painted a decade later, Sterling calls the fish "monstrously human with its cruel, sardonic face." (*Still Life from Antiquity to the Present*, 1959)

Soutine, who painted rays often, shows one here dominating the scene like an Ubu Roi. Even when in its natural habitat, the flat-bodied ray, with its pectoral fins developed into large "wings" that ripple as it swims, is an odd enough phenomenon. But here its small, mask-like face is endowed with a menacing, demonic quality. Coloristically, the picture is a gem thanks to the strong, juicy red of the tomatoes and the fluently painted objects around the fish, which somehow stands up without any visible support.

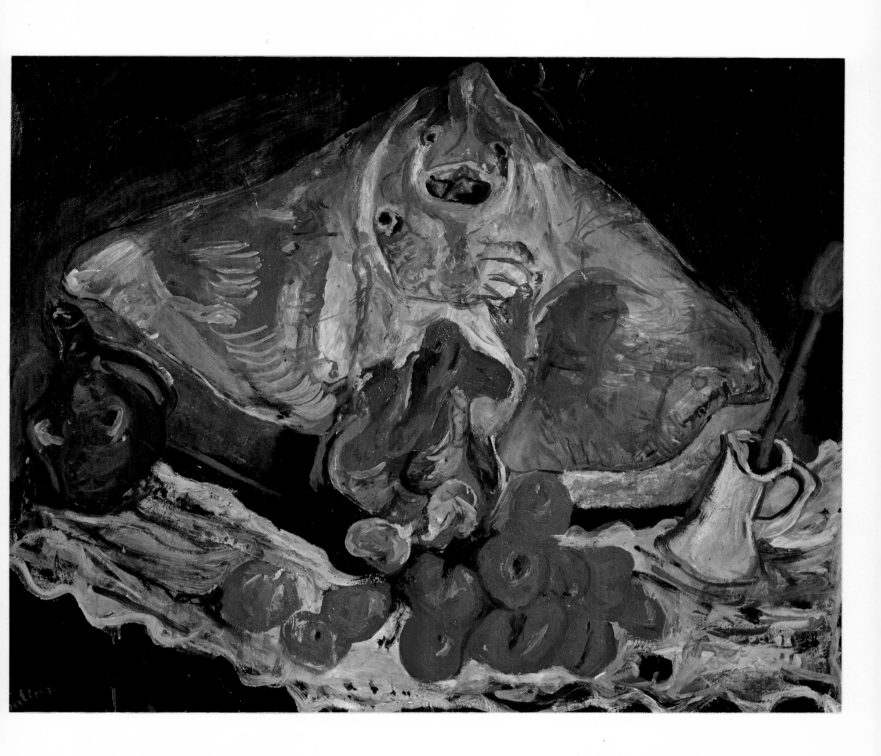

23. DEAD FOWL

Painted c. 1924. Oil on canvas, 43½ x 32"
The Museum of Modern Art, New York
Gift of Mr. and Mrs. Justin K. Tannhauser

Around 1925, Soutine painted more than twenty versions of fowl hung by the head or the legs from a hook on the ceiling or the wall. Childhood memories may have influenced the artist when he painted the plucked fowl hanging from a hook, a frequent theme with him. His birds are not shown in the relaxation of death, but frozen in the last struggle; they seem to have just emitted their last cry of agony, and their legs and wings are stiff with pain. Soutine complained that his parents once punished him by locking him into the chicken coop. One might see in this series of pictures a belated revenge on the excitedly fluttering chickens that frightened the little boy. Perhaps he repeated this theme so often to make sure that they were no longer alive.

This theme was also favored by other painters, among them Dürer and Rembrandt, who painted the dead birds with great emphasis on detail. In Soutine's pictures, however, all we have is the dramatically suspended shape. The specific form is much more clearly defined than in his pictures of fish. Incidentally, in *Humboldt's Gift* by Saul Bellow, one of the major characters refers to "an eviscerated chicken by Soutine."

Though we know that this bird is lifeless, it appears to be engaged in some hysterically wild dance against the Prussian blue of the wall, as though the artist had wished to depict the animal as a symbolic victim of cruelty and torture. Just as the fish in Soutine's pictures seem to be writhing on the plate, so these birds are convulsed in the process of dying. One is reminded of people strung up by the neck in a lynching.

In all likelihood, Soutine had observed the *kapparah* ceremony in his parental home. It was practiced yearly on the day before the Jewish Day of Atonement. A chicken was taken by the legs in one hand and swung over the head, while certain penitential prayers were recited, designating the bird as a sin-offering. The animal, after having been used in this form of mitigated sacrifice, was eventually slaughtered and eaten, or given away to a poor family. One cannot help wondering whether Soutine in Paris might not have dimly recalled this gruesome ritual.

24. PORTRAIT OF A MAN WITH A FELT HAT

Painted c. 1924. Oil on canvas, 36 x 28"
Collection Dr. and Mrs. Joram Piatigorsky, Bethesda, Maryland

In this picture a great deal more is stated about the locale in which the sitter is presented than in most of Soutine's portraits. On a small table beside the man are placed a crumpled hat and an apple. Attention is strongly drawn to the background by the swirling red blotches, which appear to push the man's head toward the center, and by the strange Art Nouveau pattern in the background.

The overly long arm, stretched toward the edge of the canvas to form a triangle, returns to meet the other slender, drooping, well-defined hand. Hat and table give the composition its balance; without them, it would appear lopsided.

Who was this "Man with a Felt Hat"? We will never know. Soutine, in common with his friend Modigliani, did not care whether the person he chose to paint was famous or even had a past that showed any kind of accomplishment or achievement.

25. BOY IN BLUE

Painted c. 1924. Oil on canvas, 36½ x 29"
Collection Mr. and Mrs. Henry F. Fischbach, New York

When Van Gogh painted a portrait of his postman friend Roulin, he used color "arbitrarily" to express his feelings "forcibly," instead of endeavoring to record what his eyes actually saw. On the whole, Vincent, as well as Soutine, clung to traditional portraiture, yet they both introduced emphatic exaggerations of forms and colors. Here, Soutine fully exploits the expressive properties of the Prussian blue and ultramarine in the boy's clothing.

The boy is made to look like a monkey. He appears to have enormous shoulder pads. The hands are grotesquely large and red, and there seem to be six fingers on one hand. While part of a chair is noticeable, the boy does not really appear to be sitting; he gives the impression of dangling from the ceiling like a marionette without any definite support.

26. WOMAN KNITTING

Painted 1924–25. Oil on canvas, 32½ x 23½"
The Norton Simon Foundation, Los Angeles

In the last century, many sentimental pictures of women engaged in pleasant domestic activities were produced, because they were much in demand. Young Edvard Munch rebelled, and wrote in his journal in 1889: "No longer shall I paint interiors, and people reading, and women knitting. I shall paint living people who breathe and feel and suffer and love. People will understand the sacredness of it [this new kind of painting] and will take off their hats as though they were in church."

Soutine's picture is an expression of a state of mind rather than a sentimental genre painting. The bony old lady's grin resembles his own; it is not unfriendly, but not warm, either, and it suggests amused resignation rather than any real joyfulness.

Like most of Soutine's "portraits," this has a more or less frontal, symmetrical and pyramidal composition (unlike classical art, from Poussin to Cézanne, Expressionist art arouses interest more by its painterly vigor than by a conceptual basis or elaborate formal values). Two colors prevail: the rich Prussian blue of the dress and the viridian green, mixed with ocher, of the background. The halo-like yellow spot above the head accentuates the hat, whose excrescences are echoed by the big curves of the hunched shoulders and the billowing on either side of the skirt.

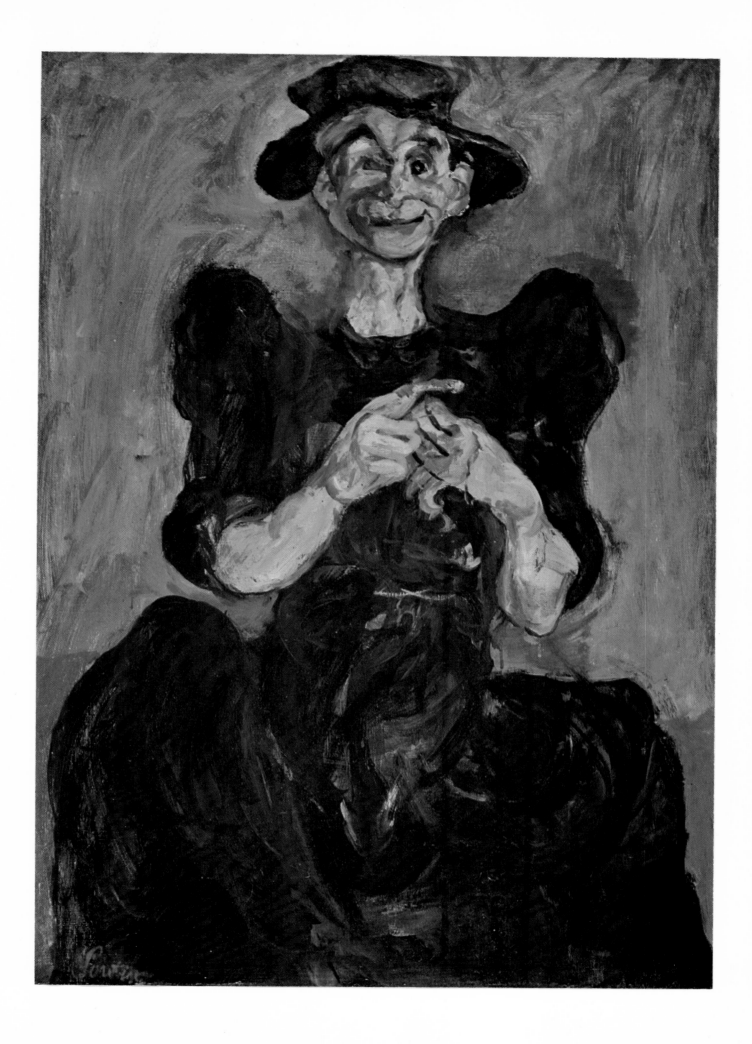

27. THE STUDENT

Painted 1925. Oil on canvas, 28⅝ x 23¾"
The Evelyn Sharp Collection, Los Angeles

This young man is seated on a simple chair; he clasps his own arms above the elbows in an uneasy, tense manner. One almost has the feeling that he is gripping his body to make sure that he is still present, that he is not going to be taken away. Note the lush manner of painting, and the varieties of green, white and red mixed into the background. A few strokes of red, corresponding to those in the student's cap, lend a certain form and contour to the jacket.

In many European countries university students were required to wear a distinctive uniform, as this sitter does. In all likelihood Soutine wore a corresponding uniform when he attended the Academy of Fine Arts at Vilna. Soutine liked to paint people in professional uniforms, secular or clerical.

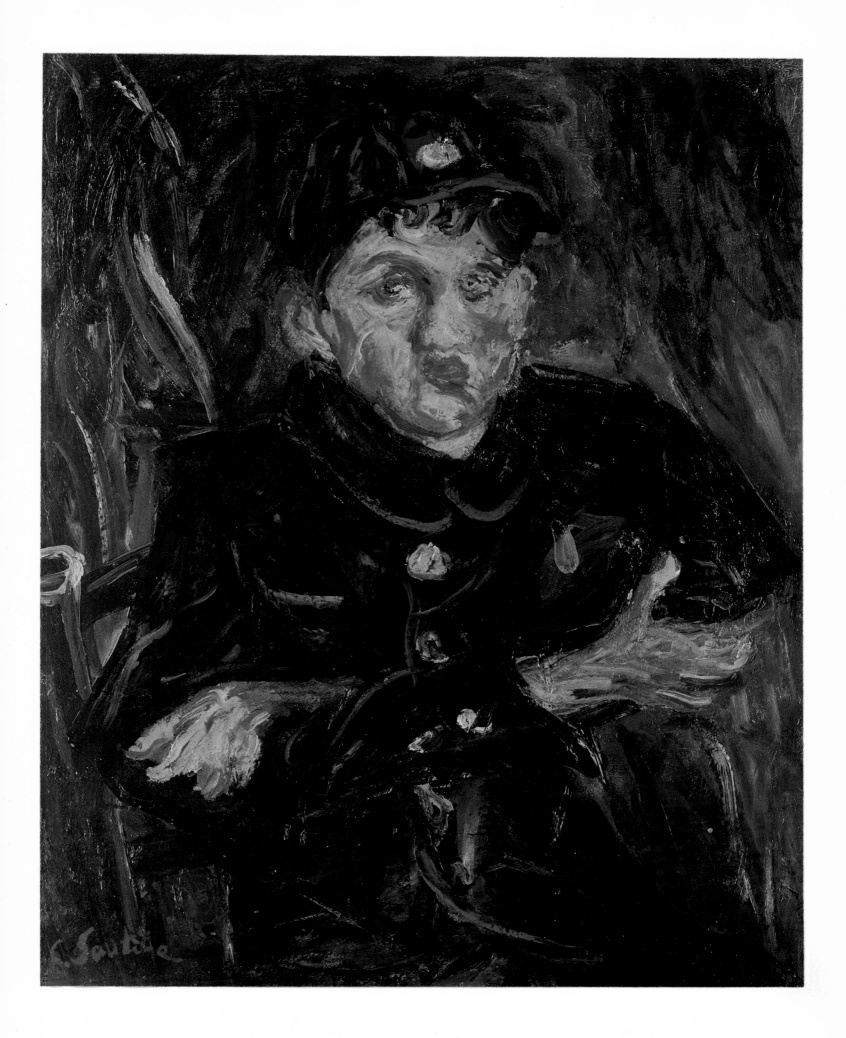

28. THE COMMUNICANT

Painted c. 1925. Oil on canvas, 32 x 18¾"
Estate of Edward G. Robinson, Beverly Hills

This little girl is ready for her first communion, the Christian sacrament commemorating Christ's Last Supper. For this solemn rite, the sharp-faced girl is dressed in the traditional white gown, white gloves, and white flowers on her headgear. White, of course, symbolizes innocence and purity. Here, the cold white is made warmer through the addition of yellows and viridian greens. The Prussian blues blended with the white of the gown at the bottom left of the canvas create a slight three-dimensional recession.

The frothy dress, which spreads over most of the canvas, is superbly painted (it rivals the white garments of the actor Gilles in Watteau's portrait). There are as many nuances of white here as one finds in the early views of Montmartre by Utrillo. An unusual feature is the ornamented background. In most of Soutine's portraits the figure is cut into by the frame, but here, surprisingly, it is given completely.

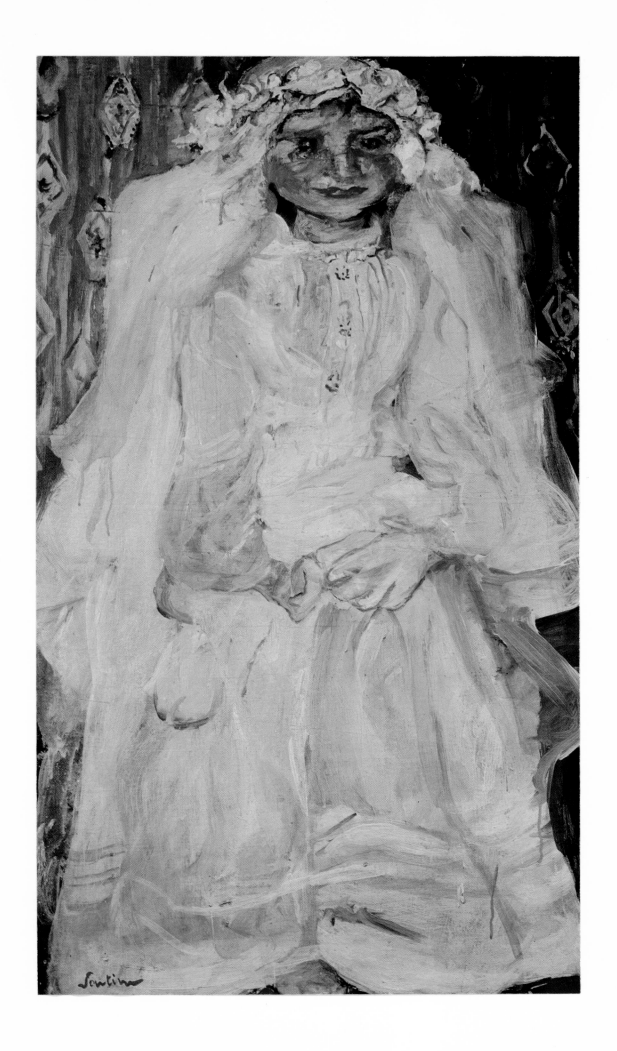

29. CARCASS OF BEEF

Painted c. 1925. Oil on canvas, 55¼ x 32⅜"
The Albright-Knox Art Gallery, Buffalo, New York

Soutine was not the first artist of importance to occupy himself with this grisly theme. Rembrandt's *Slaughtered Ox* of 1655 depicts a disemboweled carcass hanging on a wooden frame in a butcher's cellar. The Louvre acquired this picture in 1857 for only a small sum, since the subject was considered shocking and no high bidders were found at the sale. It was admired by Delacroix, who copied it, and by Daumier, who was inspired by it to do a series of butcher-shop scenes. Quite independently, Chagall, whose maternal grandfather was a kosher butcher, painted pictures with carcasses of beef.

An ardent admirer of Rembrandt, Soutine painted several versions of this, of which three others are also in public collections: the Musée de Peinture et de Sculpture in Grenoble, the Stedelijk Museum in Amsterdam, and the Minneapolis Museum of Arts. This picture is larger than most Soutines; it is perhaps the most startling of his works. Its genesis is told in a story handed down in many variants. It appears that Soutine procured the entire carcass of a steer and hung it in his studio until it developed a stench that drove the neighbors to call for police intervention; luckily the officers defended the artist's right to his "subject."

In Rembrandt's picture, a young woman emerges from the shadows with a smile. In Soutine's painting, only the spread-eagled flayed animal is visible, a frightening orchestration of reds, blues, yellows—colors as rich, as luminous, as those of a stained-glass window in a medieval cathedral. The old picture in the Louvre and the modern one in Buffalo have much in common, especially in their intense, broad brushstrokes. But Soutine dispensed with all details of setting, and placed the huge chunk of meat against a free-flowing sea of blacks and dark blues.

Soutine is quoted as having boasted: "In the body of a woman Courbet was able to express the atmosphere of Paris—I want to show Paris in the carcass of an ox." If he wished to convey the brutality of the metropolis, he succeeded astonishingly well.

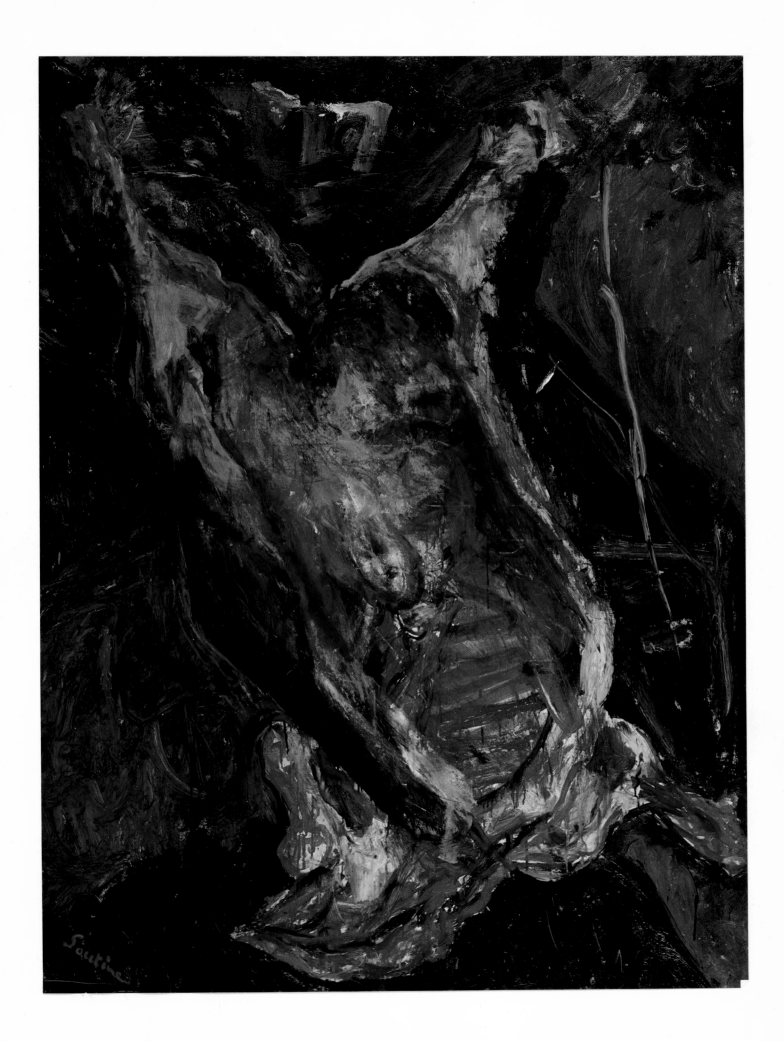

30. RABBIT

Painted 1925–26. Oil on canvas, 28½ x 18⅞″
Collection Mr. Eric Makler, Philadelphia

Dead fowl, hares, rabbits, and other small game appear in still-life paintings from the sixteenth century onward. These objects have traditionally been depicted with considerable concern for rendering all details with the utmost accuracy. This was especially true of Chardin, who often painted hares or rabbits, along with a variety of wild fowl and kitchen utensils. Charles Sterling's description in his book on still-life is apt: "When Chardin set to painting the coat of an animal, glistening in broad daylight, he did not halt till, by the alchemy of his brush, it had become fur and foam at the same time."

Although Soutine admired Chardin, many of whose works he saw in the Louvre, his own treatment of the rabbit is diametrically opposed. While the general shape of the animal, hanging by its hind legs, is basically correct, no attempt has been made to come even close to the natural color. Like a ghost, this greenish creature appears in the midst of a bluish mass without any hook from which it could be suspended. To the right, the general outline of the animal is repeated in dark blue, as a spectral shadow.

31. PAGE BOY AT MAXIM'S

Painted 1927. Oil on canvas, 60⅜ x 26"
The Albright-Knox Art Gallery, Buffalo, New York

Soutine was attracted by the scarlet of the uniform, and also by the emotional qualities of its wearer. While the livery gave the artist a chance to indulge his enormous gifts as a colorist, he was also able to identify with this proletarian and his frustrations. The face is grotesquely twisted; the large red ears stand out from the head like wings. The forward movement, the open hand extended for a tip, suggests a class of people insecure in their jobs, forced into inevitable stances of humility and servility.

Soutine often painted these loose-jointed homely youths with twisted noses and pinched waists, their alert faces often showing a hint of a sneer (contempt for the "higher" class masking the fear of the obsequious). Regarding the frequency with which the artist painted a variety of employees of nightclubs, hotels and restaurants, Monroe Wheeler made this pertinent remark:

"What a boon for Soutine that the servant class of France should have kept so many archaic styles of garment, fancy dress without frivolity, which enabled him to strike that note of pitiable grandeur that was compulsive in his mind and heart, and thus avoid our modern drabness."

Maxim's is one of the oldest and most famous deluxe restaurants in Paris.

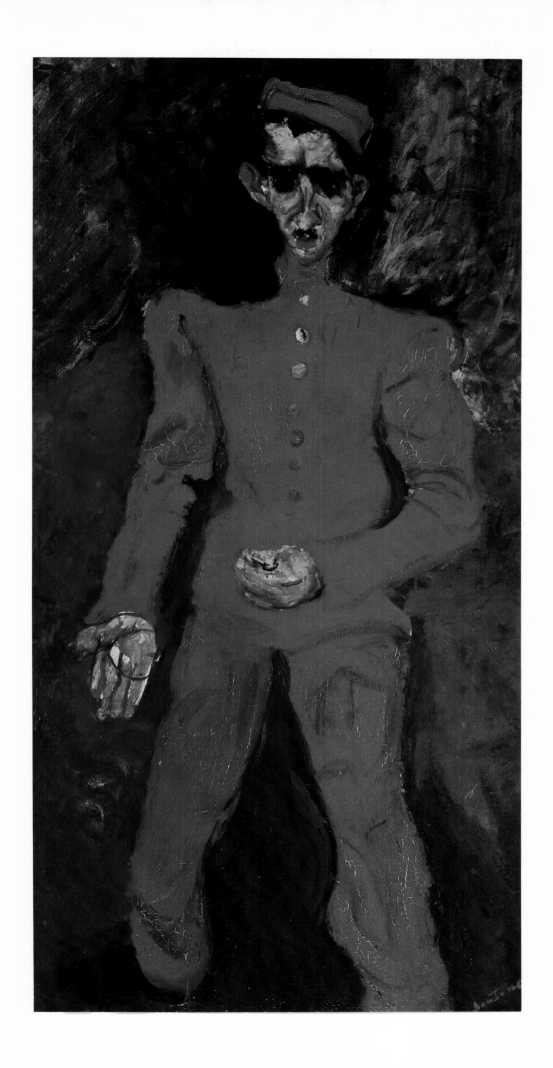

32. THE PASTRY COOK

Painted c. 1927. Oil on canvas, 30⅛ x 27¼"
Collection Mr. and Mrs. Sidney F. Brody, Los Angeles

The stark white of the cap and garment engaged Soutine in several studies of this sitter. In an earlier version (colorplate 15) owned by the Portland Art Museum (Oregon) he is seen full-length next to a chair, complete from the crown-like cap to the tips of his shoes (a rarity in the work of Soutine, who preferred to have the frame cut off legs or arms, or even all the limbs). In another picture, formerly in the collection of Mme. Jean Walter, Paris, the young cook is enthroned on a chair and is clutching a red kerchief.

In the painting reproduced here, he is seen standing in the pose most frequently struck by Soutine's models—hands firmly on hips. An early version on the same theme caught the attention of the American collector Albert C. Barnes in the winter of 1922–1923, when he saw it in the home of the dealer Paul Guillaume. It led him to seek out the artist and buy all the paintings in his studio.

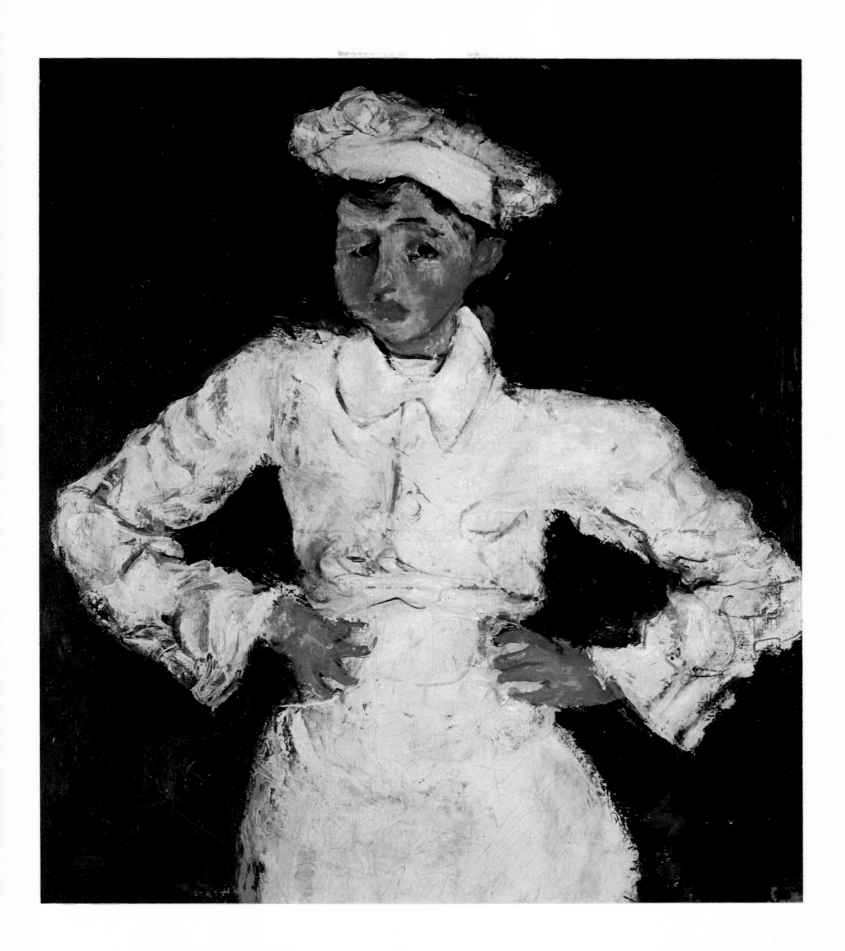

33. THE GROOM

Painted c. 1927. Oil on canvas, 38⅝ x 31¾"
Musée National d'Art Moderne,
Centre National d'Art et de Culture Georges Pompidou, Paris

Raymond Cogniat wonders whether one might "read into this portrait an attempt on Soutine's part to achieve a geometrical pattern." But he is more inclined to think that the artist, who had no use for theories, was guided "by instinct rather than by intellect," and that "this curiously disjointed figure stems rather from the artist's emotional response than from any thought-out schema."

There is movement in this figure, which sits without any visible support. The cadmium red of the uniform dominates the picture; the light Prussian blue at the top lends diversion, as the background is otherwise dark. While the eyes are desolate, the mouth is rather voluptuous. In character, this page boy is very similar to the one at Maxim's (see colorplate 31).

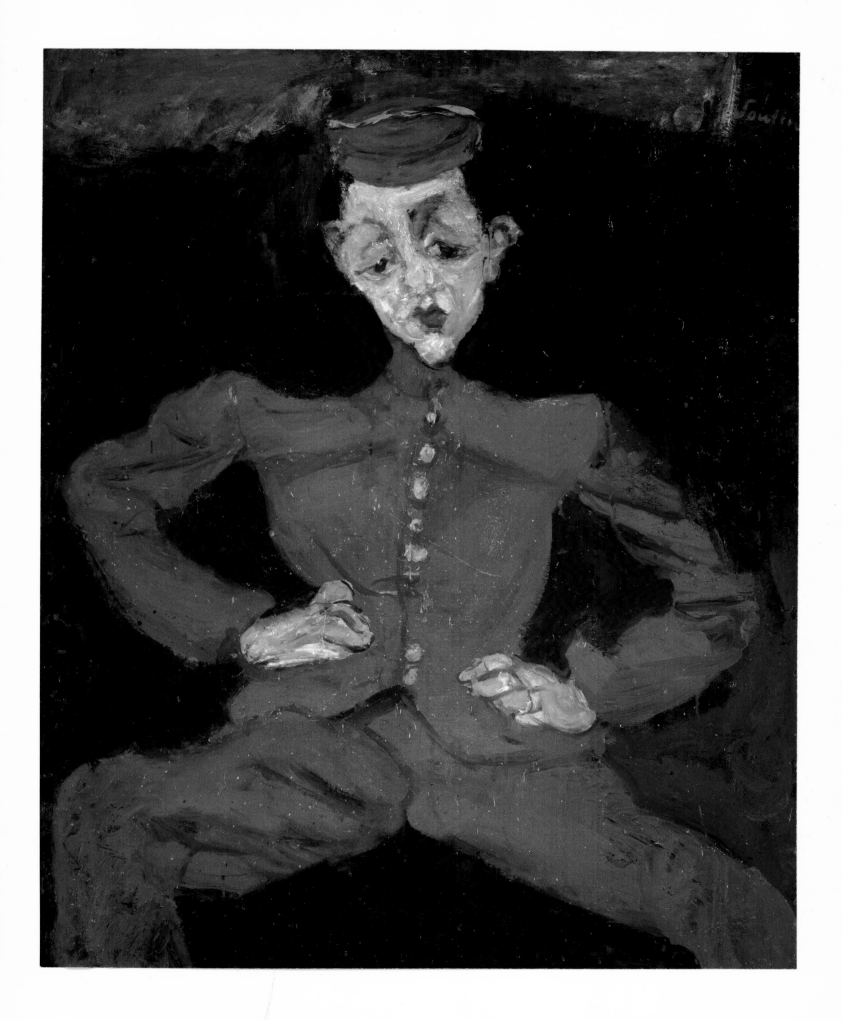

35. PORTRAIT OF MADAME CASTAING

Painted c. 1928. Oil on canvas, 39⅜ x 28⅞"
The Metropolitan Museum of Art, New York
Bequest of Miss Adelaide Milton de Groot (1876–1967), 1967

In the catalogue of a Museum of Modern Art exhibition, 20th Century Portraits, Monroe Wheeler wrote:

"The subject of this exceptional portrait is the wife of his [Soutine's] chief patron and collector for many years. It is what must be called an unflattering likeness but it shows many of the qualities which have led art lovers, especially in France, to think him a great artist: the vehement statement of personal vision, the burning and palpable color, the directness of design, the almost awe-inspiring earnestness. All his painting, even when his subject is a woman of the world, is full of feeling for the distress and the innocent ugliness of poor humanity."

Madeleine Castaing—widow of Marcellin Castaing and co-author, with Jean Leymarie, of a volume on Soutine—is indeed a woman of the world. The well-to-do Castaings met the artist, then a starving and utterly obscure bohemian, at the Café de la Rotonde in Paris in 1919. They wanted to buy a picture from him, but he angrily stalked out, in the belief they were making a mere gesture of charity. Five years later, there was a more successful meeting. Gradually, Soutine came to be as close to them as he could be to anyone. He often spent his summers working at their country home near Chartres. Over the years she and her husband assembled what appears to be the world's finest and most comprehensive private collection of Soutines.

This picture is traditional only in its pose. Mme. Castaing's round face is made triangular, and one would never guess that the sitter in her youth was quite pretty. The woman—the only one of Soutine's sitters shown smoking—appears less twisted, less distorted than the subjects in earlier "portraits." Exceptional, too, is the care devoted to the rendering of the dress. The erstwhile violence is gone. But the brooding expression with the downcast eyes which one also finds in the portrait of the actress Maria Lani (colorplate 38) has persisted. Incidentally, the model is depicted at a distance farther from the artist than usual.

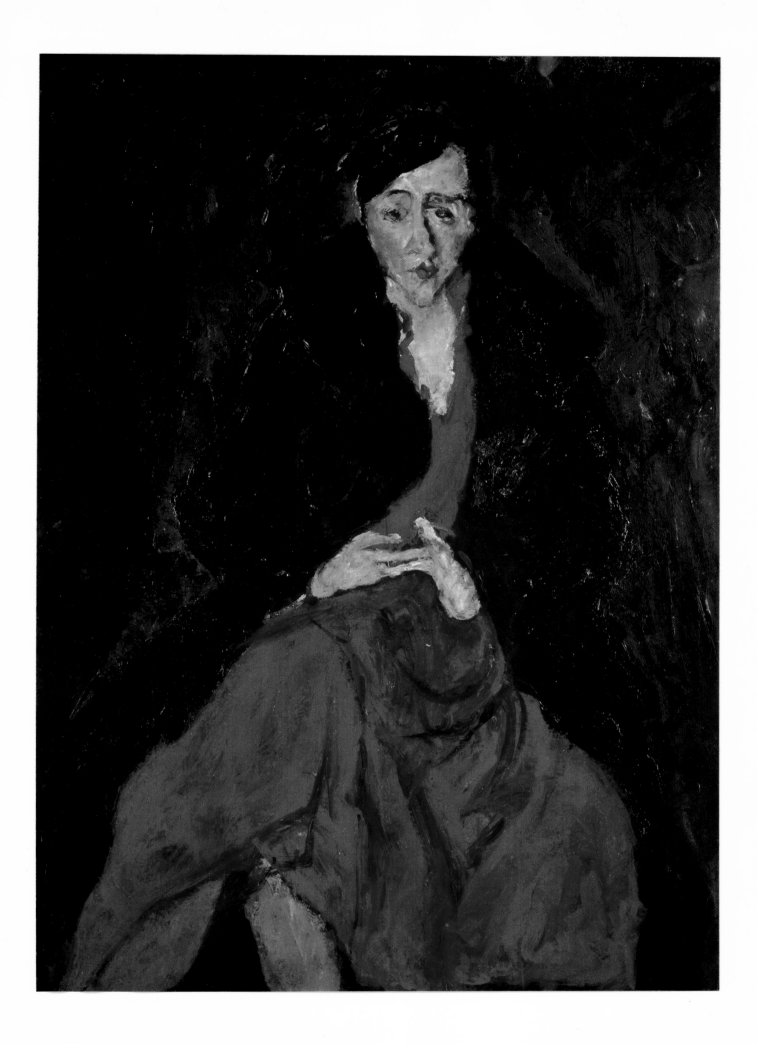

36. SMALL TOWN SQUARE

Painted 1929. Oil on canvas, 28 x 18¼"
The Art Institute of Chicago, Joseph Winterbotham Collection

It is instructive to compare this picture of 1929 with another bearing the same title, done almost a decade earlier. In the picture of about 1920 (Pearlman Collection, New York) everything—houses, trees, hills—looks uprooted as if tossed helterskelter by an earthquake. The later picture is calm by comparison. Nothing moves except for the snake-like bands of color.

This gnarled old tree, which may look like a monster to us, looked to the artist "like a cathedral" and stood, and perhaps still stands, in the center of the town of Vence, in the south of France. It is a quiet French square, yet Soutine, giving vent to his own agitation, turned it into the backdrop for some theatrical presentment of lurking danger. On the green bench encircling the tree, a man can be discerned. He is a small, almost indistinguishable, part of the whole as is the case with figures in interiors by Bonnard, whom Soutine admired, and especially Vuillard. The giant ash tree looms over the small houses that curve around the square at the entrance to the old hill town. The eye is led to a narrow street that recedes into the distance. While the picture may be "topographically" as correct as anything Soutine painted, the coloristic treatment and the surrealistic rendering of the tree and its branches make the picture appear as fantastic as one of the settings for the Ballets Russes by the color magician Léon Bakst.

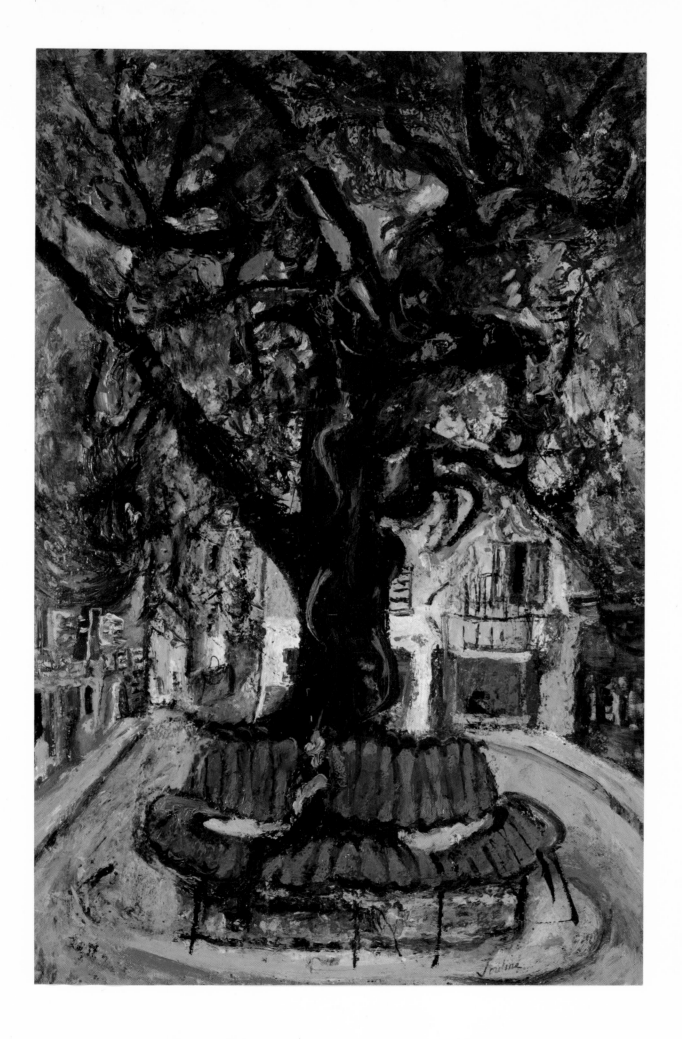

37. BOY IN BLUE

Painted 1929. Oil on canvas, 30 x 23"
Collection Mr. and Mrs. Ralph F. Colin, New York

We do not know who the sitter was. While Modigliani often wrote at least the first name of a sitter into the picture, usually in large capitals, Soutine left us no information as to the identity of his models. Often photographs of Modigliani's sitters have come down to us, enabling us to ascertain to what extent the artist took liberties with the features to enhance and increase the picture's aesthetic validity. As for Soutine's *Boy in Blue*, we can only guess that we have here a speaking likeness, a portrait in the truest sense of the term.

In the paintings of the early 1920s, Soutine's people appear to be rendered in a fashion that some observers have classified as "caricatural." The figures are like flickering flames. Here, a state of timelessness, of permanence, is sought. The colors are subdued; there are no striking contrasts between one color and the next, adjoining one. Deep blues and dark greens prevail. A bit of three-dimensionality is achieved by recessive shadows. The shape of the figure tends toward the rectangular rather than the usual triangular composition. While this is one of Soutine's most quiet pictures, the sitter is hardly at ease. His thick round hands are clasped, and his face is full of apprehension. He looks as if he had his bicycle waiting outside, and would jump on it at a moment's notice, should the artist frighten him in any way.

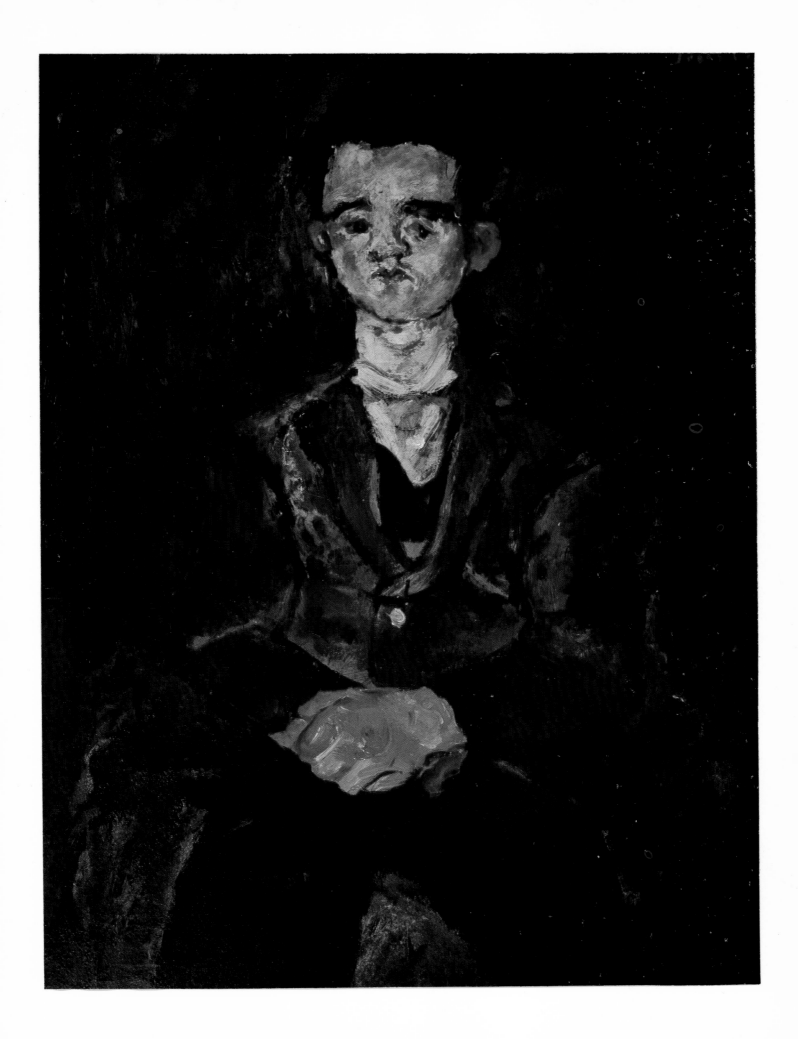

38. PORTRAIT OF MARIA LANI

Painted 1929. Oil on canvas, 28⅞ x 23½"
The Museum of Modern Art, New York
Mrs. Sam A. Lewisohn Bequest

Here, as in the picture of Mme. Castaing (colorplate 35), there is calmness, quiet, sophistication, introspection that one does not find in Soutine's more typical, more Expressionist portraits. One is reminded of Modigliani's elongated faces, but Miss Lani's face is more triangular, the chin coming to a sharp point. Also reminiscent of Modigliani is the sketchy treatment of the body, focusing attention on the clever face, with its firmly drawn eyes, arched brows, and determined lips.

As for the sitter, biographical accounts differ. According to one source, she was a native of Warsaw, studied at Max Reinhardt's acting school in Berlin, and became a member of the Théâtre Gaston Baty in Paris. Another report is less charitable: she was a secretary from Prague, whom two con men had managed to pass off in Paris as a great star of the Czech cinema. A clever publicity campaign persuaded fifty celebrated French artists—among them Chagall, Derain, Despiau, and Matisse, as well as Soutine—to ask her to pose for them. An album containing photos of these paintings and sculptures was issued with a preface by the poet Jean Cocteau, who hailed a mysterious quality that all artists discovered in her:

"Every time you take your eyes off her, she changes. You see her in turn as a young girl; as a ravaged woman, a college girl, a cat with thin lips, thick lips, a slender neck, a herculean neck, non-existing shoulders, broad shoulders, with Chinese eyes, with the eyes of a dog. I have forgotten to tell you that she has three profiles. She turns round and you cannot recognize her."

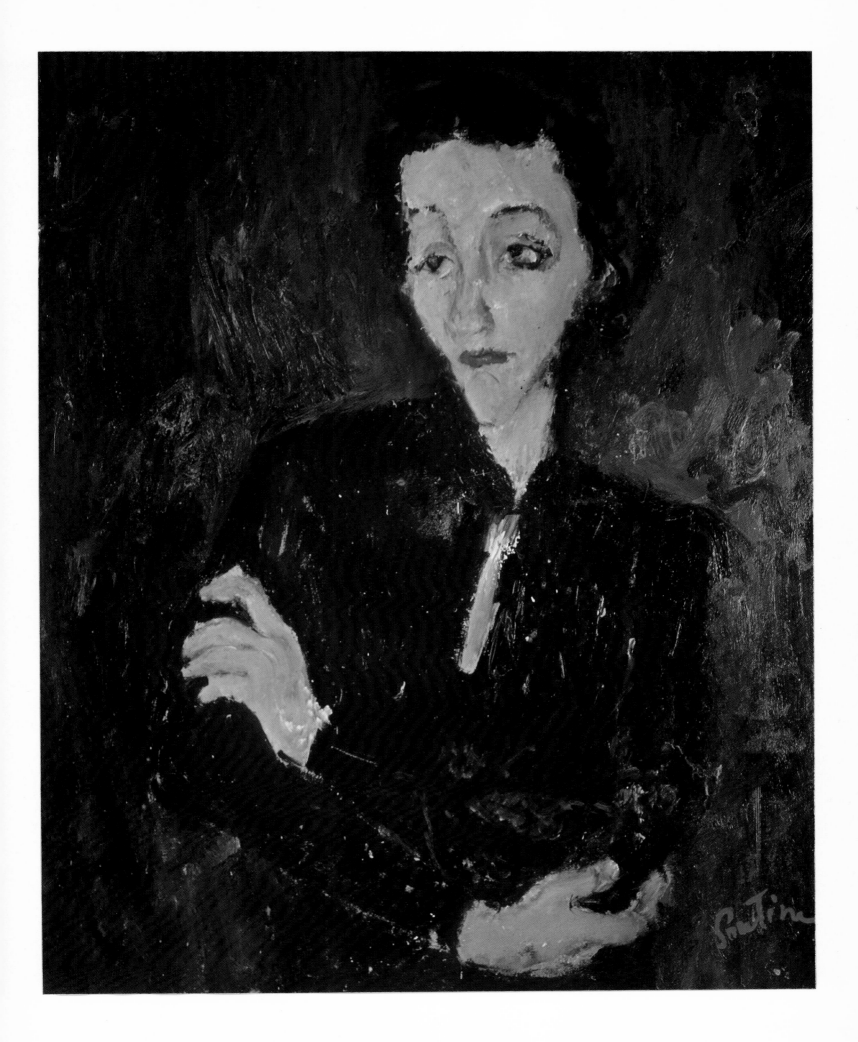

39. SEATED CHOIRBOY

Painted 1930. Oil on wood, 25¼ x 14¼"
Collection Lillian L. Poses, New York

While Soutine often used Modigliani's hieratic convention of form, he imparted a fluidity of movement that, in this example of a seated boy, expresses itself in the rolling waves of red. Soutine admired Courbet's *Funeral at Ornans* at the Louvre, which includes red-robed beadles and choirboys in white surplices. Watching the celebration of Mass in a church in Provence, the artist was able to observe the red and white garments of the choirboys at close hand, and afterwards he arranged for them to pose for him. This boy's long close-fitting robe is painted in a bright pure cadmium red— red being at times symbolic of love, and often used in the Christian service.

The youngster's stance is tense and fearful, as was that of the painter. His frightened face is devoid of any caricatural element. The tiny cap, except for its color, resembles the *yarmulke* worn by Orthodox Jews. The timid country boy is overshadowed by his garb and enveloped by the background color, mostly Prussian blue.

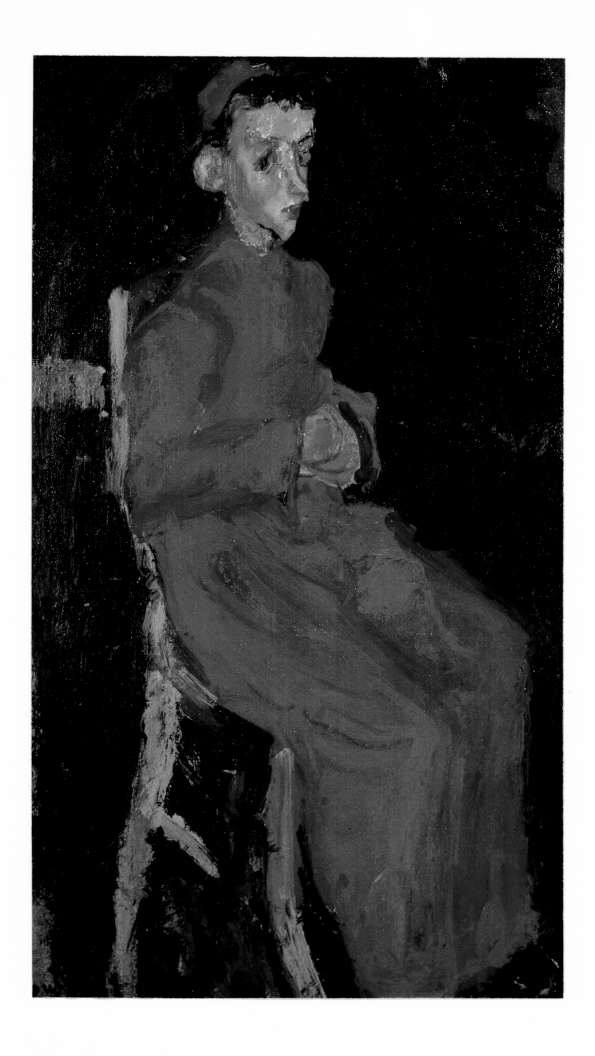

40. FEMALE NUDE

Painted c. 1933. Oil on canvas, 18⅛ x 10⅝"
Collection Mr. and Mrs. Ralph F. Colin, New York

Modigliani and Soutine were close friends, yet worlds apart in their approach to subject matter, as well as in their manner of painting. Both were Jews, but the Italian was totally unaffected by traditional Jewish prudishness about sex and the representation of the undraped body. Modigliani loved the motif of the female nude, portraying her without inhibition and with a frankly erotic enjoyment of sensuality and voluptuousness. Soutine's surviving oeuvre, however, contains only this one rendering of the nude. Was the artist influenced by the stern taboos against nakedness that prevailed among East European Jews? In *Life Is with People,* Mark Zborowski and Elizabeth Herzog have written about this attitude of the Ghetto Jew:

"The body is respected primarily as the container and squire of the mind and spirit. Physical superiority is not Jewish, but is rather ascribed to the goy [the non-Jew]...ideals of beauty reflect the exalting of the spiritual over the physical. Jewish portraits and paintings characteristically depict a head that is real; if the body appears, it is apt to look like a dummy covered with clothes."

Soutine appears to have been shy with women. Though he had several affairs, he strongly resisted a permanent relationship with any woman. Symptomatically, in this painting the model looks uncomfortable and self-conscious, as if both she and the artist were embarrassed.

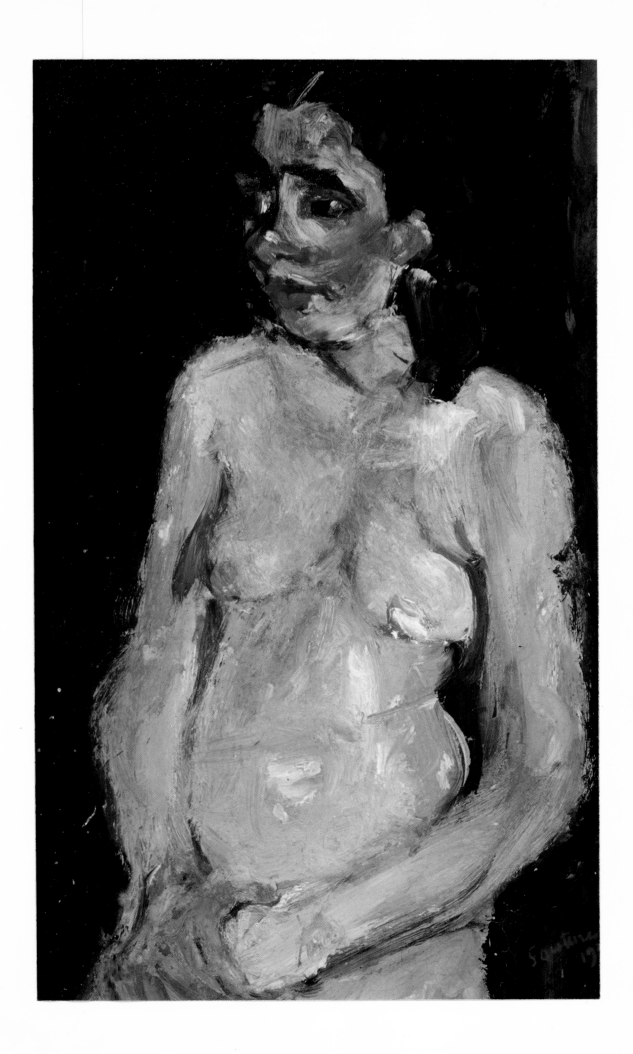

41. THE SALMON

Painted 1933. Oil on wood panel, 13¾ x 30½"
Collection Mr. and Mrs. Ralph F. Colin, New York

Creatures, alive or dead, were usually given more realistic treatment by Soutine than people. In his early years, he often painted herrings on a plate (they were the staple food of East European Jews). There, the poor, emaciated specimens are shown with jaws gaping and eyes popping out of their heads. By contrast, this fish appears to be a proud king of the greenish waters.

This picture is reminiscent of the two versions of *The Trout* by Gustave Courbet, whom Soutine admired. Soutine repeatedly drew his inspiration from works by this nineteenth-century French master, protagonist of *réalisme*. Courbet was a born colorist, who used the palette knife in a deliberate effort to get away from the more traditional manner of painting, paving the canvas with pigment in thick impasto.

Courbet's renditions of trout are characterized by anguish. The trout are being pulled out of the water at the moment chosen by the artist. The hooks are fastened in their jaws and the taut fishing lines, visible in the picture, are yanking the struggling fish upward. The entire expression is one of pain. In Soutine's work, the fish is placidly traversing the canvas.

146

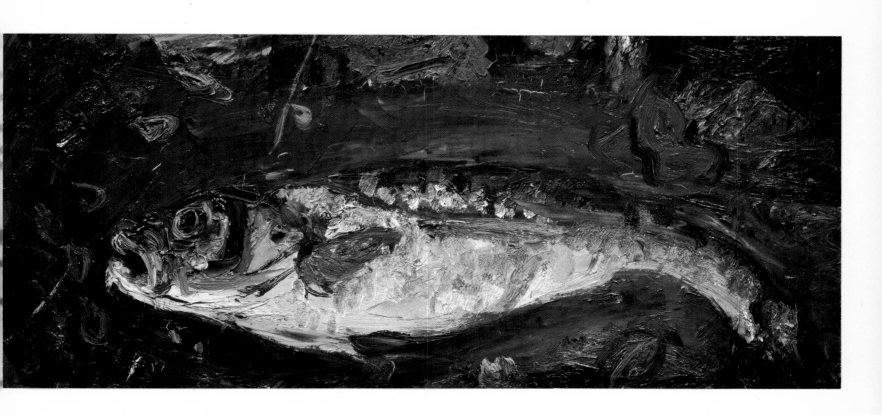

42. CHARTRES CATHEDRAL

Painted 1933. Oil on wood, 36 x 19¾"
The Museum of Modern Art, New York.
Gift of Mrs. Lloyd Bruce Wescott

As a guest in the Castaings' summer home at Lèves, Soutine was not very far from Chartres, whose cathedral has for eight centuries been a proud landmark of France. Corot painted this "French Queen of Gothic Cathedrals" in 1830. Shortly before World War I, at the height of his "White Period," Maurice Utrillo painted many versions of this majestic building. ("He had developed a passion for the Catholic liturgy and secretly haunted churches during Mass," as one of his biographers put it.)

Corot and Utrillo were French Catholics. Soutine was a Russian Jew. But he had overcome the East European Jew's fear of Christian places of worship. An Orthodox Jew like the artist's father would have refrained from even glancing at a church. Ironically, choir-boys and communicants were among Soutine's favorite subjects. His rendering of the cathedral is astonishingly accurate for him: the church with its *Clocher Neuf* on the left, the *Clocher Vieux* on the right, the huge rose window in the center, the gray façade (hovering between mauve and ivory-white), is clearly recognizable, though, of course, Corot and Utrillo are more painstakingly correct in architectural details. The deep red in the foreground is Soutine's way of putting his own stamp on the scene.

Pier Carlo Santini, who includes this picture in his book *Modern Landscape Painting*, writes: "A tormented, grandiose representation of the Cathedral. The exalted, instinctive frenzy of Soutine's style is well shown in this instant deformation, this masterful recasting of material elements. We are at the extreme limit of tragic feeling, on the verge of the cataclysm so often reflected in the author's work."

This, by the way, was the only time Soutine allowed himself to be inspired by one of the countless architectural treasures of France.

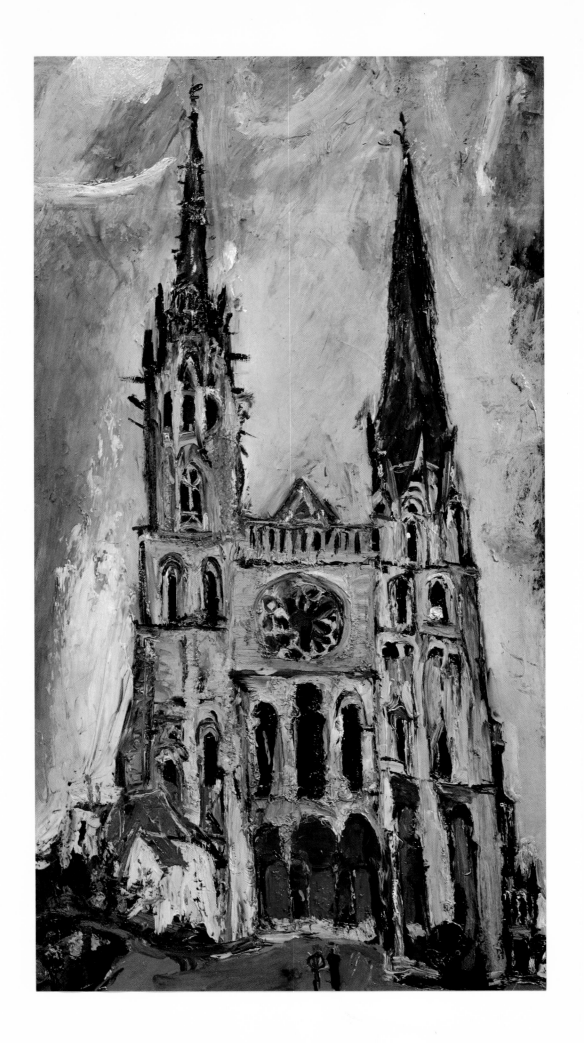

43. PORTRAIT OF A MAN

Painted 1935. Oil on canvas, 22 x 13¼"
Collection Dr. Ruth Bakwin, New York

This subject is exceptional in Soutine's work, for as a rule his male sitters are either cooks, valets, or choir boys in their appropriate uniforms, or else sloppily dressed bohemians, like his artist friends from the Left Bank of Paris. Here, however, is a carefully and formally dressed man, who may be the headwaiter in an expensive restaurant. He has the large head, sullen expression and exaggeratedly large hands one nearly always finds in Soutine's studies of people. For this kind of body, the head is certainly much too large. The white of the dress shirt acts as a focal point. The man seems to be standing in front of a column, but it is almost impossible to identify the background, composed as it is of a variety of blues and greens. The artist's mocking attitude toward this man, dressed *à quatre épingles* (dressed to the nines), reminds us of Modigliani's overdressed groom in the double portrait *Bride and Groom*, in New York's Museum of Modern Art.

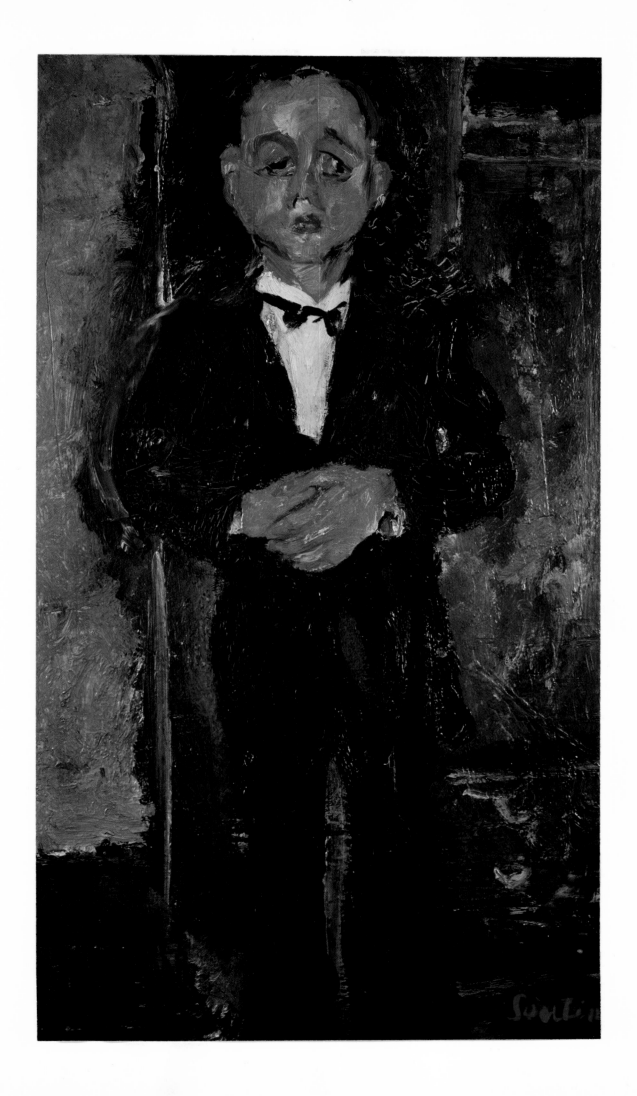

44. SERVANT GIRL

Painted 1937. Oil on canvas, 43¼ x 13⅜"
Kunstmuseum, Lucerne

In an almost classic style, the girl's figure is confined in a niche. This buxom little servant girl, about 15 or 16, appears vexed, perhaps angry. The surrounding darkness squeezes her in, seeming to evoke even more annoyance from her.

The artist had greater rapport with the unsophisticated and unaffected people in the provinces than with the intellectuals with whom his friend Modigliani had mingled. For Soutine never shook off the heritage of the dismal Eastern European village where he spent his childhood. With little formal education, without the good manners (which Modigliani tried to teach him in vain), or the worldliness most Montparnos came to acquire at one point or another, Soutine remained to his end a "man of the people," a *moujik* in outlook, temperament and even, one might say, in his preferred way of living.

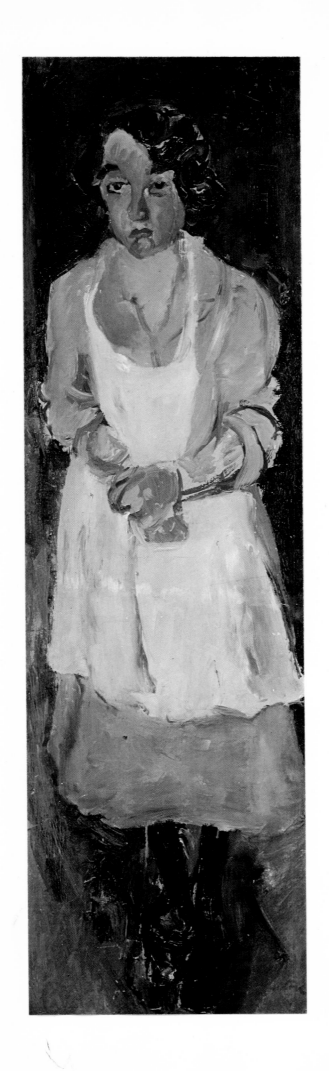

45. WOMAN IN PROFILE

Painted 1937. Oil on canvas, 18½ x 11"
The Phillips Collection, Washington, D.C.

Most of Soutine's sitters appear in the center of the picture, frontally posed. Arrangements like this one, where the model is seen off center, and with the face in near profile, are rare in his work. Here, as in *Portrait of a Man* (colorplate 43), the head is much too large for the small, almost insignificant body.

The shapes of eye, nose and pouting mouth had become mannerisms by 1937. The hair swings away from the face and somewhat offsets the tendency to lopsidedness. Monroe Wheeler finds "an extreme spirituality" in this picture, and believes that because of "an acute scrutinizing or questioning position of the head, a pouting thoughtfulness," it is "one of Soutine's finest portraits." There is much less of the caricatural aspect than in earlier works of this kind. The brushstrokes are less heavily agitated. Again, a central bit of white is the focus of attention: the white shirt under the dark outer clothing.

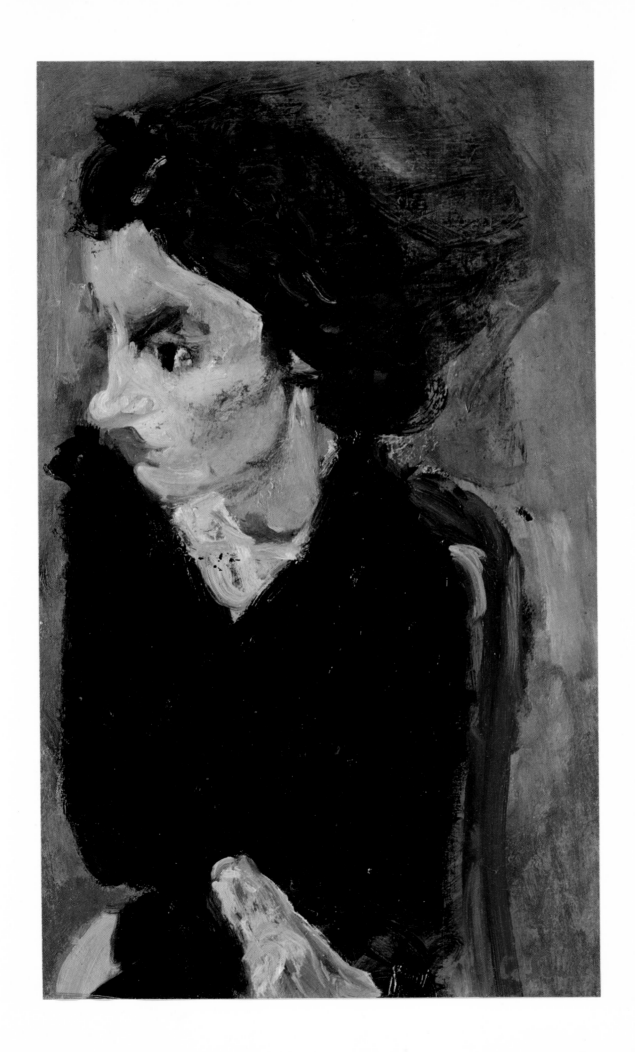

46. RETURN FROM SCHOOL

Painted 1939. Oil on canvas, 17 x 18 "
The Phillips Collection, Washington, D.C.

Although a woman claimed to have been married to Soutine according to the Jewish rite, unrecognized by the state, and a daughter is said to have been born of this brief "union," Soutine remained a bachelor to his end. Yet this lonely man, whose misanthropy pervades his portrayals of adults, seems to have had a tender feeling for little children. This sympathy or empathy is demonstrated in pictures like *Girl in a Polka-Dot Dress* (1942, Jacques Guérin Collection, Paris) or in *Maternity* (1942, Castaing Collection).

Return from School is one of several pictures showing young children walking toward the viewer on a country road that extends into the distance, leading to a wood or a field. The trees form a band where the road ends. Flowers, blades of grass and foliage are agitated by the strong wind (in Soutine's landscapes, the peace and plenty of the Impressionists never prevails).

Dwelling on the fact that these genre pictures were painted in the artist's final years—when Europe was threatened with, and finally engulfed in, a most ferocious war, and when Occupied France no longer could offer any security to this Jewish immigrant—Monroe Wheeler commented: "Perhaps in that twilight of his life, in that eclipse in the life of his adopted country, children two by two in brotherhood or friendship may have seemed to him an image of the condition of all human beings on earth, more acceptable than any other ideal furnished to his mind by patriotism, or religion, or romantic love."

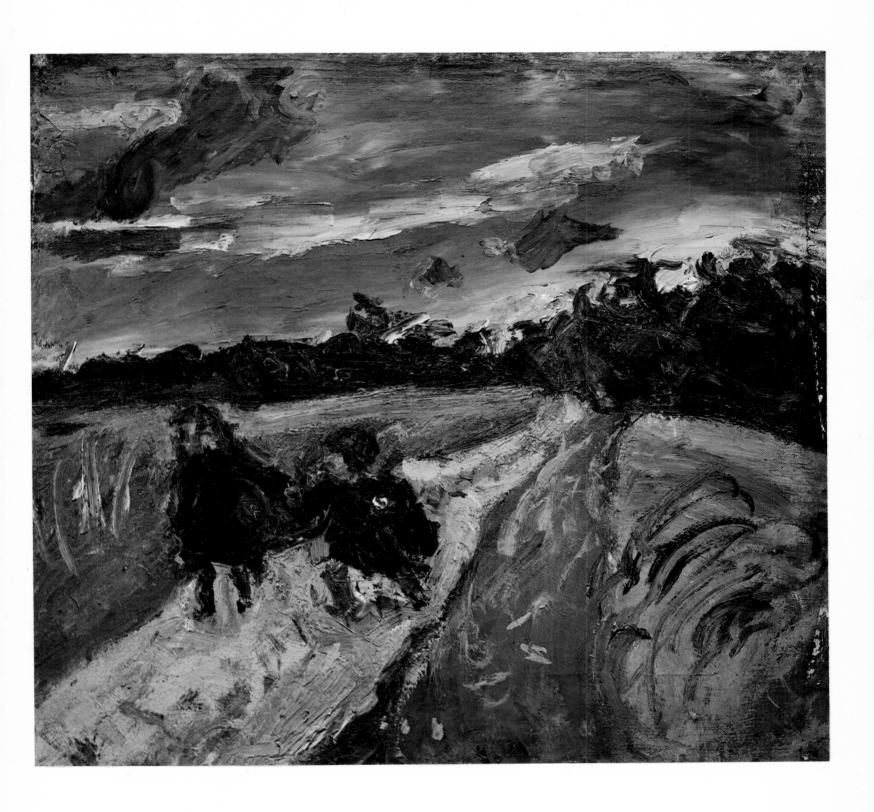

47. WINDY DAY, AUXERRE

Painted 1939. Oil on canvas, 19¼ x 25⅝"
The Phillips Collection, Washington, D.C.

Worship of trees by painters may be said to have begun in seventeenth-century Holland, where Jacob van Ruisdael was hailed as "the painter of the forest." He bequeathed his love of trees and appreciation of their unique qualities to his pupil Meindert Hobbema. In the last century, Corot and other artists chose to settle in the village of Barbizon, on the edge of the Fontainebleau forest, to observe and paint nature there with pantheistic fervor.

The trees in the canvases of the more classical artists, such as Claude Lorrain and Poussin, are straight and still, each standing apart and painted individually. But later artists like Van Gogh or the German Expressionists painted trees in a much less serene and peaceful manner, more like Soutine's trees, which are always shaken by storms, and are true reflections of the upheaval in the artist's soul. They are tall and majestic, yet never individualized, always appearing as a collective. In this picture, the branches, tossed by the wind, whose whistling one can almost hear, pierce a moody, dark sky. The trees dominate the scene which is lit up only by a bit of crimson that shines out from behind the trunks and suggests a small cottage. Two tiny figures are seen coming down the winding road. Their smallness accentuates the tremendous height of what seem to be poplars (though no precise botanical identification can be made).

When, in 1940, Soutine was offered a chance to leave war-torn Europe for the United States, he at first refused. One of the reasons he gave was: "There are no trees to paint in America!" Later on, when immigration became a necessity he was unable to produce all the required documents.

Incidentally, the picture's title was challenged by Mlle. Gerda Groth who claimed that the scene represented the road from Civry-sur-Surein to L'Isle-sur-Surein.

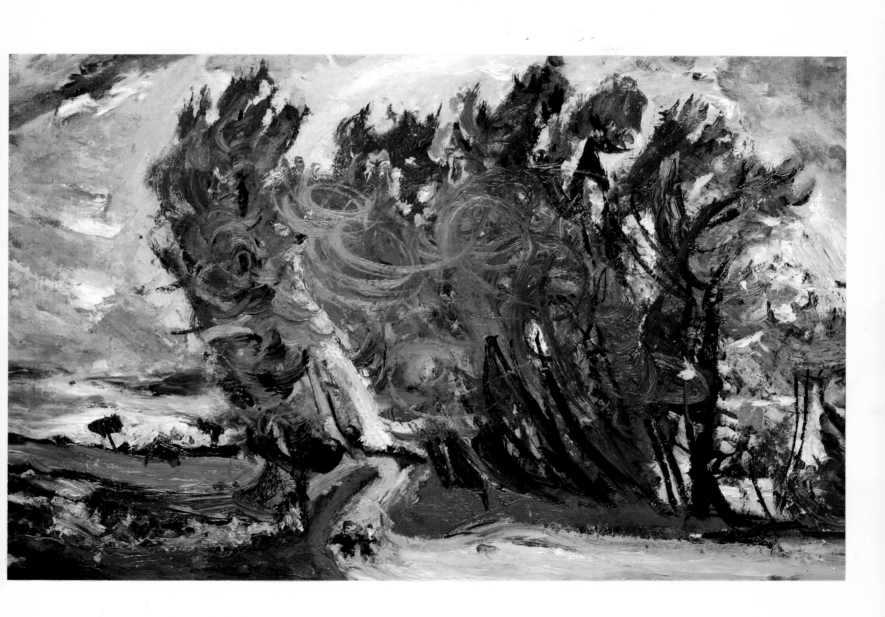

48. GIRL AT FENCE

Painted c. 1942. Oil on canvas, 33 x 25½"
Collection Mr. and Mrs. Nathan Cummings, New York

Repeatedly Soutine placed children at the center of pictures. He seemed to be more at ease with young people than with adults. This painting is very similar to *Girl in a Polka-Dot Dress*. The row of tree trunks in the distance reminded Monroe Wheeler of prison bars. One might say that the fence upon which this child is leaning also suggests confinement and lack of freedom.

While the green background is warm and cheerful, the shy little girl has nothing happy about her. She looks away from the spectator. Her hands twist the wooden structure as if she were embarrassed by the artist's presence. The deep reds in her cheeks suggest an awakening youth. The group of trees on the round hill behind her echoes the curves of her full white shirt.

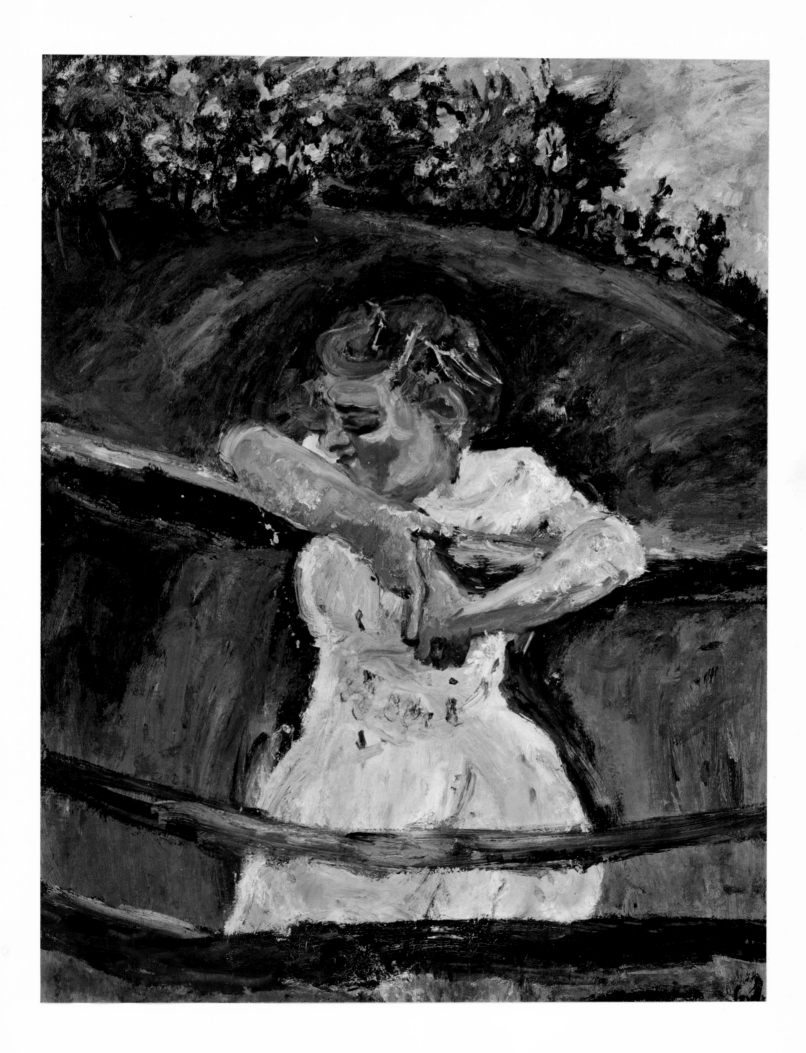

SELECTED BIBLIOGRAPHY

For a more comprehensive listing of writings about Soutine, including newspaper and magazine articles, the reader is directed to the extensive bibliographies in Maurice Tuchman's Soutine catalogue (Los Angeles, 1968) and in Pierre Courthion's Soutine (Lausanne, 1972).

Barnes, A.C., *The Art in Painting.* New York, 1925

Cabanne, P., *Outlaws of Art.* London, n.d.

Castaing, M., and Leymarie, J., *Soutine.* New York, 1963

Chapiro, J., *La Ruche.* Paris, 1960

Cogniat, R., *Soutine.* New York, 1973

Courthion, P., *Soutine: Peintre du Déchirant.* Lausanne, 1972

D'Ancona, P., *Some Aspects of Expressionism: Modigliani, Chagall, Soutine, Pascin.* Milan, 1953

Dorival, B., *Twentieth Century Painters.* New York, 1958

Douglas, C., *Artist Quarter: Reminiscences of Montmartre and Montparnasse.* London, 1941

Faure, E., *Soutine.* Paris, 1929

Forge, A., *Soutine.* London, 1965

George, W., *Soutine.* Paris, 1959

Georges-Michel, M., *From Renoir to Picasso.* New York, 1957

Gimpel, R., *Diary of an Art Dealer.* New York, 1966

Lassaigne, J., *Soutine.* Paris, 1954

Marevna, *Life with the Painters of La Ruche.* New York, 1974

Nacenta, R., *School of Paris.* New York, 1960

Raynal, M., *Modern French Painters.* New York, 1928

Soby, J.T., *Contemporary Painters.* New York, 1948

Szittya, E., *Soutine et son Temps.* Paris, 1955

Tuchman, M., *Soutine.* Los Angeles, 1968

Werner, A., *Modigliani, Utrillo, Soutine.* New York, 1969

Wheeler, M., *Soutine.* New York, 1950

SELECTED BIBLIOGRAPHY

For a more comprehensive listing of writings about Soutine, including newspaper and magazine articles, the reader is directed to the extensive bibliographies in Maurice Tuchman's Soutine catalogue (Los Angeles, 1968) and in Pierre Courthion's Soutine (Lausanne, 1972).

Barnes, A.C., *The Art in Painting*. New York, 1925

Cabanne, P., *Outlaws of Art*. London, n.d.

Castaing, M., and Leymarie, J., *Soutine*. New York, 1963

Chapiro, J., *La Ruche*. Paris, 1960

Cogniat, R., *Soutine*. New York, 1973

Courthion, P., *Soutine: Peintre du Déchirant*. Lausanne, 1972

D'Ancona, P., *Some Aspects of Expressionism: Modigliani, Chagall, Soutine, Pascin*. Milan, 1953

Dorival, B., *Twentieth Century Painters*. New York, 1958

Douglas, C., *Artist Quarter: Reminiscences of Montmartre and Montparnasse*. London, 1941

Faure, E., *Soutine*. Paris, 1929

Forge, A., *Soutine*. London, 1965

George, W., *Soutine*. Paris, 1959

Georges-Michel, M., *From Renoir to Picasso*. New York, 1957

Gimpel, R., *Diary of an Art Dealer*. New York, 1966

Lassaigne, J., *Soutine*. Paris, 1954

Marevna, *Life with the Painters of La Ruche*. New York, 1974

Nacenta, R., *School of Paris*. New York, 1960

Raynal, M., *Modern French Painters*. New York, 1928

Soby, J.T., *Contemporary Painters*. New York, 1948

Szittya, E., *Soutine et son Temps*. Paris, 1955

Tuchman, M., *Soutine*. Los Angeles, 1968

Werner, A., *Modigliani, Utrillo, Soutine*. New York, 1969

Wheeler, M., *Soutine*. New York, 1950

INDEX

PHOTOGRAPHIC CREDITS

*(Numbers refer to figures; an asterisk * denotes a colorplate)*

The author and publisher wish to thank the libraries, museums, and private collectors for permitting the reproduction of works in their collections. Photographs have been supplied by the owners or custodians of the works of art except for the following, whose courtesy is gratefully acknowledged:

Apple, Arthur, St. Louis (*10); Beville, Henry, Washington, D.C. (*24, *45, *46, *47); Blatas, Arbit, New York (57); J.-E. Bulloz, Paris (*18); Clements, Geoffrey, New York (*11, *14, *22, *39, *42, *43); Cornachio, Edward, Los Angeles (*12); Cserna, George, New York (6); Dräyer, Walter, Zurich (22); Giraudon, Paris (17, 19, 23, 27); Greenberg-May Productions, Inc., Buffalo (*4); Hachette, Paris (55); Izis, *Paris Match*, Paris (37); Klima, Joseph, Jr., Detroit (*7); Limot, Paris (9, 10, 11); Marlborough Fine Art, Ltd., London (63, 65); Mills, Charles, Philadelphia (*5, *9, *30); The Museum of Modern Art, New York (72); from *My Years with Soutine* by Garde, publishers DeNoël, Paris (7, 18, 36, 39, 40, 41); Perls Galleries, New York (25, 64, 68); Roger-Viollet, Paris (71); Roos, George, New York (*17); Service de documentation photographique de la Réunion des musées nationaux, Paris (*20, 26, 30, 51, 54, 67); Studio Pyrénées, Céret (60, 61, 62); Sunami, Soichi, New York (34, 52); Suter, Duane, Baltimore (*13); Thomas, Frank, Los Angeles (*32); Thomson, John F., Los Angeles (*21, *27); Varon, Malcolm, New York (*48).